Rodin and Michelangelo

Rodin
and
Michelangelo

A Study in Artistic Inspiration

Flavio Fergonzi
Maria Mimita Lamberti
Pina Ragionieri
Christopher Riopelle

Philadelphia Museum of Art

This book is published on the occasion of the exhibition *Rodin and Michelangelo: A Study in Artistic Inspiration*

The exhibition was conceived by Giovanni Agosti and Pina Ragionieri and organized by Maria Mimita Lamberti and Christopher Riopelle.

Casa Buonarroti, Florence
June 11–September 30, 1996

Philadelphia Museum of Art
March 27–June 22, 1997

The exhibition is made possible in Philadelphia by the Iris and B. Gerald Cantor Foundation and by Schnader Harrison Segal & Lewis.

Additional support has been provided by The Pew Charitable Trusts and the Robert Montgomery Scott Endowment for Exhibitions, and by an indemnity from the Federal Council on the Arts and the Humanities. US Airways is the official airline for the exhibition. NBC 10 is the media sponsor.

Originally published as *Michelangelo nell'Ottocento: Rodin e Michelangelo*

English-language edition produced by the Department of Publications and Graphics Philadelphia Museum of Art Benjamin Franklin Parkway at Twenty-sixth Street P.O. Box 7646 Philadelphia, PA 19101-7646

Editors
George H. Marcus
Curtis R. Scott

Translators
Charles Doria
Anthony Shugaar

Designer
Gabriele Nason
Edizioni Charta, Milan

Editorial Coordinator
Emanuela Belloni
Edizioni Charta, Milan

Production Manager
Sandra M. Klimt

Color separations and printing
Amilcare Pizzi Arti Grafiche
Milan

Printed and bound in Italy

Library of Congress Cataloging-in-Publication Data may be found on p. 236

Distributed in the United States and Canada by the Philadelphia Museum of Art
ISBN 0-87633-110-X (cloth)
ISBN 0-87633-109-6 (paper)

Distributed elsewhere by Edizioni Charta
ISBN 88-8158-072-1 (paper)

Contents

Foreword

The history of art has been created in good part by one great artist's fascination, even obsession, with the work of another. Artistic inspiration leaps across the centuries and across national boundaries, imitation being not only the sincerest form of flattery but also the wellspring of creative energy. One has only to think of Cézanne's admiration for Poussin, Picasso's for Velásquez, or the passion of Ingres for the work of Raphael to understand that such inspiration can be a major force without in any way diminishing the stature of the later artist. The sixteenth-century Florentine genius Michelangelo Buonarroti (1475–1564) was a figure of such overwhelming importance that in his own time his influence extended broadly across the fields of painting, sculpture, and architecture. More than three centuries later his impact could still be felt, perhaps nowhere more deeply than in the art of the young French sculptor Auguste Rodin (1840–1917), who made a fateful journey to Italy at the age of thirty-six.

For Rodin, the year 1876 was an *annus mirabilis*, marked by his visit to Florence and his firsthand encounter with the Medici Chapel and other masterworks of his Renaissance hero. This exhibition is the first to suggest the full impact of Michelangelo's art upon the career of Rodin, for whom this creative encounter came at a crucial juncture. Thanks to the scholarship of the exhibition organizers, we now know that Michelangelo's powerful drawing of the Virgin and Child, here shown in Philadelphia for the first time, was surely among the first works of art to greet Rodin's gaze when the young sculptor visited the Casa Buonarroti, the museum created in the family palazzo in Florence that had played such an important public role the previous year, during the celebrations commemorating the four hundredth anniversary of Michelangelo's birth. Among the many happy connections celebrated by this international exhibition project are the sister-city relationship between Florence and Philadelphia and

the affinity between the Casa Buonarroti, one of the earliest museums in Europe to be devoted to a single artist, and the Rodin Museum in Philadelphia, which holds the same distinction in the United States.

It was the inspiration and enthusiasm of our colleague and partner, Dr. Pina Ragionieri, director of the Casa Buonarroti, that launched the present exhibition as one of an ongoing series that she and her staff have devoted to aspects of Michelangelo's influence. We are enormously grateful to her and to Professor Luciano Berti, president of the Ente Casa Buonarroti, for their willingness to share the exhibition and their invaluable help and advice along the way, as well as for their generosity as lenders. The exhibition was organized by Professor Maria Mimita Lamberti of the Università Statale, Milan, and by Christopher Riopelle, associate curator of European painting and the Rodin Museum in Philadelphia, who together with Professor Flavio Fergonzi of the Accademia di Belle Arti di Brera, Milan, and Giovanni Agosti, curator at the Galleria degli Uffizi in Florence, have done a splendid job of exploring and clarifying the connections between these two great artists, separating much myth from fact. We also owe a debt of gratitude to the Musée Rodin in Paris for its important loan of drawings, which provide evidence of the way in which Rodin approached Michelangelo; to the Cleveland Museum of Art for parting with its rare and recently acquired ceramic sculpture by Rodin, which reveals Michelangelo's impact so vividly; and to the Metropolitan Museum of Art for lending not only a spectacular Michelangelo drawing but also plaster casts of three Medici Chapel sculptures, which have served American art students for decades as an introduction to the master's work and which now help this exhibition to suggest its scale and impact as Rodin would have experienced it on his first Italian journey.

9

Together with Christopher Riopelle, who has served with such elegance and energy as the Philadelphia-based director of this project, we thank all the Philadelphia Museum of Art staff who have worked so hard to bring it about. To Missy Maxwell of the Philadelphia firm of Susan Maxman Architects we owe our most vivid appreciation for her handsome and intelligent design of the exhibition installation, as well as for her sensitive ongoing renovations to the Rodin Museum, a splendid little Beaux-Arts building and gardens designed by the architects Paul Cret and Jacques Gréber, which opened to the public in 1929.

It is a source of particular joy that the sponsors whose generosity makes this undertaking possible include the Iris and B. Gerald Cantor Foundation, and we are only saddened that the late Gerald Cantor never had the opportunity to see this exhibition in which he surely would have taken so much pleasure. His lifelong commitment to the work of Rodin, both as a great collector and as a benefactor of museums and scholarly projects, has advanced public knowledge and appreciation of the sculptor's achievement and is without peer in the second half of the twentieth century. Mr. Cantor was in turn an admirer of Jules E. Mastbaum, whose much briefer but equally intense engagement with Rodin in the 1920s resulted in the creation of Philadelphia's Rodin Museum. We are delighted that the Philadelphia Museum of Art is able to present the exhibition *The Hands of Rodin: A Tribute to B. Gerald Cantor* to coincide with *Rodin and Michelangelo: A Study in Artistic Inspiration*, knowing that these two tightly focused projects will reinforce each other and give the public a sharpened insight into Rodin's working methods, and we are immensely grateful to Iris Cantor for her support. The Cantor Foundation staff have been unfailingly helpful, and we must express special thanks to Susan Sawyers, executive director

of the foundation, and to Rachael Blackburn, its curator of exhibitions.

In Philadelphia, it has been a distinct honor to have the sponsorship of the law firm of Schnader Harrison Segal & Lewis. Their willingness to assume a leadership role in bringing these exhibitions to Philadelphia is profoundly appreciated.

This ambitious undertaking could not have been launched without the invaluable support for both planning and implementation from The Pew Charitable Trusts. We are thankful as well to US Airways for providing in-kind assistance with international transportation, and to NBC 10 for their efforts to promote the exhibition. An indemnity from the Federal Council on the Arts and the Humanities helped defray the costs of insurance.

We are by no means alone among art museums in the constant quest for support for special exhibitions. Our jubilation at the creation of a new and stable source of endowment income intended for that purpose is made especially meaningful by the fact that it derives from an outpouring of contributions in honor of retiring Museum president Robert Montgomery Scott. It seems particularly apt that this exhibition, which celebrates both the Museum's international ties and its own distinguished artistic and curatorial resources, should be the first recipient of monies from the Robert Montgomery Scott Endowment for Exhibitions, and we hope that the many generous donors to the fund will share that sentiment.

Anne d'Harnoncourt
The George D. Widener Director
Philadelphia Museum of Art

Joseph J. Rishel
Senior Curator of European
Painting and the Rodin Museum

Acknowledgments

My co-curator Mimita Lamberti and I wish to thank many people on both sides of the Atlantic without whose help this project might well have proved impossible. In Florence, our first thanks go to the indefatigable Pina Ragionieri, director of the Casa Buonarroti, who conceived the exhibition and who prodded and supported us at every step. Also in Florence, we thank Luciano Berti, president of the Ente Casa Buonarroti, as well as Elisabetta Archi, Elena Lombardi, and Giovanni Agosti; in Milan, we thank our coauthor Flavio Fergonzi. In Florence and in Philadelphia, Carl Brandon Strehlke was the indispensible matchmaker who brought together the Casa Buonarroti and the Rodin Museum in fruitful cooperation. In Paris, Claudie Judrin of the Musée Rodin generously supported our research with her vast knowledge of Rodin's drawings and with crucial loans. In New York, our thanks go to Emily Braun, George Goldner, Johanna Hecht, Carol Potter, Scott Schaeffer, and especially John Tancock, whose 1976 catalogue of the Rodin Museum in Philadelphia remains a central reference in Rodin studies. In Cleveland, we thank Diane DeGrazia and Henry Hawley; in Los Angeles, Susan Sawyers and Rachael Blackburn of the Iris and B. Gerald Cantor Foundation; in Baltimore, Elizabeth Cropper and Charles Dempsey proved, among many other accomplishments, to be masters of the Rodin bibliography as well.

At the Philadelphia Museum of Art, the unflagging commitment of Anne d'Harnoncourt, director, and Joseph J. Rishel, senior curator of European painting and the Rodin Museum, kept the project moving ahead. Also at the Museum we thank Nancy Ash, Alice Beamesderfer, Marigene Butler, Elie-Anne Chevrier, Mary Alice Cicerale, John Costello, Donna Farrell, Alison Goodyear, Diane Gottardi, Priscilla Grace, Jean Harvey, John Ittmann, Mari Jones, Gina Kaiser, Sandra Klimt, Andrew Lins, Tom Loughman, Katherine Crawford Luber, George Marcus, Melissa Meighan, Lilah Mittelstaedt, Martha Mock, Ann Percy, Martha Pilling, Danielle Rice, Lynn Rosenthal, Curtis Scott, Innis Howe Shoemaker, Irene Taurins, Allen Townsend, Jennifer Vanim, Dean Walker, Mary Wassermann, Suzanne Wells, Maia Wind, Graydon Wood, and Faith Zieske.

My wife Caroline has been my support.

C.R.

Rodin and Michelangelo

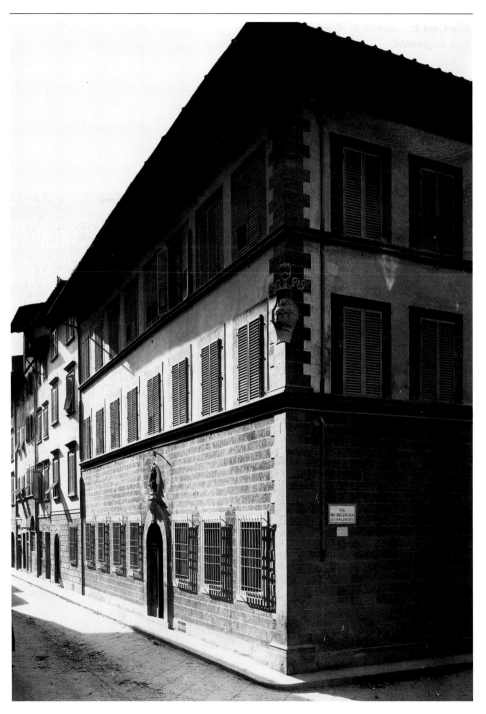

14

The Casa Buonarroti in Florence
Pina Ragionieri

A document discovered by the Michelangelo scholar Giovanni Poggi and published in 1965 by Ugo Procacci in his thorough catalogue of the Casa Buonarroti indicates that on March 3, 1508, Michelangelo purchased, for a price of 1,050 "fiorini larghi," three houses and a smaller building in Florence, between the via Ghibellina and what is now via Michelangiolo Buonarroti. Another adjoining structure was purchased by the artist in April of 1514. Of this complex of five houses, three were probably rented out immediately. From 1516 Michelangelo lived in the two larger houses, except for when his Medici commissions took him to the marble quarries of Carrara and Pietrasanta. In 1525, at the urging of the Medici pope Clement VII, he moved to another part of town near the basilica of San Lorenzo, where for years he had been hard at work on the facade of the church, the New Sacristy, and the Laurentian Library. In that year, the unassuming complex in the via Ghibellina was entirely rented out.

Michelangelo lived elsewhere; all the same, a constant, if not obsessive, desire—more than a desire perhaps, a determination—comes through in his correspondence (especially after his move to Rome in 1534) to connect his family's name for posterity to a building in Florence, to that which he himself described as an "honorable house in the city." The family's sole male heir, Leonardo (1519–1599), the son of Michelangelo's younger brother Buonarroto, managed to find some respite from his renowned uncle's continual pressure in this regard by marrying Cassandra Ridolfi in 1553 and agreeing to a partial renovation of the property. Not much else happened regarding the house during Michelangelo's lifetime, and it was not until 1590 that Leonardo's sporadic efforts culminated in the family "palazzetto" for which Michelangelo had so long yearned (see fig. 1).

The most important period in the early history of the Casa

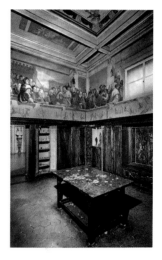

Fig. 2. The Study on the main floor of the Casa Buonarroti

Fig. 1. The Casa Buonarroti in the early twentieth century

Buonarroti came during the lifetime of one of Leonardo's sons, Michelangelo Buonarroti the Younger (1568–1647), a figure of considerable importance in the Florentine cultural landscape of the first half of the seventeenth century. Michelangelo Buonarroti the Younger has heretofore been known more as a man of letters—he was the author of two well-known plays, *La Tancia* and *La Fiera*—than for his remarkable qualities as a versatile and enterprising cultural entrepreneur and as a friend and generous host to artists and scientists. Most of the numerous volumes of his correspondence, domestic accounts, and other writings (all preserved in the Archivio Buonarroti) remain unpublished, and if properly studied, these papers might clearly fill in the gap in his intellectual biography.

Michelangelo the Younger expanded the family landholdings, and it was through his efforts, between 1612 and 1640, that the house took on its present-day appearance. He was responsible for the construction and decoration of the public rooms on the main floor, in which the greatness of the family and the glory of its most famous ancestor are commemorated in a sort of compendium of the art of seventeenth-century Florence and Tuscany. He planned out and personally supervised the complex decorative program of these rooms, and he kept detailed accounts of the progress, payments, and dates; as a result, there are no doubts concerning authorship of the works or the dates of their execution. This impressive project is moreover described in numerous documents of varied provenance, including the late seventeenth-century inventory drawn up by a great-grandson of the same name, known as the "Descrizione Buonarrotiana."

The first room, known as the Gallery, was completed between 1613 and 1635. Its theme is the glorification of Michelangelo—artist, man, and poet—which takes the form

Fig. 3. Michelangelo, *The Battle of Lapiths and Centaurs*, 1490–92. Marble, 31 3/4 x 34 5/8" (80.5x88 cm). Casa Buonarroti, Florence

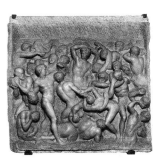

of a remarkable biography, narrated in paintings that were executed by the most important artists working in Florence during those years. The place of honor in this hall was occupied by a very important marble relief that Michelangelo had sculpted when he was no older than sixteen and was still studying under the sculptor Bertoldo di Giovanni in the Medici garden near the monastery of San Marco: *The Battle of Lapiths and Centaurs* (fig. 3), which is still today emblematic of the Casa Buonarroti and its museum. The relief remained there until 1875, set beneath a large painting that Michelangelo the Younger had purchased in Rome as an original work of his great ancestor, which although based on a cartoon by Michelangelo was in fact executed by his pupil and biographer Ascanio Condivi (1525–1574).

The decoration of the second room, the Room of Night and Day, was begun in 1624 and continued for many years. In 1625 Jacopo Vignali frescoed the ceiling with a portrayal of God the Father separating the light from the shadows and with personifications of Night and Day; without a doubt, the most distinctive feature of the hall is the Scrittoio, a small alcove decorated with lively frescoes, which can be closed by doors like a cabinet and to which Michelangelo the Younger withdrew to study. The fresco decorations featuring family members continue along the walls of the main room, which is also furnished with important works of art, including a panel showing scenes from the life of Saint Nicholas of Bari (fig. 6), a masterpiece of the painter Giovanni di Francesco, active in Florence in the fifteenth century; Giuliano Bugiardini's famous portrait of Michelangelo; and Daniele da Volterra's bronze head of the artist (no. 34).

The next room, known as the Room of the Angels, has walls frescoed by Jacopo Vignali with figures of saints proceeding from the Church Militant toward the Church Triumphant.

Fig. 4. Michelangelo, *The Madonna of the Stairs*, c. 1490. Marble, 22 $^{1}/_{4}$ x 15 $^{3}/_{4}$" (56.7 x 40.1 cm). Casa Buonarroti, Florence

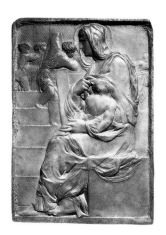

Visitors to this room can hardly fail to admire the great wooden intarsia (situated above the altar), which depicts the Virgin and Child and is based on a cartoon by Pietro da Cortona that dates from around 1642. Several of the doors on the main floor of the Casa Buonarroti are also exquisite intarsias likewise based on cartoons by Pietro da Cortona, who was a friend of the owner and a frequent guest during the years he worked at the Palazzo Pitti in Florence. In the same room is a renowned marble bust of Michelangelo the Younger by Giuliano Finelli, a pupil of Bernini (fig. 5).

The fourth room, the Study (see fig. 2), was decorated in the years 1633–37; its frieze, frescoed by Cecco Bravo, Matteo Rosselli, and Domenico Pugliani, features depictions of illustrious Tuscans in a picturesque and faithful lineup of well-known physiognomies. Beneath the frescoed frieze is a set of wooden cabinets with ivory and mother-of-pearl inlay. These cabinets contain diverse objects from the family's varied collections. In one of them is a *bozzetto* (sculptural sketch) in terracotta, certainly by Michelangelo, portraying two nude men engaged in combat (no. 45).

These four rooms and another smaller one in which Michelangelo the Younger liked to assemble numerous items from his collections have miraculously survived intact, the only instance within the house, which over the years has undergone all sorts of changes and sometimes rather heavy-handed renovations. For example, one project undertaken at the turn of the nineteenth century almost entirely destroyed another of Michelangelo the Younger's contributions: a sort of hanging garden of delights situated in the loggia of the top floor, consisting of a grotto with stucco reliefs, artificial sponges, and water effects. Of that, only a single space survives, adjacent to the existing roof terrace and restored in 1964. It has a ceiling frescoed in 1638 by Giovan Battista

Cartei, with a gracefully decorative depiction of a pergola and flying birds. Sadly, access is limited, and this room is not part of the regular tour of the museum.

Two of the fundamental characteristics of Michelangelo the Younger—his passion for collecting and his cult of family history—underlie the formation of the Buonarroti artistic patrimony. He deserves full credit for the acquisition of family portraits and ancient sculpture. It was he who decided to place *The Battle of Lapiths and Centaurs* in a prominent position in the first of the public rooms; it was he who negotiated with the sacristan of the church of Santa Croce for the purchase of the aforementioned panel with the scenes from the life of Saint Nicholas of Bari by Giovanni di Francesco; and it was he who obtained the marble relief of *The Madonna of the Stairs* (fig. 4), done by the young Michelangelo, as well as numerous Michelangelo drawings.

At this point, we should best turn back a bit, to speak of the most precious treasure of the Casa Buonarroti: the collection of Michelangelo drawings. Michelangelo's best-known biographer, the painter and architect Giorgio Vasari (1511–1574), recounts as evidence of the artist's uncompromising desire for perfection that, prior to his death in Rome in 1564, Michelangelo decided to burn "a great number of designs, sketches, and cartoons made with his own hand, to the end that no one might see the labours endured by him and his methods of trying his genius, and that he might not appear anything less than perfect" (Vasari 1912–15, vol. 9, p. 104). Luckily, many of Michelangelo's drawings remained in Florence at the time of his death, and his nephew Leonardo obtained others in Rome. Nonetheless, around 1566, in order to satisfy the collecting ambitions of Cosimo I de' Medici (1519–1574), grand duke of Tuscany, Leonardo made him a gift of many of those drawings along with the precious *Ma-*

donna of the Stairs and everything that remained in the Florentine studio that Michelangelo had left when he moved definitively to Rome.

When, more than fifty years later, Michelangelo the Younger decorated the series of rooms in the family home primarily in commemoration of his great ancestor, *The Madonna of the Stairs* and some of the drawings that had been given to the Medici family were returned to him by Grand Duke Cosimo II (1590–1620); meanwhile, the loyal grand-nephew was also purchasing other drawings by Michelangelo, at considerable cost, on the Roman market. Many of the drawings were then collected into volumes, but the most beautiful were framed and hung on the walls of the new rooms.

The Buonarroti family collection at this point constituted the largest gathering of drawings by Michelangelo in the world, and so it remains to this day, with its more than two hundred items, despite various depredations. The collection was reduced at the end of the eighteenth century by an initial sale made by the revolutionary Filippo Buonarroti (1761–1837) to the French collector and painter Jean-Baptiste Wicar, and in October 1858 the collection was further reduced when the Cavalier Michelangelo Buonarroti sold a number of drawings to the British Museum in London.

Just a few months before this, Cosimo Buonarroti (1790–1858), the last direct heir of the Buonarroti family, died. He was the owner of the largest portion of Michelangelo's papers and drawings, which he bequeathed to the public along with the house in the via Ghibellina and the objects in that building. From then on, the precious drawings remained for many years on display, framed or in vitrines. Not until 1960 were they rescued from such inadvisable treatment. They underwent careful restoration at the Gabinetto Disegni e Stampe degli Uffizi in Florence and in 1975 were returned to

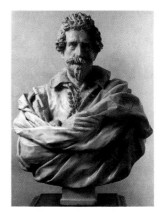

the Casa Buonarroti. The drawings are now exhibited on a rotating basis in a specially equipped room, under proper conditions of temperature, humidity, and lighting.

Let us now return to the history of the Buonarroti family and of the Casa Buonarroti. In 1704, the complex was ceded to Filippo Buonarroti (1661–1703), a fine antiquarian and archaeologist, president for life of the Accademia Etrusca di Cortona, member of the learned linguistic society called the Accademia della Crusca, and author of noteworthy archaeological publications. Under his supervision, the Casa Buonarroti, enlarged and enriched with numerous ancient Etruscan and Roman artifacts, became once again a meeting place for the leading scholars of the period. With Filippo Buonarroti, however, the most enlightened period of the Casa Buonarroti came to an end. In the course of a few decades, the situation of both the Buonarroti family and the Casa Buonarroti itself had become quite desperate. In fact, between the end of the eighteenth century and the turn of the nineteenth century, the direct heirs even lost their rights of ownership to the property. At the beginning of the nineteenth century, troops were barracked in the increasingly decrepit building.

Finally, in 1812, the previously mentioned Cosimo Buonarroti succeeded in gaining back ownership of the house; he carried out major restorations and lived in the house until his death. In 1846 he married the gentle Rosina Vendramin (1814–1856), an Anglo-Venetian noblewoman who nourished genuine adoration for her great ancestor by marriage and for the family history; she was responsible, among other things, for the transcription of numerous archival documents and for the rediscovery of a number of *bozzetti* believed to be by the hand of Michelangelo himself.

When Cosimo died in 1858 without leaving direct heirs, the house in the via Ghibellina was handed over to the city of

Florence, although not without some opposition on the part of the more distant heirs. The Casa Buonarroti was set up a year later as a nonprofit organization as one of the first decrees of the provisory government after the exile of the Grand Duke Leopold II of Lorraine. Florence would soon become part of the kingdom of Italy.

The most striking event in the early years of this organization involved the commemorative celebrations of the four hundredth anniversary of the birth of Michelangelo, held in Florence in 1875. The Casa Buonarroti possesses numerous memorabilia of that occasion, which are now on exhibit in two rooms of the museum. The quadricentennial had a lasting effect on the city, ranging from the new layout of the Piazzale Michelangelo to the design of the Tribune for the display of Michelangelo's *David* in the Galleria dell'Accademia. There was talk at the time of embellishing the facade of the Casa Buonarroti with a complex decoration to be executed in *graffito*, and the plans for that project survive. But financial problems became so serious that it was necessary to rent out many areas of the house as private quarters, while in

Fig. 6. Giovanni di Francesco (Italian, 1428?–1459), *Scenes from the Life of Saint Nicholas of Bari* (detail), c. 1457. Tempera on panel. Casa Buonarroti, Florence

1881 it was decided to move the collections of antiquities to the Museo Archeologico (these collections were finally returned to the house in the spring of 1996). At the turn of the twentieth century, the Casa Buonarroti housed the Museo Storico-Topografico Fiorentino (Florentine Historical and Topographic Museum), although after the First World War, the Casa Buonarroti was once again broken up and rented out in part.

The first modern restoration efforts date back to 1951, carried out in honor of the Michelangelo scholar Giovanni Poggi (1880–1961), who had been responsible for the transfer of numerous works of art from the galleries of Florence to the collections of the Casa Buonarroti. Immediately after the four hundredth anniversary of the death of Michelangelo (1964), the Italian government established the Ente Casa Buonarroti, and Charles De Tolnay, a Hungarian scholar, was invited to come to Florence from Princeton after the publication of his well-known and monumental monographic work on Michelangelo, to be its director. De Tolnay remained the head of the Ente Casa Buonarroti until his death in 1981, and in that position he carried on his studies of Michelangelo's drawings, reordering the collections and enriching the library.

One of the results of the events of 1964 was the deposit in the Casa Buonarroti of the *Crucifix* of Santo Spirito, a wood sculpture first attributed to Michelangelo two years earlier by Margrit Lisner, and now considered by most critics to be an authentic work by Michelangelo. During this same period, from the Accademia delle Arti del Disegno, came the only large-scale model known to be by Michelangelo, depicting a *River God* (no. 43, fig. 1). This powerful work can now be admired in the museum in a gallery that also includes the wooden model of the facade of the church of San Lorenzo.

Today the Casa Buonarroti is not merely a museum but

Figs. 7, 8. The exhibition
Rodin and Michelangelo, as
installed at the Casa Buonarroti,
Florence, June 1996

also a place of study and of meditation, overseeing and pre-
serving its rich heritage. It is in this sense that one should
view the efforts that have been made in recent years to re-
search a number of events concerning the Buonarroti family,
with special attention to its greatest member. Collaboration
with Italian and foreign scholars both young and old, ongo-
ing relationships with national and international institutions,
the daily encounter with the drawings, papers, and works of
Michelangelo, and annual exhibitions constitute its basic mis-
sion. In recent years this has led us to investigate, among other
things, Michelangelo's troubled relationship with the con-
struction of San Lorenzo and Saint Peter's, and to examine
such unusual topics as a comparative study of the life and the
handwriting of the artist, his youthful education in the Medici
garden near San Marco, as well as this exhibition of Rodin
and Michelangelo (see figs. 7, 8), a comparison that, hereto-
fore, has never been attempted in visual and physical terms.

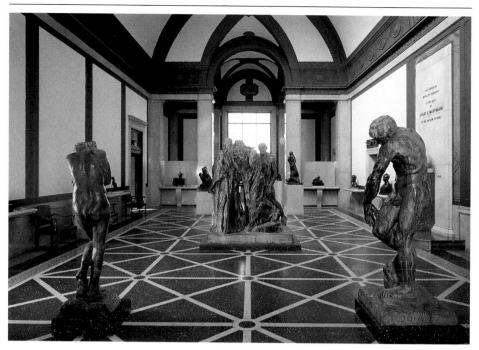

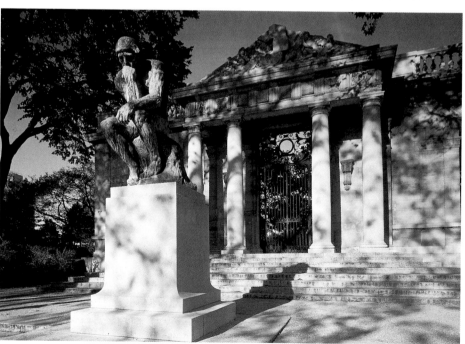

The Rodin Museum in Philadelphia
Christopher Riopelle

The first works that Auguste Rodin ever exhibited in the United States were shown in Philadelphia. In 1876, the same year that he first visited Italy and was overwhelmed by the art of Michelangelo, Rodin sent eight of his early sculptures to the Centennial Exposition in Philadelphia's Fairmount Park, commemorating one hundred years of American independence. Because he had worked in Brussels since 1871, Rodin exhibited with the Belgian delegation, but while five of the eight Belgian sculptors were awarded medals, Rodin himself went unrecognized. The local press was silent. Not a single Philadelphian seems to have spotted this budding sculptural genius, and Rodin was disappointed by his American debut (Butler 1993, p. 86)

Decades later, one of the most passionate collectors of Rodin's sculpture that America has known would be a Philadelphian, and the bequest he made to his native city, the Rodin Museum, ensures that the sculptor, once ignored, remains a vital artistic presence here. Born in 1872, Jules E. Mastbaum started his fortune in real estate and by the late 1890s had turned his attentions to the emerging motion picture industry, opening his first movie theatre in Philadelphia in 1905. By 1920, Mastbaum's Stanley Company of America—named for a brother who had recently died—was the largest operator of motion picture theatres in the United States. A distinctive American type, the "movie mogul," Mastbaum lived grandly, traveled in splendor, and indulged his appetites with gusto. It was common for wealthy American businessmen to form art collections as their fortunes increased, and Mastbaum was no exception. However, before 1923 there was little sign that for him art would become a ruling passion.

In 1923, while traveling in Paris, Mastbaum acquired his first Rodin sculpture, said to be a *Hand* spotted in the window of a gallery; from that moment, it seems, he was seized

Figs. 1, 2. The central gallery and gateway to the Rodin Museum, Philadelphia

by what his art advisor, the portrait painter Albert Rosenthal, called a "mania" (Tancock 1976, p. 11). Mastbaum began buying and commissioning bronze casts of works by Rodin at a furious pace. Until his death in 1926, he worked methodically at assembling the collection. Ships from Europe unloaded his acquisitions by the hundreds on the docks of Philadelphia. Comparisons might be made with Mastbaum's exact contemporary, the legendary Philadelphia collector Dr. Albert C. Barnes (1872–1951), who during these same years and with similar determination was collecting the works of his favorite artists (notably Cézanne, Renoir, Matisse, and Picasso), and with the late B. Gerald Cantor (1916–1996), who in the second half of this century was America's most assiduous collector and generous donor of Rodin's works, enriching museums across the country with his gifts.

A shrewd businessman, Mastbaum was among the first to fully appreciate the implications of Rodin's bequest of his estate to the French nation in 1917, and of the establishment of the Musée Rodin in Paris as the executor of that estate. The Musée Rodin was given the right to cast Rodin's works posthumously, and as Mastbaum realized, by commissioning such casts it would be possible for him to assemble a representative collection of Rodin's sculptures, large and small, intimate and grandly public, showing the full range of Rodin's artistic achievement. Mastbaum quickly established a close working relationship with the director of the Musée Rodin, Léonce Bénédite, and then with his successor, Georges Grappe. With their advice and encouragement, he set about ordering bronze casts to be made of many of the most important monuments of Rodin's career, including *The Burghers of Calais*, *The Thinker* (see no. 19), and *The Age of Bronze* (no. 3). He also ordered casts of smaller-scale and lesser-known pieces, including portrait busts, and allegorical figures related to Rodin's

masterpiece, *The Gates of Hell* (p. 46, fig. 5).

Although he never met Rodin, who died in 1917, Mastbaum was able to employ the services of the same bronze founders who had worked closely with Rodin in the final decades of his career and who understood intimately the artist's intentions with regard to casting and patination. At the same time, Mastbaum was also buying Rodin sculptures on the open market, including preparatory studies in plaster. He acquired large numbers of drawings, not all of which were authentic, but then Mastbaum was not alone in the 1920s in being duped by skilled forgers actively producing "Rodin" drawings, even during Rodin's lifetime. During this period, the collector also acquired the so-called *Mastbaum Album* (no. 1), a rare and intriguing sketchbook dating from the artist's early years.

In his most important act of patronage, Mastbaum commissioned the first-ever bronze casts of *The Gates of Hell*, the great work that had occupied so much of Rodin's time and imagination from 1880 to his death. The second bronze cast was Mastbaum's gift to the Musée Rodin in Paris, in whose garden it stands today. The first was destined to be the centerpiece of the Rodin Museum in Philadelphia, for almost from the beginning of his collecting odyssey, Mastbaum determined that his would be not a private but a public collection, his gift to the city of his birth. As he wrote in 1926, he wished to make the collection "freely available for the study and enjoyment of my fellow citizens of Philadelphia" (quoted in Tancock 1976, p. 12.) There, visitors would be able to study the range and depth of Rodin's artistic endeavor in bronze, marble, and plaster, and on paper as well. As he built the collection, Mastbaum began to plan his museum: the two activities were in reality one.

The Rodin Museum was to rise at an important location along the Benjamin Franklin Parkway, a monumental proces-

sion route that sweeps diagonally from the city center to the hilltop Philadelphia Museum of Art at the entrance to Fairmount Park, the largest urban park in the United States. To design his museum, Mastbaum turned to the French-born Jacques Gréber (1882–1962), one of the great landscape architects of the twentieth century, who in the first decades of the century had laid out the plan for the Parkway. Gréber in turn chose Paul P. Cret (1876–1945), a fellow Frenchman, to be his collaborator. Trained like Gréber in the Beaux-Arts architectural tradition, Cret had recently arrived in Philadelphia as a professor of architecture at the University of Pennsylvania. Concurrently, he was designing Dr. Barnes's house and gallery in the nearby suburb of Merion. The two men collaborated closely on the project, yet as Gréber later explained, he had been primarily responsible for siting the Rodin Museum along the Parkway and for the general composition and layout of the garden, while Cret had created the final designs for the grand and austere elevation of the museum building, an important example of contemporary classicism in 1920s American architecture, and for its light-filled, Italian Renaissance–style interior (Brownlee 1989, p. 80).

The patron too played a vital role in the design of his museum, for Mastbaum determined that the entrance to its garden, facing the Parkway, would be a replica of the ruined stone facade of the eighteenth-century Château d'Issy that Rodin had reconstructed at Meudon, near Paris. At Meudon, the artist is buried in front of the facade, a cast of *The Thinker* atop his tomb. The motif is repeated at Philadelphia (see fig. 2), and this evocation of the artist's tomb seems to have been for Gréber and Cret a key to their conception of the museum. An early critic described their design as "funereal" (Brownlee 1989, p. 78), and indeed the museum and garden they planned can be viewed as a Romantic meditation on death

and the transcendance of art. In plan, the sequence of facade, garden, and museum can be compared to one of the great monuments of French Beaux-Arts architecture, well-known to Gréber and Cret: Pierre Fontaine's Chapelle Expiatoire of 1816–26 in Paris, which itself derives from the traditional Italian *campo santo*, such as Santa Maria Novella in Florence. Built to atone for the murders of Louis XVI and Marie-Antoinette, the Parisian complex incorporates, in succession, an entrance pavilion, an enclosed garden, and a domed chapel toward which the visitor must climb.

The Rodin Museum in Philadelphia deploys the same progression through open and enclosed spaces upward into the light. Passing by *The Thinker*, the visitor climbs a broad flight of steps through the haunting, blank portal of the château, into a formal French garden. Symmetrically disposed around a fountain and pool, it is a sanctuary from the noise of the city. Across the garden, the visitor again climbs to a terrace in front of the museum and up, through twin Ionic columns, into a deeply shadowed veranda. There, he or she confronts *The Gates of Hell*. Inspired by Dante's *Inferno*, the great doors, forever closed, are Rodin's own monumental meditation on death, damnation, and eternal torment. (Originally, figures of *Adam* [no. 20] and *Eve* [no. 22], responsible for mankind's fall, flanked *The Gates* in niches on the facade, and other large-scale sculptures stood out-of-doors in the garden. However, these works were brought indoors some thirty years ago, for reasons of their preservation from the effects of weather.) The visitor then turns to left or right to climb a final short flight of steps, passing through low anterooms before entering the museum proper. There, brilliant light pours in through huge windows at either end of a tall, vaulted space, and from a skylight as well, splashing onto the sculptures distributed around the principal space and in smaller galleries symmetri-

cally arranged around it (see fig. 1). This continuous, control-ling movement upward leads to the realm of light. Having begun the progression in front of *The Thinker*, evoking Rodin's tomb, the visitor now is free to contemplate the works of ge-nius that Rodin has left behind.

Construction of the museum had not yet begun when Mastbaum died on December 7, 1926. After his death, and with the active support of his family, Gréber and Cret contin-ued their work, bringing it to completion in 1929. The mu-seum opened to the public on November 29 of that year in the presence of, among others, Paul Claudel, the French am-bassador to the United States and brother of Rodin's former mistress, the sculptor Camille Claudel. It contained more than 120 sculptures surveying Rodin's entire career, the most com-plete presentation of the artist's work outside of France. Over the years, a few important works have been added to the col-lection. These include a plaster *Eternal Springtime*, inscribed by the artist to the writer Robert Louis Stevenson, and a rare cast of *The Athlete (First Version)* (no. 30), which was a gift from the model himself, Mastbaum's friend Samuel S. White 3rd of Philadelphia.

In 1939, the Rodin Museum came under the jurisdiction of the Philadelphia Museum of Art, which also houses the ex-tensive collection of works on paper that Mastbaum had as-sembled. In 1976 a major catalogue of the sculpture was pub-lished by the noted Rodin scholar John Tancock, and in 1989 the Rodin Museum building was completely restored and re-installed under the direction of senior curator Joseph J. Rishel, working with the architect Missy Maxwell of Susan Maxman Architects, Philadelphia. A program of interpretive signage and an audio tour system have been added. An active sup-port group, the Friends of the Rodin Museum and Garden, raises funds and gives financial aid for the maintenance of the

garden and other projects, including an ongoing program of lectures and colloquia. The museum is also a generous lender to Rodin exhibitions around the world.

A jewel-like oasis in the heart of one of America's largest and busiest cities, and also one of the country's oldest museums devoted to a single artist, the Rodin Museum plays a prominent role in a city unusually rich in public sculpture, including works by Rodin's French contemporaries, Barye and Frémiet, and by other European and American sculptors of the age. The Philadelphia Museum of Art contains a distinguished group of nineteenth- and early twentieth-century European sculptures as well, including an all but unparalleled collection of works by the great Romanian-born sculptor Constantin Brancusi (1876–1957), who briefly served as Rodin's apprentice. Together, these resources ensure that the city may be unrivaled in North America in its ability to show the development of modern sculpture from the mid-nineteenth century onward.

The Rodin Museum remains a place of daily study and contemplation for students in the city's numerous art schools, but it also draws young lovers and mothers with their babies, who on hot summer days come only to sit in the cool shade of the garden. The east coast of the United States is now home to many immigrants from the former Soviet Union, and surprisingly large numbers of them visit the museum to study and discuss Rodin in their native languages, and then to pose happily for snapshots in front of the sculptures, as with members of the family. In few places is Rodin better known and admired than in Philadelphia, and nowhere is a collection of his sculpture so intimately related in people's minds with a noble work of modern architecture, the enduring legacy of the enigmatic and driven collector Jules E. Mastbaum.

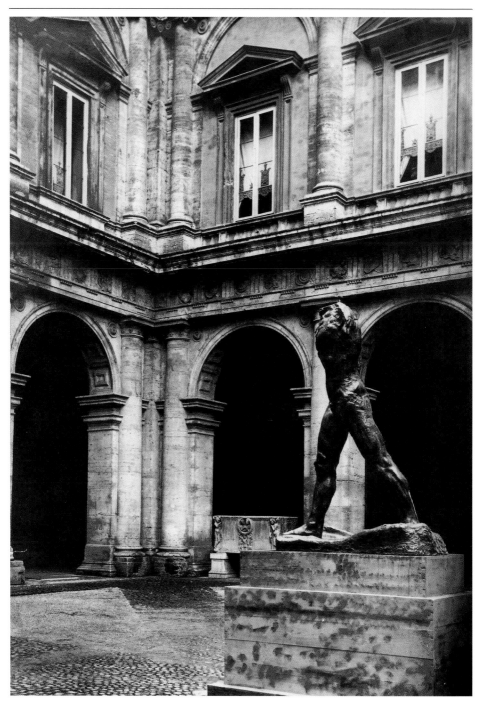

Rodin Confronts Michelangelo
Christopher Riopelle

In her recent study of the Medici Chapel, the American scholar Edith Balas states that her interest in Michelangelo began twenty-five years ago, "when I was writing a dissertation on the sculptor Constantin Brancusi. I soon realized that it was impossible to understand Brancusi without reference to Rodin, and impossible to understand Rodin without reference to Michelangelo" (Balas 1995, p. ix). While Brancusi would deny a debt to either predecessor, Rodin for his part always readily acknowledged his artistic genealogy. He saw himself as the legitimate heir to a great tradition of monumental nude figural sculpture in western art, begun by ancient Greek and Roman sculptors, revived in the Renaissance, and advancing through the works of Michelangelo, Bernini, Puget, and Carpeaux, down to modern times. Within this lineage, no one meant more to Rodin than Michelangelo. "My liberation from academicism was via Michelangelo," he stated in a letter to Antoine Bourdelle, written late in life. "He is the bridge by which I passed from one circle to another" (quoted in Varnedoe 1985, p. 19). Michelangelo's example proved important for two reasons: not only was Michelangelo a sculptor of vast technical and expressive power, but by the late nineteenth century he had come to be seen as an embodiment of the genius of Italy, a shaping presence of the national imagination. For Rodin also—brooding, driven, and vastly ambitious—these were the goals that he set for himself. His work too would explore the expressivity of the human body. He too could aspire to represent the genius of his people. By the time of his death in 1917, Rodin was indeed the most famous artist in the world; in the popular imagination, and not just in the minds of Frenchmen, he was the very embodiment of artistic genius. This exhibition traces the development of Rodin's admiration for and emulation of Michelangelo, suggesting ways in which the example of the Italian

Fig. 1. The bronze cast of Auguste Rodin's *The Walking Man*, 1877–78, installed in the courtyard of the Palazzo Farnese in Rome, 1911

master, and Rodin's testing of himself against Michelangelo, led to some of the French artist's most innovative sculptural achievements.

Except for precocious skill as a draftsman, the young Auguste Rodin exhibited little sign of the achievements to come. Born in Paris in 1840 to parents of modest means, Rodin was by age fourteen studying at the École Spéciale de Dessin et de Mathématiques. The school prepared young men for careers in technical draftsmanship and the decorative and applied arts. Rodin's attempts to enter the more prestigious École des Beaux-Arts failed not once but three times, and the possibility of a career as an academically trained fine artist, showing his sculptures at the official Salons and receiving the accolade of state commissions, seemed closed to him. Rodin haunted the galleries of the Louvre, however, sketching antique statues and often stopping before Michelangelo's *Slaves*. At the École Spéciale he studied under Horace Lecoq de Boisbaudran, an extraordinary teacher who pushed his students to rely on their memories so that, after examining a motif, afterwards they could reproduce it faithfully (Butler 1993, p. 10). The lesson stayed with Rodin, who developed a prodigious visual memory for works of art, upon which he repeatedly drew.

During the massive building campaigns of the Second Empire, the young Rodin worked for Paris contractors as an ornamental mason. In 1864 he entered the employ of the fashionable sculptor Albert-Ernest Carrier-Belleuse (1824–1887), who worked in a decorative eighteenth-century style. The relationship lasted on and off for many years, and although Rodin resented Carrier-Belleuse's indifference to his own artistic ambitions, he was given the opportunity to sculpt human figures rather than ornaments, and to learn practical lessons about the organization of a large and complicated studio.

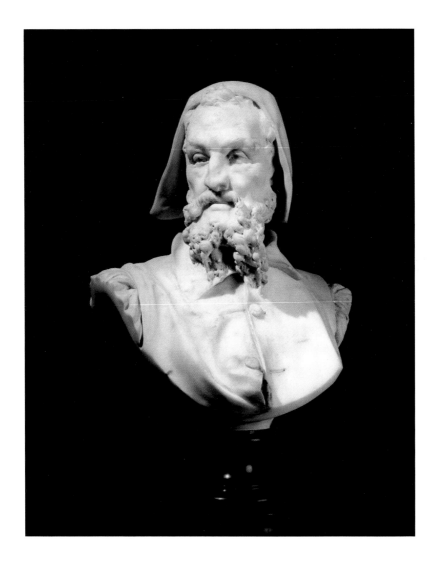

During these years, Rodin undertook independent work as well. He was bitterly disappointed when his most ambitious sculpture to date, the *Mask of the Man with the Broken Nose* (no. 2), was rejected for the Salon of 1865. By presenting the work to the Salon jury in its fragmentary state, as a mask rather than a bust, Rodin was following Michelangelo, who had so effectively unleashed the expressive potential of the *non finito*, the unfinished. In some ways, Rodin's sculpture can be seen as an implicit portrait of Michelangelo, the most famous man with a broken nose in the history of art. Critics noticed the resemblance between Rodin's mask and Daniele da Volterra's *Portrait of Michelangelo* (no. 34, fig. 1), itself based on a death mask, when both works were shown in Paris in 1878. Long before Rodin ever traveled to Italy, Michelangelo loomed in his imagination, even if (as he later averred), he "saw him at a great distance" (quoted in Bartlett 1965, p. 30).

In evoking Michelangelo, Rodin was also tacitly competing with his master Carrier-Belleuse, who had in 1855 sculpted a prim and academically precise marble *Bust of Michelangelo* (fig. 2). In fact, Michelangelo had never been regarded with total approval in the French classical tradition. From the seventeenth century onwards, the *terribilità* of his work—its almost explosive tension and the suspicion that a demonic subjectivity lay behind it—was contrasted unfavorably with the calm, fluid grandeur and idealism that characterized the works of Raphael and Poussin, and which informed the highest aspirations of French art. Michelangelo was a kind of artistic loose cannon from whom rules could not safely be derived. Only with the Romantic reassessment of subjectivity in nineteenth-century France did his reputation begin to rise. Carrier-Belleuse's bust of the artist is evidence of that growing reputation at mid-century. With the *Mask of the Man with the Broken Nose* a decade later, Rodin offered a more enig-

matic homage to the master, alluding to Michelangelo and exploring aspects of his aesthetic, but not naming him. There is in the mask something of a precocious challenge to Michelangelo.

Rodin followed Carrier-Belleuse to Brussels in 1871, later working with architectural sculptors there on increasingly ambitious and complex monuments and building facades. More and more, his work was dominated by robustly physical male nudes. As noted by Ruth Butler, Rodin's most perceptive modern biographer, the Michelangelesque figure type "was present in Rodin's work as soon as he got the opportunity to create monumental figures" (Butler 1993, p. 75). In June 1875, he began work on a life-size, freestanding male nude, the sculpture now known as *The Age of Bronze* (no. 3), which he hoped would establish his reputation. At the same time, perhaps sensing that his grasp of the art of antiquity and the Italian tradition remained superficial, he planned his first trip to Italy. He would join the long list of French artists, reaching back two and a half centuries, for whom exposure to Italy was an essential component of their educations. *The Age of Bronze* remained unfinished when Rodin left Brussels in February 1876, passing through Turin, Genoa, and Pisa before arriving in Florence in March.

It was an extraordinary moment to confront Michelangelo in the city of his birth. The previous year had marked the four hundredth anniversary of that birth, and Florence was the scene of months-long international celebrations (see Florence 1994). An imposing new monument to Michelangelo, which included bronze copies of his *David* and other works, now looked down over the city from the newly named Piazzale Michelangelo at San Miniato. That same year, the artist's family home, the Casa Buonarroti, had opened to the public as a museum where visitors could come to know the titanic ge-

Fig. 3. Michelangelo, *Tomb of Giuliano de' Medici, Duke of Nemours*, 1520–34. Marble. Medici Chapel, Church of San Lorenzo, Florence

Fig. 4. Michelangelo, *Tomb of Lorenzo de' Medici, Duke of Urbino*, 1520–34. Marble. Medici Chapel, Church of San Lorenzo, Florence

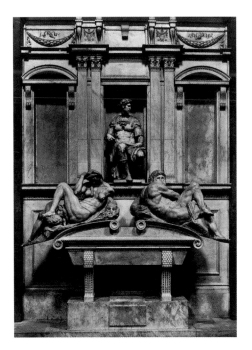

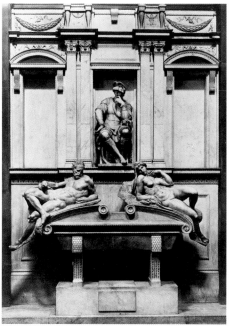

nius on a more intimate scale. Critics, connoisseurs, and commentators from across Italy and Europe flocked to Florence to experience and extol the "divine" Michelangelo. (The epithet "divine" had first been applied in the sixteenth century and was now enthusiastically revived.) In the newly unified Italian nation, newspapers and journals reported extensively on the events, acclaiming the artist as a representative figure of Italian civilization. Similar reports circulated widely across Europe, and the celebrations of 1875 proved instrumental in establishing the critical fortune of Michelangelo into the twentieth century. When Rodin arrived in Florence early in 1876, the excitement of the celebration was still in the air. The struggling sculptor, nearing middle age and not yet successful, must have been deeply impressed by the abundant evidence around him of an earlier sculptor who had been enshrined in the pantheon of his people, the subject of universal myth and awe.

The greatest discoveries are the ones we know are waiting for us, and in Florence it was indeed Michelangelo who overwhelmed Rodin's eye and mind. Years later, in an interview with Paul Gsell, Rodin recalled that he had been "disconcerted before the works of Michelangelo" in Italy (Rodin 1984, p. 92). In the only letter that survives from the Italian trip, Rodin wrote to his companion, Rose Beuret, "To tell you that since my first hour in Florence I have been making a study of Michelangelo will not astonish you, and I believe that the great magician is giving up a few of his secrets to me." In Florence he discovered the Medici tombs at San Lorenzo (figs. 3, 4): "Everything that I have seen of photographs or plasters gives no idea at all of the sacristy of San Lorenzo. These tombs must be seen in profile, in three quarters. I have spent five days in Florence but it is only today that I saw the sacristy and so for five days I've been cold. . . . I have made sketches at night, in my hotel, not after the works, but after all the

scaffolding, the systems I construct in my imagination in order to understand them" (Rodin 1985, p. 34). Days were spent studying Michelangelo's works, moving around them and examining their profiles; evenings passed with sketchbook or clay in hand, attempting to plumb their secret, that "thing without a name" that, for Rodin, Michelangelo's works alone possessed (Rodin 1985, p. 34). The Musée Rodin in Paris contains numerous sheets executed during and immediately after the trip (catalogued in Judrin 1984–92), including rapid pencil sketches after individual sculptures, and quick line drawings that are free inventions in a Michelangelesque mode (see no. 8). As well, there exists a series of studies of individual figures from the Medici tombs in which Rodin used shading to capture the essential masses and rhythms of the forms (see nos. 4–7). While it has been argued that these were made after the Italian trip, from casts in Paris, it seems more likely that they were in fact executed in Florence (see p. 90, below). Rodin was fascinated by Michelangelo's *contrapposto* and the massively muscular proportions of the figures. Years later he would model a small clay figure (no. 45, fig. 3) for Paul Gsell in order to demonstrate to the writer how, through the opposed movement of the upper and lower body, Michelangelo achieved effects of violence and constraint in his sculptures (Rodin 1984, pp. 87–93). Most important, Rodin sought to understand the Italian's skill in defining an intricate succession of animated profiles that sustained the interest of the eye as it traveled around a sculpture.

From Florence, Rodin moved on to Rome, where he visited the Sistine Chapel, with its ceiling and *Last Judgment* frescoes by Michelangelo, and to Naples, where he studied antiquities. As the sketches from the Italian trip attest, it was less the equilibrium and grace of antique sculpture that intrigued Rodin than it was the tension and torsion of

Michelangelo's figures (Rodin 1984, pp. 87–93). Henceforth, Michelangelo was his master, and Rodin's major achievements, which revolutionized modern sculpture, testify to the influence. Indeed, Kirk Varnedoe says simply of Rodin's 1876 confrontation with Michelangelo: "Rodin's trip to Italy might rightly be seen as one of the seminal events in modern art" (Varnedoe 1985, p. 19).

Back in Brussels, Rodin began what Varnedoe has termed "a re-examination and consolidation of his previous work" in light of his Italian experiences (Varnedoe 1971, p. 50). An early attempt at an Adam that seemed to be only an imitation of Michelangelo's manner was abandoned; Rodin understood the difference between emulation and mimicry. More important, he resumed work on *The Age of Bronze*, completing it by the end of 1876 in an essentially naturalistic mode. Indeed, so veristic was the work, for which a young Belgian soldier had posed, that for years Rodin was plagued with charges that he had used life casts. Michelangelo's influence is detected, however, in the figure's langorous posture—as if, like *The Dying Slave* (no. 3, fig. 1), he were passing out of consciousness—and in Rodin's decision to remove a spear from the nude's left hand so that his gesture, losing specific reference, became enigmatic and evocative. Rodin continued in a naturalistic vein with his next major male nude, *Saint John the Baptist Preaching* (no. 10), although the figure's rugged torso, twisting with energy as the saint strides toward the viewer, reveals Rodin's continued study of Michelangelo's tense deployment of figures.

In 1877 Rodin moved back to Paris, hoping to establish himself as an independent sculptor. Finances decreed, however, that he still hire himself out to other masters, including his former employer Carrier-Belleuse, who was now the art director of the revitalized porcelain manufactory at Sèvres.

Carrier-Belleuse's name is inscribed on the ceramic sculpture of the *Titans* (no. 9), but scholars have long recognized the twisting, muscular figures as the unmistakable work of Rodin. During this same period, Rodin attempted to establish himself as a sculptor of public monuments, the necessary route to acclaim. Although he met with little success in the sculptural competitions he entered in 1879, his proposals reveal the deepening energy and gravitas of his art. In *The Call to Arms* (no. 12), the proposal for a monument to the defenders of Paris in 1870, the outstretched arms of a ferocious Genius of Liberty open the sculpture upwards and out into space, like the bloom of a terrifying flower. Appropriately, the pose of the martyred soldier who slumps against her thigh derives from the dying Christ of Michelangelo's *Pietà* in the Duomo in Florence. With his proposal for an allegorical bust of the Republic from the same year—the helmeted and wrathful warrior woman since known as *Bellona* (no. 13)—Rodin achieved a condensed energy that in the work of Michelangelo had been termed *terribilità*.

In 1880 Rodin began to enjoy the fruits of success. Early in the year, the French state acquired a plaster of his *Age of Bronze*. The official who arranged the acquisition, Undersecretary of State for Fine Arts Edmond Turquet, was a passionate admirer of the sculptor. Later the same year, he commissioned from Rodin a set of bronze doors, featuring relief scenes from Dante's *Divine Comedy*, for a new Museum of Decorative Arts in Paris. The doors would become *The Gates of Hell* (fig. 5), one of the pivotal works of art of the modern age. The museum was never built—on the site, a train station was erected that has now become the Musée d'Orsay—but the doors became the principal focus of Rodin's artistic activity until his death in 1917, the laboratory wherein he invented many of his most important sculptures, and the testing ground

for the volcanic play of his imagination. *The Gates* themselves were never finished—the bronze casts in Philadelphia, Paris, and at four other sites represent the work as it stood in plaster on the day of Rodin's death; had he lived, Rodin would have continued to add to, subtract from, and alter the piece—but the commission at last provided the sculptor with a task of Michelangelesque complexity, comparable in ambition, scope, and grandeur of theme to *The Last Judgment*, the tomb of Pope Julius II, or the Medici Chapel. It was at this point that the floodgates of Rodin's creativity opened and that he arrived at his deepest discernment of Michelangelo's art.

The original notion of distinct relief panels with scenes from Dante, on the model of Italian Renaissance doors like Ghiberti's *Gates of Paradise*, soon gave way to something more fluid, indeed turbulent. Focusing on Dante's *Inferno*, with its imagery of tormented humankind confronting eternal damnation, Rodin conceived a series of open fields barely contained within an architectonic framework that, precariously, seems at key points to melt away. Within the open spaces, figures rise out of the flux, writhing in anguish and clinging to one another desperately, only to sink away again. Like Michelangelo's *Last Judgment*, itself rich with Dantean significance, the imagery at first seems formless and difficult to interpret. But presiding over *The Gates*, like Christ at the center of *The Last Judgment*, are monumental figures who guide our gaze. *The Thinker* stares down from the the tympanum, contemplating the chaos below while, atop the doors, the arms of *The Three Shades* point relentlessly to the melee beneath, as if to invoke Dante's famous warning, "Abandon hope, all ye who enter here." Indeed, many of Rodin's most famous sculptures, like *The Thinker* (no. 19), began as motifs for *The Gates of Hell*. Others, like *The Shade* (no. 21), were autonomous works, but the artist quickly understood how

Fig. 5. Auguste Rodin, *The Gates of Hell*, 1880–1917. Bronze, 250 3/4 x 158 x 33 3/8" (636.9 x 401.3 x 84.8 cm). Rodin Museum, Philadelphia. Bequest of Jules E. Mastbaum

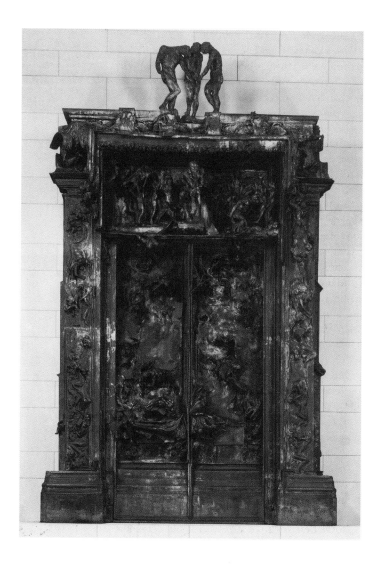

they could be incorporated into the project. Only later did Rodin invest these works with independent existence as monumental freestanding sculptures. Others still, like *The Crouching Woman* (no. 24), were conceived for *The Gates* then joined with other independent figures to create powerful new groups like *I Am Beautiful* (no. 25), and then these new sculptures too were assigned their places on the doors.

Rodin almost always began to make his sculptures in miniature, kneading pellets of clay in his fingers, modeling arms, legs, torsos, and heads, fitting them together, sometimes with arbitrary brutality, and then, with the aid of assistants who made plaster casts from the clay models, enlarging and enlarging them again, undertaking modifications as he assessed the implications of scale. With *The Gates of Hell*, Rodin moved decisively beyond naturalism to a new expressivity, seeking to signify the actions of the mind under torment through the depiction of the nude body. Here, the towering example of Michelangelo proved most significant. From long contemplation Rodin came to understand how the complex torsion with which Michelangelo invested his tautly muscled figures conveyed suffering, or the vaulting movements of the intellect, or states of awareness beyond human consciousness. Michelangelo's great sculptures and painted figures instructed Rodin how to move forward with his monumental project. But Rodin's sculptures do not resemble Michelangelo's. Rather, as he worked on *The Gates*, Rodin arrived at a profoundly individual style, in which the informing presence of Michelangelo is implicit.

By the turn of the twentieth century, Rodin was the subject of international acclaim. Casts of his best-known works were commissioned for the great cities of the world. The mightiest creative minds sat to him, including Victor Hugo, Gustave Mahler, and George Bernard Shaw. So too did politicians and

captains of industry, for whom a bust by Rodin served as proof of their accomplishments and guarantee of their fame. Sycophants gathered around him. He had become a titan. And as commentators searched for superlatives, the comparison with Michelangelo was ubiquitous, a commonplace of encomium. Said the young French sculptor Henri Gaudier-Brzeska: "Rodin remains for France what Michelangelo was for Florence. He will have imitators but never rivals" (quoted in Butler 1993, p. 361). Rodin would have agreed. Indeed, he actively participated in publicizing the comparison, discussing Michelangelo at length with the writer Paul Gsell. According to Gsell, Rodin characterized Michelangelo as "the result of all Gothic thought" (Rodin 1984, p. 92). That Rodin allied himself with that same tradition is clear from his intense study of Gothic architecture. With his friend Helene von Nostitz Hindenburg, Rodin discussed both the sculpture and the sonnets of Michelangelo, and the author devoted an early chapter of her *Dialogues with Rodin* to the relationship between Rodin and "his great brother Michelangelo . . . One felt the unity of these two beings, who clasped hands throughout the centuries" (Hindenburg 1931, p. 12). In his 1911 work *Philosophische Kultur*, the German philospher Georg Simmel devoted contrasting essays to the two sculptors. At the same time that writers celebrated Rodin's emulation of Michelangelo, however, young sculptors sounded a note of caution. Gaudier-Brzeska quickly added to his above comments about Rodin having imitators but no rivals: "But this is fatal, because such personalities bleed a nation to death; they leave no other alternative save imitation or veneration" (quoted in Butler 1993, p. 361). And Brancusi, briefly an apprentice of Rodin's, almost immediately fled the studio, sensing that his own creativity would be crushed. "Nothing grows," he famously remarked, "in the shade of a tall tree"

(quoted in Hulten, Dumitresco, and Istrati 1987, p. 66).

In 1911 Rodin seized yet another opportunity to confront Michelangelo. The French government had recently acquired the Palazzo Farnese in Rome—a masterpiece of Michelangelo's architecture—to serve as the French embassy. A group of patrons purchased a large-scale cast of Rodin's *Walking Man* and presented it to the French government with the intention that it be installed in Rome. Rodin himself traveled there to supervise its installation in the courtyard of the palace, where it remained until 1923. Rodin's startling work had been conceived around 1900: to a Michelangelo-like torso made after returning from Florence in 1876, Rodin joined with intentional awkwardness two striding legs, but neither head nor arms. Battered, incomplete, poignant in its vulnerability, *The Walking Man* stood in the center of the Farnese courtyard on a simple wooden pedestal, surrounded by the grand and noble rhythms of the space Michelangelo had created (see fig. 1). This was perhaps a final powerful statement of Rodin's lifelong regard for his greatest master: a statement of homage to Michelangelo at the heart of the monumental space he had created, yet at the same time a proud assertion of Rodin's hard-won equality with the master.

L'ART

REVUE HEBDOMADAIRE ILLUSTRÉE

A. BALLUE, ÉDITEUR

PARIS

LIBRAIRIE DE L'ART, 33, AVENUE DE L'OPERA, 33

LONDON

134, NEW BOND STREET, 134

1875

The Discovery of Michelangelo: Some Thoughts on Rodin's Week in Florence and Its Consequences
Flavio Fergonzi

French Echoes of the Quadricentennial

For a variety of reasons, which are difficult to distinguish, Rodin traveled from Brussels to Italy in the first few months of 1876 (his stops included Turin, Genoa, Pisa, Florence, Siena, Rome, Naples, Padua, and Venice). In undertaking as ambitious a project as *The Age of Bronze* (no. 3), he must have felt the need for what was then considered a fundamental experience for artists of his time, the Italian sojourn in the Villa Medici awarded to the winners of the much sought-after Prix de Rome. For Rodin, in the wake of his three-time failure to gain admission to the École des Beaux-Arts, this canonical access route to Italy was out of bounds. The only viable alternative was to travel on his own, with no institutional endorsement and at his own expense. In statements and interviews given in later years (when the myth of Rodin as a sculptor whose earliest years had been marked by a stubborn anti-academic stance was already well in place), Rodin of course remained silent about his intention of emulating his more fortunate colleagues (among others, during the preceding decade, Jules-Clément Chaplain, Eugène Delaplanche, Louis-Ernest Barrias, Jean-Baptiste Hugues, and Jean-Antoine-Marie Idrac). Instead, he cited different reasons, more closely linked to problems of creativity but equally persuasive. *The Age of Bronze*, which he had left unfinished in Brussels, was at a dead end. As Rodin wrote in 1904, he needed to find solutions, and he wanted to seek inspiration from examples of ancient statuary, which he could do only in the rich museums of Rome and Naples (Rodin 1906, p. 193). His figure of a sailor sculpted for the monument to the burgomaster J. F. Loos in Antwerp seemed to him, once it was finished, strangely Michelangelesque, and after a period of studies that led nowhere, Rodin wanted to examine directly the principles of composition and movement to be found in Michelangelo's

Fig. 1. Frontispiece to the journal *L'Art* for the year 1875, featuring an illustration of Michelangelo's *Moses*

figures in Italy (Bartlett 1965, pp. 30–32).

Rodin's decision to shift the focus of his visit from Rome to Florence, making his visits to the Florentine sites of Michelangelo's work the crucial aspect of the entire trip, was perhaps the result of events in the French artistic milieu to which Rodin could not have remained indifferent. The first of these events, which has been nicely reconstructed in a 1981 essay by Ruth Butler, was the emergence of the so-called sculptural Florentinism fashionable among French sculptors in the 1870s. Overcoming the awesome Michelangelism of the Romantic tradition, which culminated in the *Ugolino* (1858–62) by Jean-Baptiste Carpeaux, critics began to notice, beginning with the Salon of 1872, a sober and rigorous neo-Renaissance style that complemented the seriousness of the new values of the Republic. This style reached its extreme in the bodies of Donatellesque realism in the statues of Antonin Mercié (*David, Newborn, Eve, Gloria Victis*) but it also accommodated the more explicitly Michelangelesque work of Paul Dubois (culminating in his *Military Courage* with the paraphrase of the figures of Giuliano and Lorenzo de' Medici in the Medici Chapel), Louis-Ernest Barrias, and René de Saint-Marceaux (Butler 1981). The infatuation with the Renaissance found followers at every level: in the competition for the Prix de Rome in 1875, for instance, many artists depicted the subject proposed for the occasion—Homer, accompanied by a young guide, declaiming poetry in the cities of Hellas—as if the protagonists were Florentines not Greeks, "a sacrifice to the fashion of the day," as Roger Ballu acidly observed (Ballu 1875, "Concurrents," p. 349).

Less closely studied is the second event, which had to do with the quadricentennial of Michelangelo's birth and the reactions to it in French culture. Beginning in January of 1875, the artistic scene in Paris was enlivened by a new periodical

entitled *L'Art*, a lavish, large-format journal edited by Eugène Véron, aiming to establish a readership among lovers of early art, dealers and experts in that market, and collectors of prints. The ideological position on the figurative arts that this journal supported—a return to a rigorous anti-academic art following a line that extended from the ancient Greeks to the Florentine Renaissance, Flemish art, and nineteenth-century purism, with strong anticlassical, anti-Baroque, and anti-eclectic attitudes (in favor of ornament, opposed to the illustrations of *Art pour Tous*, a magazine of industrial and decorative arts, and other such publications)—must have appealed to Rodin. In accordance with the attention the various contributors paid to the surrounding areas (Germany, England, Italy, Holland, and Belgium), the journal, from its very first year of publication, repeatedly published features on Brussels, its Salon, and its artistic life in general, and it is very possible that Rodin knew about the journal during his stay in Belgium.

From the first issue of *L'Art*, Michelangelo was the tutelary deity, so to speak, and his *Moses* from the tomb of Pope Julius II in San Pietro in Vincoli in Rome was illustrated as the frontispiece (fig. 1). In the third part, which includes the numbers that were published beginning in September (coinciding with the Florentine quadricentennial), interest in the Michelangelo commemoration dominated the sequence of issues. Standing out amid the biographical articles and the monographic pieces on Michelangelo's chief works (an essay on the tomb of Julius II, three on the Medici tombs), reviews of the publications of the quadricentennial, and accounts of the events and travel journals from the correspondents (Roger Ballu and Paul Leroi) was an extensive series of illustrations of sculptural works, paintings, and, especially, drawings, reinterpreted in a free and rapid style, with a powerful and un-

Fig. 2. Preparatory study for
the figure of *Day*, attributed to
Michelangelo, from *L'Art*
(Ballu 1875, "Centenaire," p. 83)

precedented graphic effect (fig. 2). In the pages of this maga-
zine, Florence became a mythical place, permeated with an
atmosphere of solemn, arcane harmony, where the severe sim-
plicity of the ornamentation was a tangible sign of the equi-
librium that had been attained among the arts: the sculpture
of Michelangelo coexisted perfectly (and indiscriminantly)
with the heritage of Dante, the sober decorations of fifteenth-
century palazzi, the works of Donatello and Cellini, the natu-
ral courtliness of the customs of the people, and the fiery rheto-
ric of the speeches made on the occasion of the quadri-
centennial. The visit, "a pilgrimage in honor of the greatest
genius who ever lived," was transformed into an homage to
the ideal birthplace of art and was always starkly opposed to
the Rome of Raphael and Bernini ("The work of Raphael can
leave one quite cold. Instead, put even a peasant from the
Black Forest in front of the Moses, and he will be deeply
moved"; Ballu 1875, "Centenaire," p. 84).

The New Sacristy of San Lorenzo (Medici Chapel), which
just a few months later was to make a profound and indelible
impression upon Rodin, was the monument that received the
most admiration (see p. 40, figs. 3, 4). The sculptures of the
two dukes (especially that of Lorenzo, for which a drawing
"after Michelangelo" by Delacroix was reproduced, and
which was insistently called "Il Pensieroso," or even "Le
Penseur"—The Thinker—the same title that Rodin was to
give his work as early as 1889), along with the allegorical
figures at their feet, were the works most widely illustrated
from the entire oeuvre of the master. A fine text by Giovanni
Dupré, in translation, emphasized the impressive antinatu-
ralistic daring of the marble statues (Dupré 1875); an article
by Marie Frédéric de Reiset, curator of the Cabinet des Dessins
of the Louvre, presented (in an engraving by E. Thomas) the
drawing of a Virgin and Child as an example of a graphic

Fig. 3. Illustration after
Michelangelo's *Day*, by Jules
Jacquemart (French, 1837–1880),
from the *Gazette des Beaux-
Arts* (Guillaume 1876, p. 93)

style dominated by a furor of execution not unlike that found in his marbles (Reiset 1875); an account of Paul de Musset's visit to the tombs was skillfully based on the terrifying atmosphere of grandeur and severity that emanated from the chapel (De Musset 1875). These are all commonplaces now consolidated in the interpretation of the work of Michelangelo: in France, they had reached their climax in a book on the Medici Chapel by Émile Ollivier, who had discerned in the statues, especially in the allegorical figures, the height of the expression of pathos in world art (Ollivier 1872, pp. 38–42). But a similar grouping of texts and illustrations consecrated the remarkable qualities of the Medici tombs with the power that only visual emphasis can confer.

The concluding article on the celebration of Michelangelo's quadricentennial, written by Paul Leroi, appeared in November of 1875; in it Leroi proclaimed a "new era of regeneration" (Leroi 1875, "12 septembre," p. 333), which Michelangelo's inspiration had opened for modern art, and announced the establishment of the Concours Michel-Ange— Grand Prix de Florence. A jury, which it was hoped would enjoy the sponsorship of Ubaldino Peruzzi and Aurelio Gotti (respectively, mayor and director of the museums of Florence; plans to obtain the cooperation of these noted Italians were, however, unsuccessful), would select a young artist who had been an exhibitor at the Salon for the award of five thousand francs for a two-year stay in Florence. The competition was explicitly set up against the Prix de Rome ("For Florence against Rome, for the present and the future against the routines of the past and the slavish submission to academic formulas, which are nothing less than the absolute negation and the complete opposite of the creations of genius throughout the ages"; Leroi 1876, p. 5), resulting in the pairing of the names of Florence and Michelangelo as an unavoidable pres-

Fig. 4. Auguste Rodin, head of
The Shade (see no. 21), from
Cladel 1908, facing p. 56

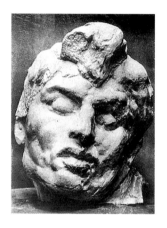

ence in the landscape of references for art at the time. The prize for the first competition, awarded in 1876, went to the ultrapurist sculpture *Adolescence* by Louis-Étienne-Marie Albert-Lefeuvre.

Heading the jury for the prize was Eugène Guillaume, a sculptor and the powerful director of the École des Beaux-Arts in Paris (and, shortly thereafter, director of the Villa Medici in Rome). Guillaume had written a long essay on Michelangelo as a sculptor, which appeared in the *Gazette des Beaux-Arts* in January 1876 as the central text of the monographic issue of the magazine. If this number (which was also published separately as a book) did fall into Rodin's hands before his trip (it is thought that he left for Italy around the middle of February, making that possible), then what he saw was an imposing array of illustrations that might well have altered the idea of Michelangelo that Rodin had formed as a youth based on the reproductions from the Cabinet des Estampes in Paris. Here, marble statues and frescoes were juxtaposed with, and placed for the first time in relationship to, the drawings, which were considered the most significant aspect of Michelangelo's work. The array of precise reproductions of the sculptures gave a good idea of the chiaroscuro effect of his creations (fig. 3), emphasizing their interrupted and dramatic gestures.

These were the most illustrious publications, enriched with the most notable array of illustrations, issued for the commemoration, but it is enough to look at the list of French-language newspapers that were accredited with the secretariat of the exhibition (*La Dépêche de Toulouse, Le XIX Siècle, L'Echo Universel, La Gazette de France, L'Illustration Universelle, L'Indépendance Belge, Journal des Beaux-Arts, Journal Officiel de France, Le Moniteur Universel, Le National, L'Opinion Nationale, La Revue Politique et Littéraire, Le Siècle,*

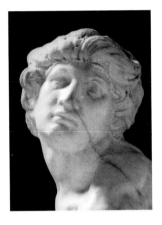

Fig. 5. Michelangelo, *The Rebellious Slave* (detail), before 1513. Marble. Musée du Louvre, Paris

and *Le Temps*) to gain an idea of the echo that must have reverberated outside of Italy from the quadricentennial of Michelangelo's birth. "To study [Michelangelo's masterpieces] in their original surroundings," as Truman Bartlett noted in 1889 (Bartlett 1965, p. 31), was then an event not to be missed, clearly in step with the artistic fashions of the time.

Florence

It was not until the fifth day of his brief stay in Florence that Rodin made the decisive discovery of his Italian journey, when he visited the Medici Chapel. In the only letter that he wrote from Italy addressed to Rose Beuret, the sculptor tells of the new meaning that the statues of the tombs assumed in the context of the architectural equilibrium of the sacristy, and of the surprising difference between the original marble sculptures and the casts with which he had been familiar (as early as 1834, casts of the sculptures were on view in the Gipsoteca, or gallery of plasters, of the Louvre; Mastrorocco 1989, pp. 163–67). His inspection of the works of Michelangelo during the first days must have been an intense experience. In the Duomo, in the midst of a solemn Mass, Rodin discovered the *Pietà* (this episode is recounted in Cladel 1908, p. 132), which even years later had the ability to influence (with the aid of an Alinari photograph, number 890, still in the photographic albums of the Musée Rodin, Paris) specific details— in particular, the arm, the bending of the leg, the modeling of the torso—of *The Call to Arms* (no. 12). He surely visited the Bargello: the gesture of the arm, bent at the height of the neck, and the *contrapposto* of the legs of the *David-Apollo* (which some fifteen years earlier Paul Dubois had already cited in his *Narcissus*) are recorded in a sketch of the statue in his Italian album (catalogued in Judrin 1984–90, vol. 1, no. 218) and reappear obsessively in his freer drawn variations

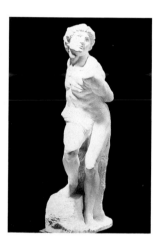

on Michelangelesque themes (Judrin 1984–90, vol. 1, no. 285). In all likelihood, Rodin visited the Casa Buonarroti. The French press had greatly emphasized the young museum's aura of a hushed sanctuary, only just violated, and had glorified its masterpieces as "pearls of an inestimable price" (Gonse 1875, p. 375); in Brussels, in a lecture in 1875, Louis Alvin had spoken of a setting in which it seemed one could almost see the ghost of Michelangelo (Alvin 1875, cited in Butler 1993, p. 91). Certainly, Rodin visited the Accademia to see the *David* (which would be recalled in his *Orpheus and Eurydice* [no. 35, fig. 3], executed in marble in the 1890s) and the *Saint Matthew* (no. 12, fig. 1; which would serve as the inspiration for the series of marble works such as *The Broken Lily* and *Sappho*, in which the figure emerges from an obviously chiseled marble background, yielding an effect like that of the *non finito*, or the unfinished, of Michelangelo). At the Accademia, moreover, the plaster casts from the quadricentennial exhibition were still on view, meant by the organizers to serve as a sort of permanent Michelangelo museum (following the model of the celebrated Thorvaldsen museum in Copenhagen; *Relazione* 1876, p. 32), available to artists and enthusiasts at a time when there was less of an awareness than there is today of the differences between a cast and an original.

One should consider this visit to the Accademia with closer attention. The collection of plaster casts of the Accademia constituted Rodin's first opportunity to survey firsthand a broad selection of Michelangelo's statuary, and there the sculptor made a number of important discoveries. Consider, for example, the *Crouching Youth* (no. 24, fig. 1), now in the Hermitage, which inspired the dramatically huddled pose for the *Crouching Woman* in *The Gates of Hell*. The plaster cast had been exhibited in the Accademia with the title *Caryatid*,

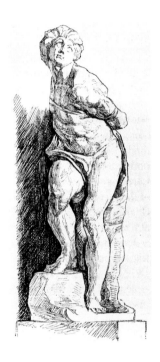

a gift from Grand Duchess Maria Nikolaevna of Russia on the occasion of the quadricentennial (Florence 1994, p. 19), and a photograph of it is documented as number 4754 in the post-1879 Brogi catalogue (Brogi 1889, p. 111).

Above all, however, Rodin had occasion to indulge in fruitful reappraisals, to reconsider knowledge that he had heretofore taken for granted. Removed from any appreciation of the more synthetic and pleasing works that were in keeping with the tastes of the 1870s (the *Cupid* in the Victoria and Albert Museum, London; the *Young Saint John*, then in the collection of Earl Rosselmini Gualandi [see Florence 1994, p. 54, no. 44]; *The Bruges Madonna*, casts of which were immensely popular during the exhibition), Rodin seemed to be more interested in the works from which he could derive ideas, particularly precious to him, of muscular expressivity. In the Tribune, or central gallery, of the Accademia, the two *Slaves* from the Louvre were exhibited on either side of the *David* (the Alinari photograph is in Florence 1994, p. 8; a description of the installation is in Gonse 1875, p. 383). It was probably on this occasion that Rodin compared the pose that the Belgian soldier Auguste Neyt had taken at his direction for *The Age of Bronze* with that of *The Dying Slave*, and that he purchased a photograph of the plaster cast (still in the collection of the Musée Rodin, Paris, bearing Brogi no. 3532, documented in the sales catalogue of the photographer prior to 1878). Later (as documented by the post-1878 Brogi sales catalogue, dated 1889), he purchased photographs from the same series of works exhibited at the Accademia of the casts of *The Rebellious Slave* (fig. 6; the face would be repeated almost literally in the face of *The Shade*; see figs. 4, 5) and the *Taddei Madonna* in the Royal Academy, London (Brogi 1889, nos. 4751–52, now in the photographic collection of the Musée Rodin). Considering that photographic reproductions

Fig. 8. Auguste Rodin,
The Thinker (no. 19)

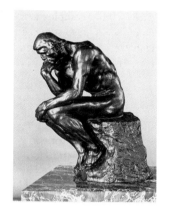

of the marble originals were available, it seems odd that Rodin would have purchased photographs of the plaster casts. Perhaps, however, plaster, in its dullness and its ability to simplify aspects of the modeling, offered clearer responses to an artist who was raptly examining the structure of the body and the tensions created by the body's movements, and who did not want to be distracted by the mirrorlike surface and the handsome finish of certain parts of the marble. The *Slaves* in the Louvre seemed to invite this rough structural interpretation: even if we disregard the illustrious series of copies (from Carpeaux to Cézanne) made of the two statues over the course of the second half of the nineteenth century, the drawings by Charles-Paul Renouard published in *L'Art* on the occasional of the quadricentennial appeared equally terse, with the surfaces of the statues described as faceted planes (fig. 7). At the Accademia, after the 1875 exhibition, the series of photographs of drawings donated by the governments of England, France, and Saxe-Weimar, an important source for Michelangelo's graphic work, remained on view (*Relazione* 1876, p. 217). This exhibition was considered by a number of critics to be the most notable event of all the commemorative exhibitions of the quadricentennial.

But Rodin's most important encounter with Michelangelo's drawings occurred at the Casa Buonarroti. On the occasion of this exhibition in Florence and Philadelphia, an effort has been made to juxtapose sculptures by Rodin with drawings by Michelangelo. While this comparison may not reveal explicit derivations of Rodin's work from the sheets in the Casa Buonarroti collection, it has clarified how Rodin the sculptor (never the draftsman) paid attention to certain types of Michelangelo's graphic solutions (the outlines of the youthful drawings that suggest a simplified and abstract anatomy; the later drawings that show a more sinuous line for the ex-

pression of a complex array of tensions and oppositions) in an effort to grasp some of the "secrets" of the "great magician" to whom he referred in his 1876 letter to Rose Beuret (Rodin 1985, p. 34).

Paris

In the late summer of 1877, following the dissolution of his partnership with Antoine Van Rasbourgh in Brussels, Rodin returned to Paris for good. By this time, the work of Michelangelo had taken on a more precise personality in the French capital than before, and it could be studied with greater ease than had been the case only a few years earlier.

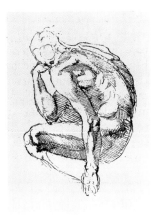

First of all, a formidable collection of plaster casts was now available. In 1876, the casts from the Atelier des Moulages exhibited at the Louvre were moved to the École des Beaux-Arts, and from December 3, 1876, the museum of copies was opened to the public in its new location in the rue Bonaparte ("Académie" 1878, p. 48). Added to the few casts of work by Michelangelo that had already been in Paris were a group ordered in Florence on the occasion of the quadricentennial. Under the supervision of the architect Ernest-Georges Coquart (who was also in charge of the installation of the adjoining museum of the Middle Ages and the Renaissance), the Michelangelo plasters—some thirty statues that covered almost the entire catalogue of work ascribed to the master (except for the *Crouching Youth* in Saint Petersburg, of which, however, a copy was on view in London; *Guide to South Kensington*, n.d., p. 8)—were arranged in the chapel of Margaret of Valois (better known later as the Salle Michel-Ange) in a theatrical display that drew emphasis to the Medici tombs in particular. Casts of works by Ghiberti (including *The Gates of Paradise*), Donatello, Verrocchio, and Della Robbia helped to place Michelangelo's work in the context of that long wake

of the Florentine Quattrocento that had so fascinated the French press on the occasion of the four hundredth anniversary of his birth. At the back of the gallery was an 1833 copy by Xavier Sigalon of *The Last Judgment* (Müntz [1889], pp. 283–88). Rodin must have walked through this installation repeatedly, with great curiosity, studying the subjects that he would appropriate just a short while later. The story of Ugolino and its transcription into the language of Michelangelo could be studied in a relief by Pierino da Vinci (at the time thought to be by Michelangelo), which had been cast in Florence from the terracotta original in the collection of Valfredo della Gherardesca. The *Dead Adonis* in the Bargello, now attributed to Vincenzo de' Rossi but then believed to be the work of Michelangelo, may have contributed to the figures of Adonis produced by Rodin from the 1880s on. Rodin's opportunity, in the wake of his Florentine enthusiasm, to see a cast of the *Lorenzo de' Medici*, with a label reading "statue known by the name Il Pensieroso," may well have contributed to his conception of *The Thinker* (fig. 8 and no. 19); for the muscular construction of the arm resting on the leg, his memory of a similar detail in the *Moses* of San Pietro in Vincoli in Rome may have played a role. But the array of Michelangelesque references linked to this work is even more diverse than is customarily thought: a drawing in the Uffizi, reproduced in Smorti (Smorti 1875, pl. 9) and featured in the *Gazette des Beaux-Arts* in 1876 (fig. 9), may have helped Rodin to hit upon the gesture of the fist placed under the chin in concentration and the forcefully forward bent of the pose, neither of which is found in the figure of Duke Lorenzo in the Medici Chapel. The fact that he could now find in the same room both *The Gates of Paradise* and *The Last Judgment* may offer some explanation for the variety of models that Rodin took into consideration immediately upon receiving the commission for *The Gates of Hell*.

Fig. 11. Auguste Rodin, *Study for the Gates of Hell with the Thinker, Adam, and Eve*, c. 1880. Pen and brown ink on paper, 6 ¹/₂ x 4 ⁷/₁₆" (16.5 x 11.2 cm). Musée Rodin, Paris

The gallery of Italian Renaissance sculpture of the Louvre had been reinstalled in 1876 (Gonse 1877). The reason for the new arrangement of the works of art was due in part to the purchase the year before of the Porta Stanga, a late fifteenth-century monumental complex that was particularly in line with the tastes of the 1870s for its wealth of sculptural ornamentation in a stern antiquarian vein (Barbet de Jouy 1876, p. 313; Guitton 1876). The new arrival was considered so important that adjacent to the two door jambs were placed the two *Slaves* by Michelangelo, unquestionably the most illustrious works in the museum's whole collection of modern sculpture. The installation decided upon by the curator of the sculpture collection, Henri Barbet de Jouy, maintained the illusion of its architectural function with the portal opening into another hall. The minute ornamentation of the portal was in striking stylistic contrast with the tragic monumentality of the works by Michelangelo. This installation is documented in a drawing by Charles-François Sellier reproduced in the *Magasin Pittoresque* of August 1877 (fig. 10). As he was working on the composition of a portal decorated with sculpture, Rodin could not have been indifferent to what had been done in the Louvre when he decided to place, on either side of the jambs of *The Gates of Hell*, the large Michelangelesque statues of *Adam* and *Eve*, as is seen in two drawings from the Musée Rodin, Paris (D.6937 and D.6940); in the second of these drawings (fig. 11), the lines creating the figure on the left seem almost to offer a refrain, as it were, of the principal lines of *The Dying Slave*, which occupied the same position in the Louvre installation.

Also exhibited at the Louvre, in the graphics galleries on the second and third floors, were thirty-seven drawings by Michelangelo and his school (Reiset 1878, pp. 35–44, and Both de Tauzia 1879, pp. 16–17). These could hardly have

Fig. 12. Auguste Rodin, *Adam* (no. 20)

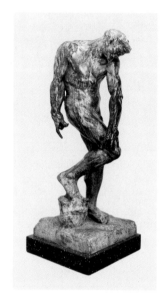

escaped the notice of Rodin, who was by this time deeply involved in a line of research that had evolved into a fierce encounter with the figurative language of the master. Having set aside the facile and emphatic Michelangelesque variations of the *Titans* base (no. 9), and having gone beyond the hypothetical paraphrases of the first (destroyed) version of the *Adam*, Rodin realized that he would have to deal with the challenge of Michelangelo's example by attempting to create a new grammar of the human body, in which he could express at once strength, tragedy, and a suspension of action, and for this, the drawings could have furnished a number of important solutions. If one compares the *Adam*, in the version known to us today (fig. 12 and no. 20), with a drawing in the Louvre (fig. 13) now generally attributed to Baccio Bandinelli but formerly considered to be by the hand of Michelangelo (Reiset 1878, no. 114; the photograph had been shown in Florence at the quadricentennial exhibition, while the reverse side of the sheet, showing a figure in a slightly varied pose had been published in Blanc 1876, p. 13), one can see how Rodin might have absorbed ideas for the pose of his own statue, with a similar twisting of the back and the slightly raised leg, but above all how he found a model for the expression of desperate suffering that spreads throughout the musculature of the statue.

There were also other opportunities to see drawings by Michelangelo in Paris, not just those in the galleries of the Louvre. In 1879, a major exhibition of Old Master drawings from private French, English, and Italian collections was held at the École des Beaux-Arts. The large selection of drawings attributed to Michelangelo, some of them notable for their powerful expression of physicality (the study for the *Death of Haman* in the Sistine Chapel; the *Flagellation of Christ* from the Malcolm collection; a male nude for the tomb of Julius II

from the Armand collection), was crowned by *The Fall of
Phaethon* (*Maîtres anciens* 1879, pp. 18–19, no. 71), which
was reproduced extensively in the press at that period (Chenne-
vières 1880, p. 30). Rodin may have been thinking of the figure
of Phaethon (fig. 14) when he created the falling man from
the left section of the tympanum of *The Gates of Hell* (fig.
15), repeating the arching of the figure, which emphasizes
the dramatic way in which he plummets into the void, and
above all, presenting the action as an inevitable consequence
of the will of a vastly superior master (Jove hurling lightning
bolts in the drawing by Michelangelo, the implacable *Thinker*
of Rodin's portal). On the same occasion, the celebrated sheet
of *The Resurrection* from the Malcolm collection (now in the
British Museum, 1860-6-16-133), with its risen Christ who,
as Kenneth Clark put it, "does not burst from his sarcopha-
gus like an explosion, but glides irresistibly into the air" (Clark
1956, p. 307), may well have served as inspiration for the
figures in the tympanum of *The Gates*, with figures floating in
a state of total unawareness.

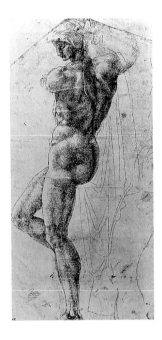

Florentine originals, Parisian plaster casts, or photographs
of sculpture that Rodin had collected himself; drawings seen
in the original or in engraved or photographic reproductions;
frescoes or copies of frescoes (in addition to *The Last Judg-
ment* by Sigalon, it was possible to see at the École des Beaux-
Arts reproductions of numerous details of the Sistine Chapel
sent back as *envois*, or examples of the work of recipients of
the Prix de Rome, by Joseph Coiny, Émile Signol, Aimé Morot,
and Jules-Eugène Lenepveu, and housed in the Salle
Melpomène and in the rooms overlooking the Quai Mala-
quais; Müntz [1889], pp. 228–34, 266)—these were the many
different ways through which Rodin, from 1875 until 1880,
had the opportunity to come into contact with the work of
Michelangelo. In that climate, while the Michelangelesque

Fig. 14. Michelangelo, *The Fall of Phaethon* (detail), 1533. Black chalk on paper. British Museum, London

Fig. 15. Auguste Rodin, *The Gates of Hell* (detail), 1880–1917. Bronze. Rodin Museum, Philadelphia. Bequest of Jules E. Mastbaum

borrowings of other artists of Rodin's generation tended to fade into generic stylistic assimilations (stern poses, heroic musculatures, imperious gestures) or in some cases to take the form of precise iconographic adaptations from paintings or even from drawings (the field is vaster than the samplings presented in Butler 1981 and deserves a separate study), Rodin succeeded in restating in radical terms, through his great series of figures of *Adam*, *Eve*, and *The Shade*, the problem of representing the nude in sculpture (this was clearly described by Judith Cladel following lengthy conversations with Rodin: for Michelangelo, "[Rodin] definitely felt that the art of sculpture was not located in movement or in characterization and that he sided entirely with modeling. Modeling alone permitted the rendering of the subtlety of movement and the intensity of character"; Cladel 1908, p. 82).

From 1878, with the comparison of the *Man with the Broken Nose* (no. 2) to the Michelangelesque head by Daniele da Volterra (no. 34) (Ménard 1878, p. 277; Véron 1879, pp. 813–14), the Michelangelism of Rodin was to become a recurrent theme in critical writings. The insistence on this, especially when in the 1890s the unfinished aspect of Rodin's marble translations was to offer an irresistible hook for observations of this sort, must have been a source of some irritation to Rodin, who sensed the danger of being seen as a facile imitator of the great master. This may be a partial explanation of the determined stance that Rodin assumed in opposition to the sculpture of Michelangelo, which he expressed in a deliberate way in many later statements. He either confined his debt to Michelangelo to his youthful years ("Rodin . . . has lost sight of Michelangelo"; Cladel 1908, p. 83) or he ruled it out entirely. In an essay of 1892, intended for a readership of American collectors who were looking with increasing interest upon the work of Rodin, the art critic William Brownell

systematically noted for the first time reasons underlying this new hostility to Michelangelo. Rodin, who "strikes so many crude apprehensions as a French Michael Angelo," revealed the differences: unlike the Renaissance master, Rodin eschewed the grandiose and did not imbue his figures with sentimental exaltation; he did not laboriously construct beauty, but revealed it; he did not crystallize natural forms into decorative visions, but expressed them with attentive and humble observation, following the lessons of naturalism of Phidias and Donatello (Brownell 1980, pp. 80–81).

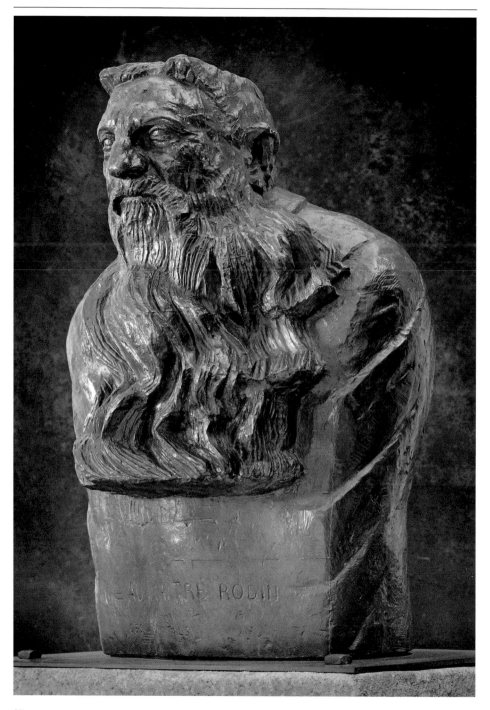

Rodin and Michelangelo: A Turning Point in Modern Sculpture
Maria Mimita Lamberti

This moment of investigating sources raises a number of questions. First, what was the significance of Rodin's Michelangelism, which was so different from that in the academies and the salons at the time? Second, what was the innovative reading of Michelangelo that in Rodin's vocabulary spread throughout European sculpture at the turn of the century, amplifying its message beyond that of historicism? Leaving behind the question of Michelangelo's popularity in relation to the academic allure of the neo-Renaissance (encouraged at the time by less innovative anti-Rodin factions), what develops instead is a hypothesis that, through quotations of his work in the artistic language of the time, Michelangelo was launched as a prime source of contemporary sculpture, with Rodin, not by chance, as his mainspring.

In 1962, in *The Shape of Time*, George Kubler, wanting to give an example of the so-called Eliot effect, according to which "every major work of art forces upon us a reassessment of all previous works," followed the methodology of André Malraux when he cited the case of Rodin and Michelangelo: "The advent of Rodin alters the transmitted identity of Michelangelo by enlarging our understanding of sculpture and permitting us a new objective vision of his work" (Kubler 1962, p. 35). The novelty of Rodin's sculptural language crosses the field of the continuing presence of and academic respect for Michelangelo to culminate in the suggestion of a hypothesis that the history of contemporary figurative art (not only of sculpture) traces its lineage back to Michelangelo following the almost obligatory path of Rodin's success. This hypothesis is well founded and can be traced in the education of artists until even recent times, with some surprising examples: notably, the drawings of nudes after Michelangelo executed by Jackson Pollock, dated about 1937–38, could derive from Pollock's apprenticeship during the early 1930s with Thomas Hart Benton,

Fig. 1. Émile-Antoine Bourdelle (French, 1861–1929), *Bust of Rodin*, 1909–10. Bronze, height 35" (88.9 cm). Los Angeles County Museum of Art. Gift of B. Gerald Cantor Art Foundation

who also borrowed from Rodin the formula of sculpture as the art of "the hollow and the bump" (Horn 1966, p. 81).

These same words, made popular in a satirical couplet concerning the division of labor in Rodin's workshop ("It is [Jules] Desbois who makes the hollows, it is Rodin who makes the bumps"), reappear in a positive evaluation offered by the British sculptor Henry Moore in 1960: "Rodin of course knew what sculpture is: he once said that sculpture is the science of the bump and the hollow" (Moore 1966, p. 134). At the Royal College of Art in London, in fact, the teachings of Sir William Rothenstein were based on a direct knowledge of Degas and Rodin, according to the statements of Moore, who in a series of interviews with Philip James in the 1960s was lavish in his praise of Michelangelo ("an absolute superman"; Moore 1966, p. 175), which was clearly framed in accordance with the Rodinian language of the turn of the century. For instance, on reading Moore's statement that "the smallest thumbnail sketches by Michelangelo project monumental figures at least 7 feet tall" (Moore 1966, p. 125), one can hardly help but think of Rodin's method, which in time became a professional practice and even an affectation, of personally working only on the first rough version of a sculpture, and then having it enlarged by workers to a monumental scale.

Moore also recognized that even the plastic quality of Matisse's sculpture was hardly a spontaneous undertaking but rather, as has also been widely recognized by critics, depended on the "very strong effect" of Rodin upon the painter (Moore 1966, p. 203). Alfred H. Barr confirmed that in 1899 Matisse had purchased from the French dealer Ambroise Vollard the original plaster bust of Henri Rochefort modeled by Rodin and once owned by Manet's widow (Barr 1951, p. 39), while the Australian painter John Peter Russell succeeded in introducing Matisse to the sculptor (who, nonetheless, paradoxi-

Fig. 2. Jackson Pollock (American, 1912–1956), *Nude (Study after Michelangelo)*, c. 1937–39. Graphite and colored pencil on paper, 16⁷/₈ x 13⁷/₈" (42.9 x 35.2 cm). The Pollock-Krasner Foundation (courtesy of the Robert Miller Gallery)

cally advised the young artist to make more "detailed" drawings). In addition to the dependence on Rodin through direct citation, which Matisse took so far as to amputate the arms of his *Slave* for the bronze cast that was exhibited at the Salon d'Automne in Paris in 1908, it is of greater interest to note how he began to study Michelangelo again in drawings (not accidentally, the Medici tombs, themselves of such central importance to Rodin). While in Nice, the painter devoted himself with the humility of an art student to drawing after Michelangelo, as he wrote in a letter to his friend the painter Charles Camoin on April 10, 1918: "I am also working at the École des Arts Décoratifs, directed by [Célestin] Audra, a former pupil of [Gustave] Moreau. I am drawing 'Night' and I am modeling it; I am studying Michelangelo's 'Lorenzo de' Medici.' I hope to absorb the clear and complex conception of Michelangelo's construction" (Paris 1993, *Matisse*, p. 126). Matisse's drawing of *Dawn* from the Medici Chapel also dates from those years, while a plaster cast of Michelangelo's *Dying Slave* is clearly seen at the center of the 1923 canvas *Checker Game and Piano Music*, set in the painter's house in Nice. In a photograph taken about 1928 in Matisse's studio (Barr 1951, p. 27), a reproduction of the drawing of *Night* is recognizable, tacked to the door. As late as 1974, in an interview with David Sylvester, the British painter Francis Bacon commented on the intense eroticism of Michelangelo's drawings ("I am sure that I have been influenced by the fact that Michelangelo made the most voluptuous male nudes in the plastic arts"; Sylvester 1988, p. 114). Although Rodin was not mentioned, Bacon went well beyond his personal interests by explicitly embracing the sensual approach that in Rodin's sculpture had been so fascinating and so scandalous.

In a biting contemporary opinion written earlier than 1890, the painter Gustave Moreau condemned in Rodin the inces-

tuous coexistence of "the dream of Michelangelo through the spirit and mind of Gustave Doré. . . . And always, always a sadism *à la [Félicien] Rops*." Yet after his censure of the charlatanism of the bad writing and facile criticism that had so deluded Rodin, pushing him to play the part of the "profound thinker," Moreau concluded by saying, "And yet . . . there emerges the conception of a new art. What a marvelous thing, the providence of God in all things!" (Moreau 1984).

Even Constantin Brancusi, "the man who doesn't like Michelangelo," according to the title of an article by Russell Warren Howe published in *Apollo* in May 1949 (p. 124), had frankly admitted in 1925 the importance of Rodin in reducing to human proportions the grand rhetoric of Michelangelo, which was attacked with forceful verbal satisfaction by the Romanian sculptor: "The decline of sculpture started with Michelangelo. How could a person sleep in a room next to his *Moses*? Michelangelo's sculpture is nothing but muscle, beefsteak, beefsteak run amok. . . . Sculpture everywhere felt his impact in one way or another, and we have a Rodin to thank for steering clear of the grandiloquent and the colossal and for bringing [sculpture] back down to human scale" (quoted in Hulten, Dumitresco, and Istrati 1987, p. 169).

Oddly enough, the humanization of Rodin's Michelangelism reappears in the writings of an Italian painter, Renato Birolli, who was asked in 1946 to write a piece for his friend the sculptor Alberto Viani: "And Rodin? . . . Rodin was a serious sculptor because he understood the necessity of sacrificing the plastic means entirely to the image. Still, he forced the rhetorical dimension, he sculpted or intended to sculpt content and feeling. But Rodin was also an Art Nouveau artist. There is still some erudition, but he already had longed for the moral dimension; he was more concerned with Michelangelo the man than with the works of Buonarroti" (Birolli 1990, p. 234).

In step with the era of postwar reconstruction, Birolli found in the moral dimension the impetus to discover the man in his work, accepting a certain pathos of Romantic derivation that even the critics who were closest to the sculptor had intentionally underscored. Thus, for instance, in 1884, Octave Mirbeau in *Le Gaulois* had addressed the public in connection with Rodin: "I tell you, Monsieur, this man is Michelangelo, and you do not recognize it" (Mirbeau 1993, p. 120).

Here was Michelangelo reincarnate, returned to life almost in order to respond in anticipation to the question that Mirbeau had discovered in Stendhal's *Peinture en Italie* and mentioned in 1889 to Geffroy, who immediately used it as the epigraph for his own study of Rodin (Geffroy 1889, p. 47); Stendhal had in fact wondered: "If a Michelangelo were born in our enlightened days, imagine what heights he might achieve! What a torrent of new sensations and pleasures he would release among a public already well primed by the theater and novels! Perhaps he would create a modern sculpture and compel the art to express passion, if indeed it *can* express passion. At least Michelangelo would make the sculpture express the soul's moods" (Stendhal 1973, p. 81). If we replace the Romantic sensibility with the sensibility of the end of the nineteenth century, the reply of Rodin's approach to the question becomes evident: the Michelangelesque modes of Rodin's nudes express the spirit of their own time, with an emotional involvement that in a singular manner takes advantage of the two sources of awareness of the new psychology already indicated by Stendhal: the theater and literature.

The literary strain found in the criticism of Rodin, nowadays hard to accept even in the poetic writing of the German poet Rainer Maria Rilke, was one of the ingredients of the success of Rodin's sculpture at the time, inasmuch as it deliberately referred to higher intentions that differed with respect

to naturalism and plastic academicism. And this reference found its form in the sculptures themselves by exaggerating to the limit the movement of the body, loading it with significance, even in the fragmentary works.

There is ample evidence of Rodin's interest in the expressiveness of the body in motion in his studies of dancers, from Javanese dancers to Isadora Duncan. Mario Praz, the Italian scholar of English literary themes, was well aware of this gesturality, although he viewed it in a negative manner. In an essay on the French sculptor, he compared the gestures of Rodin with those of Eleanora Duse, an actress who was then internationally renowned as an exponent of the expression of psychological torment. The link with Rodin was connected to the frescoes of the Sistine Chapel, seen through the writings of Gabriele D'Annunzio, who incidentally was the mentor and lover of Duse herself. Praz wrote: "The art of Rodin is full of ineffable gestures. If you look at the profile of Rodin's *Age of Bronze* in the Louvre you will discover a startling similarity to the face and gestures of Eleonora Duse (Duse herself inspired the sculptor to do another figure, that of *Sorrow*). Likewise, Michelangelo's figures in the Sistine Chapel are full of gestures. That is why D'Annunzio liked them so well" (Praz 1960, p. 68).

The reference to Duse relates to the famous passage in Rilke's monographic text on Rodin (1903) concerning the mutilation of the arms of *The Inner Voice* for the monument to Victor Hugo: "When one looks upon this figure one thinks of Duse in a drama of d'Annunzio's, when she is painfully abandoned and tries to embrace without arms and to hold without hands. This scene . . . conveys the impression that the arms are something superfluous, an adornment, a thing of the rich, something immoderate that one can throw off in order to become quite poor. She appeared in this moment as

though she had forfeited something unimportant....The same completeness is conveyed in all the armless statues of Rodin; nothing necessary is lacking" (Rilke 1965, p. 123).

But Praz goes beyond Rilke's reference to the nexus between Duse, D'Annunzio, and Rodin, specifically quoting from the *Laus Vitae*, one of D'Annunzio's many transcriptions from the work of Michelangelo, here particularly dedicated to the male nudes from the architectural framework of the Sistine Chapel: "Each its own bone structure / had created from the interior / of its spirit, an ardent craftsman / of its vital simulacrum; / and from the tarsus to the sternum, / from the elbow to the knee, / from the occipit to the heel, / from the vertebrae to the phalanges / the entire assembly was eloquent / like some spirit that speaks / of itself with a beating of wings; / so that the dreary animal weight / was transformed into eternal word." Praz then commented: "In D'Annunzio and in Rodin the gesture took on a new element, the ineffable, which attempts to suggest charming infinities: a refined grandiloquence that is generally vacuous, and which truly cannot be found in Michelangelo" (Praz 1960, pp. 68–69).

Although subsequent studies (particularly that of Tosi 1968) have indicated two different French sources for D'Annunzio's verse description of the Sistine Chapel—*Voyage en Italie* by Hippolyte Taine and *Les Deux Masques* by Paul de Saint-Victor—familiarity with Rodin is possibly a subsequent (and not the least secondary) component, if only for this passage. The nude that speaks, the insistent listing of anatomical connections, and the expressive rhythm of bodies all correspond closely to D'Annunzio's eroticism—all fit perfectly with the sculptural means of the language inaugurated by Rodin.

D'Annunzio republished these verses in his collection *Maia* in 1903, when also in Italy—beginning at least with the Venice Biennale of 1897 and above all when an entire gallery there

was devoted to Rodin's work in 1901—admiration for Rodin was widely spread by reviews and monographic articles, which were often well illustrated. And if the name of the French sculptor does not emerge in S. Tamassia Mazzarotto's thorough study of the works of D'Annunzio (Tamassia Mazzarotto 1949), the entire chapter of commentaries on Michelangelo implicitly makes reference to the particular acceptance of Michelangelism as vital to the work of Rodin. Michelangelo, not Rodin, is one of the most commonly mentioned artists in D'Annunzio's writings: a concordance of the many passages devoted to the Florentine sculptor throughout D'Annunzio's literary career responds perfectly to the late nineteenth-century taste for Rodin's exuberance. Once again, we might safely say, Rodin is the obligatory lens that brings Michelangelo's titanism into modern focus.

With Rodin as the catalyst, an updated hypothesis—one that might win acceptance in historical writing as well as with the public—can be constructed concerning the modern appreciation of Michelangelo (or the appreciation of the modernity of Michelangelo). Specifically, it is singular how the sculptors of the new century came to Michelangelo, from and through Rodin, as a privileged and uncontestable passage. In a letter to the French sculptor Antoine Bourdelle written about 1906, Rodin himself underscored, with hindsight, how Michelangelo marked his own development to a modern mode that was diametrically opposed to tradition: "Michael Angelo liberated me from Academic methods. In teaching me (by observation) rules that were diametrically opposed to the ones I have been taught (School of Ingres), he set me free" (Cladel 1937, p. 46).

It was Bourdelle himself who, in 1909, portrayed the master in his *Monument to Rodin*, in his *Rodin at Work*, and above all in his terracotta model for a bust (now in the Musée Ingres

in Montauban) with a clear emphasis on the flowing beard and the glowering expression, reminiscent of Michelangelo's *Moses* (see fig. 1). On the forehead, in fact, the pattern of the hair even seems to allude to the "horns" of the statue in Rome, which Bourdelle explicitly copied from the *Moses* in a bust of 1909 depicting Carpeaux, as if to say that the heroic iconography of the fathers of modern sculpture might inevitably find its derivation, even its physiognomy, in the groundbreaking work of Michelangelo.

Other sculptors were to follow the trail of anti-academic freedom blazed by Rodin, in an itinerary of steps strung together in a parabola that extended from the first consciousness of plastic form to a progressive discovery of the body, from the Greek world to Michelangelo, from Michelangelo to Rodin, and from Rodin onward toward new expressive realities. In this connection, the account of a visit to the Parisian studio of Medardo Rosso by the critic Julius Meier-Graefe, published by the Viennese *Neue Freie Zeitung*, January 19, 1903, is instructive: "When I visited him for the first time and he detected how amazed I was, he constructed a piece of aesthetic history, in the form of a still life. He laid out on a table a lovely bronze copy that he had executed of the head of *Vitellius* in the Vatican; alongside he placed a wax copy of the little group by Michelangelo, *The Virgin and Child* in Berlin [*sic*]; near that he placed the *Torso of Saint John* by Rodin and, finally, a work of his own, the head of a child. This he could not set out properly because it had no base. He thus had to hold it up in his hand" (De Sanna 1985, p. 86).

Even though this journalistic account is somewhat inaccurate (in his Viennese show of 1905, Rosso would exhibit, in conjunction with his own work, the bronze *Vitellius*, a cast of a Greek torso, an original *Torso* by Rodin, and the copies that he had made himself of Rodin's *Eve* and of Michelangelo's

Medici Madonna, both in varnished plaster and in reduced proportions of about twelve inches high), it is difficult not to be drawn in by the allure of this history of sculpture, a sort of minimalist puppet theater set in action by a sculptor on the table of his studio for the benefit of an art historian. Similarly, with a view to the publication in 1911 of the book by Paul Gsell, Rodin modeled as an educational exercise two small clay nudes in accordance with the lessons of Phidias and Michelangelo, as concrete and eloquent examples of historical and critical commentary (no. 45, fig. 3).

The link between Rodin and Michelangelo, repudiated by Medardo Rosso in the name of an anti-monumental impressionism, served, however, as an entrée to modernity for Umberto Boccioni, as had already been the case for Brancusi. In a letter to Gino Severini dated March 13, 1914, the painter Carlo Carrà insinuated that Boccioni, who had by then proclaimed himself the leader of Marinetti-inspired Futurism, had "four years ago . . . firmly believed that Rodin was much greater than Rosso" (Gambillo and Fiori 1958, p. 319), a fact that can be easily believed if we give the proper importance to the polemical overthrow proposed in Boccioni's "Technical Manifesto of Futurist Sculpture" (1912). For Boccioni, the theorist and artistic nationalist of the "Manifesto," Rodin embodied the heroic impulse of Michelangelo's sculpture, though he accepted from it a recognizable repertoire of forms, instead of moving past it and undermining it, as the Futurist sculptor ought properly to do: "[Rodin] brings to his sculpture an unquiet inspiration, a grandiose lyrical impetus, which would have been well and truly modern if Michelangelo and Donatello had not already possessed them in almost the identical form four hundred years ago, or if he himself had used these gifts to show a completely new sort of reality" (Boccioni 1973, pp. 61–62).

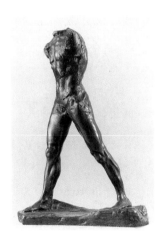

In notes made for a lecture delivered in Rome in 1911 (the year in which Rodin was the sculptural *cause célèbre* of the Esposizione Internazionale), Boccioni distanced himself more from Rodinism than from Rodin, while describing the central position of Michelangelo entirely in terms of an explicit modernity, thus of an aesthetic syncretism: "The greatest intellectual working with material means was perhaps Michelangelo. In his work, the science of anatomy was transformed into music. He resembles an architect who studied plants in order to develop architectural orders. In him we see a true aspiration of the artistic dream. The melodic lines of the muscles are composed in accordance with the laws of music, not with the laws of representational logic" (Boccioni 1972, p. 33).

Even the first reviewer of Boccioni's 1914 book *Pittura scultura futuriste* (*Dinamismo plastico*), Roberto Longhi, at the time a young graduate just testing out iconoclastic writing, borrowed concepts that he had certainly developed in friendly discussions with the Futurist sculptor. In fact, Longhi, in the journal *La Voce*, declared in 1914 his intention of one day writing "a popular history and ironical synthesis of modern sculpture, which is to say, from Michelangelo onward" (Longhi 1961, p. 133).

That modern sculpture begins with Michelangelo, or rather that "the Michelangelo block endures just on the surface, under the shroud of Puget, and so on until the serial *glissés* of Carpeaux," is stated further on in the same article by Longhi (Longhi 1961, p. 133), who thus underscores a persistence of the Michelangelesque core in the French tradition, ready to emerge with none other than Rodin, shattering academicism. The following passage, though of difficult interpretation, is in perfect accordance with the ambitious dictates of the then very young critic. It envisions a sort of rebirth of Michelangelo

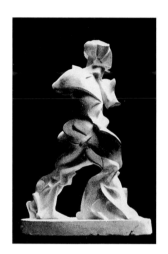

in the sculpture of Rodin, given to the refining flames in a context typical of the anecdotes of Vasari (almost like a phoenix that is reborn from the casting process, amidst feverish glare and shadows, as in the *Life* of Benvenuto Cellini): "When, on the other hand, Rodin, driven to desperation by his arthritic and gnarled realism, tossed his better, but in any case [Filippo] Cifariello-like, productions on the fire, and, miraculously, saw them rise up in a block of, my God, still classical or Michelangelesque ore (but with contracted motions everywhere except in the joints), he realized (although he pretended not to have) after curing the burns of the statuary dermis with hasty poultices of indefinable substances that he had given the glue of impressionism to his fossils of Herculaneum" (Longhi 1961, pp. 133–34).

This interpretation intended for initiates was rendered still more explicit when it was understood within the original context: the bronze of *The Walking Man*, already seen at the Esposizione Internazionale of Rome in 1911 and, from December 23 of that year, installed in the courtyard of the Palazzo Farnese in Rome (and now in the museum of Lyon; see p. 34, fig. 1)—hence, the allusion to movement and the poultices clearly visible on the surface of Rodin's statue, and the reference to the dead of Herculaneum, which were known in fragmentary bronzes or casts of the bodies that had decomposed in the volcanic ash.

It was this type of writing, charged with literary ambition, which returns (while negating it) to the Rodinian prototype in its analysis of another "representation of a man in motion," that Longhi undertook in his description of the now-lost plaster figure by Boccioni, *Spiral Expansion of Muscles in Movement* (fig. 4): "Here the torso spirals, tossing backward an armored pectoral, to the same degree that the other one thrusts forward with a compressed motion that curls around the

shoulder blade on the back. As if by fate the Doric scapula metamorphosizes into an Ionic scapula. Volutes, volutes of a form that contracts in order not to be sucked up into a sudden gush of air. It was this that broke the arms—the stumps of Rodin are something quite different—healing into a horn of skin" (Longhi 1961, p. 148).

One may well wonder whether the formal impact of *The Walking Man*, whose presence in the Palazzo Farnese courtyard had been even more greatly celebrated by the articles published during Rodin's stay in late January 1912, may perhaps, through Boccioni's sculpture and Longhi's prose, be linked to a reading of Rilke that has, however, yet to be verified in concrete terms. But in the context of the wide diffusion of the text of Rilke's lectures in Dresden and Prague, which were included in the third edition of his volume on Rodin (1907), one passage seems to be a bellwether of indications or assonances that were to be useful to Boccioni the Futurist. In this passage, Rilke, referring, as the final stage of Rodin's development, to the "tremendous new version" of *The Walking Man* (p. 34, fig. 1), singles out in the following terms the atmosphere in which Rodin's nudes act: "With ever increasing decisiveness and assurance the given details are brought together in strongly marked surface-units, until finally they adjust themselves, as if under the influence of rotating forces, in a number of great planes, and we get the impression that these planes are part of the universe and could be continued into infinity" (Rilke 1986, p. 54).

In relation to the lost *Spiral Expansion of Muscles in Movement* (1913) and to the *Unique Forms of Continuity in Space* (1913), Boccioni seems to have developed the theme of a man walking, on the basis of Rodin's prototype, which Rilke had quite rightly defined as "like a new word for the action of *walking*" (Rilke 1986, p. 50).

Catalogue of the Exhibition

1. Auguste Rodin
French, 1840–1917
The Mastbaum Album
c. 1854–64
Sketchbook composed of thirty-seven
sheets bound in leather
Graphite, ink, and wash on paper,
5 $^7/_8$ x 3 $^3/_4$" (14.9 x 9.5 cm)
Philadelphia Museum of Art. Gift of Mrs.
Jefferson Dickson. 1981-49-1

This small sketchbook, which includes thirty-seven sheets of drawings of animals and landscapes, spontaneous street scenes, and figure studies, dates from Rodin's youth and is the most complete record of his early draftsmanship. Several of the drawings show nude figures posed in elegant S curves, as if Rodin were planning ornamental sculptures such as fireplaces or carved escutcheons. While some of the drawings are heavily shaded, most of the figures are line drawings somewhat reminiscent of Antonio Canova or other neoclassical draftsmen.

The stylistic diversity and range of subjects have led to debate concerning the dating of the album. Jacques de Caso has suggested that the sketchbook dates from about 1854, before Rodin began his formal art training at the École Spéciale de Dessin et de Mathématiques (Caso 1972, pp. 155–61). J. Kirk T. Varnedoe, while pointing out discrepancies in Judith Cladel's account, accepts her testimony that Rodin made the drawings while "under the tutelage of the great [Antoine-Louis] Barye," and dates the sketchbook to 1863–64 (Varnedoe 1971, pp. 30–36). In addition, Varnedoe notes that the *ancien régime* air to some of the sketches suggests the training Rodin would have received at the École Spéciale, where an eighteenth-century revival was promoted. In fact, the sketchbook may have been used by Rodin over a long period of time—which would account for a discrepancy between drawings clearly showing immaturity and others hinting at ambition.

The last page of the sketchbook is signed and dated 1916, but this represents the moment when Rodin was hoping to recuperate it from a cousin to whom he had presented it. Ultimately it was acquired by Jules Mastbaum, who bequeathed it to a daughter; she in turn gave it to the Philadelphia Museum of Art, where it joins the large group of drawings conserved there that were bequeathed by Mastbaum to the Rodin Museum.

The drawing illustrated here (p. 8 recto) shows a youth in bathing trunks standing in front of a swimming pool; in the background two youths are wrestling while other standing figures observe. De Caso has suggested that this, the most complicated multifigure drawing in the sketchbook, represents an interior of one of several floating swimming pools that were anchored in the Seine in the heart of Paris in the mid-nineteenth century (Caso 1972, p. 159). No doubt the sketch is made from life: Rodin's thin, nervous line still betrays some uncertainty about the structure of the human body. At the same time, the sheet carries wider art-historical implications of heroic nudity, as if the young artist were thinking about multifigure nude compositions from antiquity or the Renaissance that he had studied in the Louvre, from casts, or in prints or photographs. Indeed, it carries a distant echo of Michelangelo's lost *Battle of Cascina* or the Casa Buonarroti relief of *The Battle of Lapiths and Centaurs* (see p. 17, fig. 3). Even as a young man, Rodin had identified the nude body as a prime subject of his art.

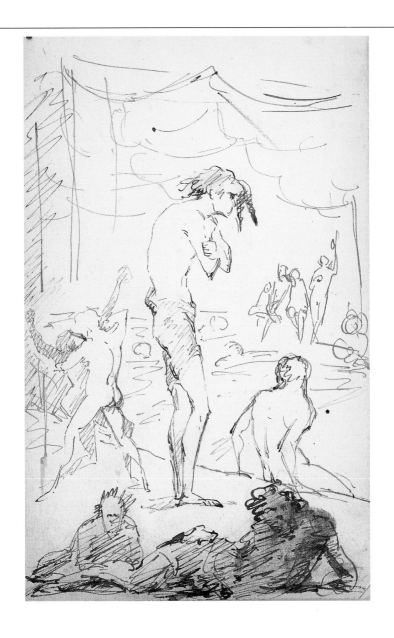

2. Auguste Rodin
Mask of the Man with the Broken Nose
1863–64
Bronze, height 10 ¹/₄" (26 cm)
Signed: A. Rodin.
Foundry mark: Alexis RUDIER / Fondeur. PARIS.
Rodin Museum, Philadelphia. Bequest of Jules
E. Mastbaum. F1929-7-55
Tancock 1976, no. 79

Rodin referred to the *Mask of the Man with the Broken Nose* as "the first good piece of modeling I ever did," telling an American journalist many years later that it "determined all my future work" (Bartlett 1965, p. 21). Created over a period of eighteen months in Paris in 1863 and 1864, it is the portrait of a local workman named Bibi whose nose was broken but whose head the sculptor found fine nonetheless. Rodin invested his model with classical dignity, and the fillet around his head indicates that he is indeed a figure from antiquity. As Ruth Butler has observed, for Rodin, the art of antiquity was often imperfect: many of the classical sculptures that he studied in the Louvre were themselves chipped around the nose (Butler 1993, pp. 44–45). Rodin later explained that when he sculpted this head, he was living in poverty and was unable to afford heat. He initially created a traditional three-dimensional bust, but one winter night the plaster froze and the back of the figure's head fell off. Audaciously, rather than repair the damage, Rodin accepted it, submitting the work to the Salon of 1865 as a mask. The judges viewed it as nothing more than a fragment, however, and to Rodin's profound dismay the work was rejected.

The *Man with the Broken Nose* was an important statement of the sculptor's dawning aesthetic. Already he shied away from conventional notions of beauty, choosing a physically flawed model. He eschewed the smooth surfaces of neoclassical art and the feminine sweetness of much contemporary sculpture in favor of something intentionally cruder and more obviously worked. He lavished tremendous care on the bust, but when the accident befell it, he acceded to chance. Finally, like Michelangelo before him, many of whose most powerful sculptures remained unfinished, Rodin exploited the expressive potential of the *non finito*, the unfinished.

Indeed, the *Man with the Broken Nose* can be seen as an implicit portrait of Michelangelo. In 1872 Rodin exhibited a reworked version at the Brussels Salon under the title *Portrait de M. B....*, it being standard practice not to give a portrait sitter's full name. The initials stand for the model, Monsieur Bibi, but they are also the initials of Michelangelo Buonarroti, the most famous "man with a broken nose" in the history of sculpture. Even as a young artist, Rodin sought to emulate the great masters of sculpture, and long before he traveled to Italy he had pored over Michelangelo's *Slaves* in the Louvre. Rodin exhibited a bronze cast of the *Man with the Broken Nose* in Paris at the Salon of 1878, during the same months that a bronze cast of Daniele da Volterra's *Portrait of Michelangelo* (see no. 34) was shown at the nearby Exposition Universelle. Critics immediately noted the striking similarities, which extend beyond broken noses to the distinctive tilts of the heads and to the sorrowful, brooding expressions. Rodin may have seen in his model not only a fine head but a fortuitous resemblance to the greatest of Italian sculptors.

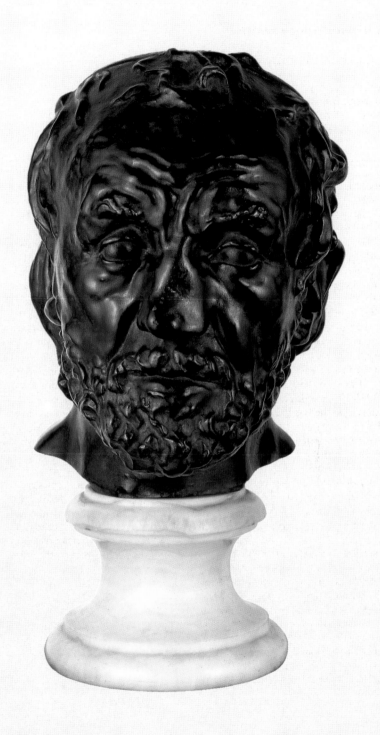

3. Auguste Rodin
The Age of Bronze
1875–76
Bronze, height 67" (170 cm)
Signed: Rodin
Foundry mark: Alexis RUDIER. / Fondeur. PARIS.
Rodin Museum, Philadelphia. Bequest of Jules
E. Mastbaum. F1929-7-126
Tancock 1976, no. 64

Intended by the artist to establish his reputation, *The Age of Bronze* is Rodin's earliest surviving life-size sculpture. Begun in Brussels in mid-1875, it remained unfinished when the artist left early in 1876 for Italy. He resumed work on his return, completing the figure in December 1876. Rodin sought to avoid the conventional postures of professional models, and so recruited an amateur to pose for him, a young Belgian soldier named Auguste Neyt. Rodin spent countless hours meticulously observing Neyt's body, studying the rhythmic play and counterplay of musculature. Constantly moving about the studio to compare model and sculpture, even climbing ladders to see them from above, the sculptor struggled to match their contours and planes. Rodin later described the despair he felt as he worked, caused in part by uncertainty about what he intended his sculpture to represent. Originally the nude wore a fillet and leaned on a spear, suggesting a soldier of antiquity, but by the time it was first exhibited in Brussels in 1877, these attributes had disappeared. The ambiguity of the figure's raised, empty left hand confused some critics, who expected the sculptor to provide visual clues that would readily identify the subject.

The Age of Bronze was among the first of Rodin's works to show the influence of Michelangelo. Even though the stance of the figure, with feet close together, does not resemble Michelangelesque *contrapposto*, the Louvre *Dying Slave* (fig. 1) is powerfully evoked, not only in the swooning semi-consciousness of the nude but also in the title under which Rodin first exhibited the work, *The Conquered Man*, with its suggestions of servitude and dejection. The intense naturalism of *The Age*

of Bronze* would cause the artist years of trouble when, almost as soon as it was first exhibited, rumors began to circulate that it was composed in part of life casts from the model and thus, by nineteenth-century academic standards, was not a true sculpture. The suspicion haunted Rodin until his "innocence" was established. In May 1880 a plaster of *The Age of Bronze* was purchased by the French state. Four years later a bronze cast was installed in the Luxembourg Gardens. This enigmatic and provocative image of man awakening to a new consciousness remains among Rodin's most popular works, with an estimated 150 casts worldwide.

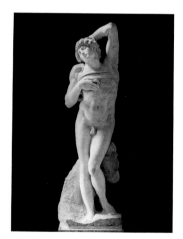

Fig. 1. Michelangelo, *The Dying Slave*, before 1513. Marble, height 92 ½" (235 cm). Musée du Louvre, Paris

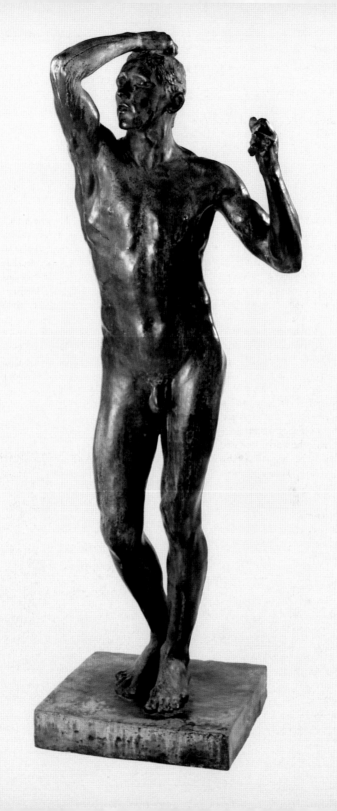

4. Auguste Rodin
Study after Michelangelo's "Medici Madonna"
c. 1876
Charcoal on paper, 29 9/16 x 24" (75.1 x 61 cm)
Musée Rodin, Paris. D.5116

5. Auguste Rodin
Study after Michelangelo's "Dawn"
c. 1876
Charcoal on paper, 24 x 29 9/16" (61 x 75.1 cm)
Musée Rodin, Paris. D.5117

Exhibited in Philadelphia only

These two large sheets are among four charcoal drawings in the Musée Rodin after sculptures by Michelangelo in the Medici Chapel in Florence (see p. 40, figs. 3, 4). The others (nos. 6, 7) represent the figures of *Day* and *Night* from the tomb of Giuliano de' Medici. The drawings have been catalogued by Claudie Judrin, who indicates that the sheets may have been tampered with (*fixées*) by a certain Mme Villedieu-Pautrier, a friend of Judith Cladel's (Judrin 1984–92, vol. 1, p. xxi). As a group, these drawings attest to the importance Rodin ascribed to the chapel, which overwhelmed him during his visit to Florence in the spring of 1876. In the only letter that survives from the Italian trip, Rodin describes his awestruck study of the Medici tomb figures, in profile and in three-quarter view, and his attempts to understand their structure by sketching in his room at night.

The dating of these drawings has long been subject to debate. One scholar has argued that they are student works dating from the 1850s; others have suggested that they were executed in the Medici Chapel at the time of Rodin's visit; in the early 1970s, J. Kirk T. Varnedoe proposed that they were made after the Italian trip, with Rodin copying not from the originals but from plaster casts such as those he might have known in the chapel of the École des Beaux-Arts in Paris (for an overview of the different dates proposed, see Varnedoe 1971, pp. 43 and 109–10, nn. 58–61). Writing in 1985, Varnedoe argued that the large size of the sheets, presumably awkward for a traveler to carry, supported the view that the drawings were done in Paris. A fifth sheet in the series, identical in tech-

nique and format (Musée Rodin, Paris. D.5115), depicts a sculpture of *Narcissus*, now thought to be a reworking of an antique figure by the Italian sculptor Valerio Cioli (1529–1599), but then universally identified as "Michelangelo's Cupid." As that sculpture had entered the Victoria and Albert Museum, London, in 1866, Varnedoe concluded that "Rodin could only have drawn it... from a reproduction" and that it "would seem to guarantee that the series was not drawn in Florence" (Varnedoe 1985, p. 24). A plaster reproduction of "Michelangelo's Cupid" was among the casts of sculptures thought to be by Michelangelo that were assembled in the Accademia in Florence for the 1875 celebrations of the four hundredth anniversary of Michelangelo's birth (see p. 58 above). These casts were still on display the following year and seem to have caught Rodin's attention: it was at the Accademia that he would have studied a plaster cast of the Saint Petersburg *Crouching Youth* that finds an echo in his *Crouching Woman* of 1880–82 (see no. 24); and the Brogi photograph of Michelangelo's *Rebellious Slave* that Rodin acquired shows not the marble original in the Louvre but the plaster cast shown at the Accademia (see p. 58, fig. 6). If the similarity in format and technique of all five drawings suggests that they were done at about the same time, and if the likely place for Rodin to have drawn from a reproduction of "Michelangelo's Cupid" was indeed the Accademia, then the four Medici Chapel drawings also may well date from the Florence visit of spring 1876.

The study of *The Medici Madonna* is the best-preserved drawing in the series. It depicts Michelangelo's unfinished marble group of *The Virgin and*

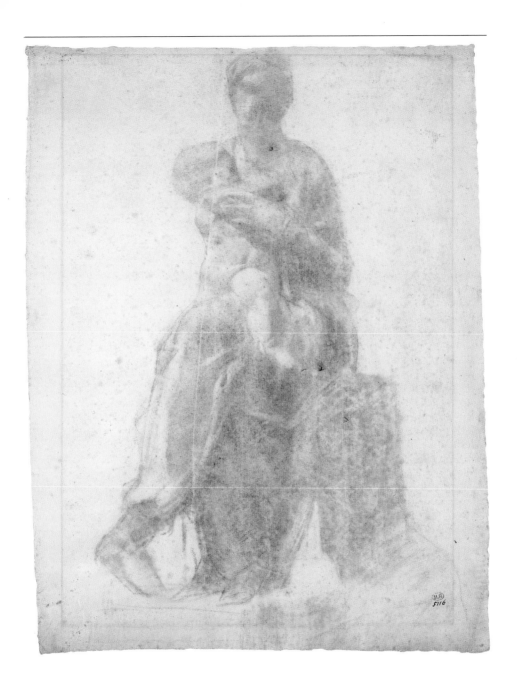

Child, which stands opposite the chapel altar and at which the sculptures of Giuliano and Lorenzo both gaze. Here, Rodin focuses on the play of shadow across the figure as a soft light falls from the left. It throws into relief the muscular baby's body as he twists to his mother's breast. Powerful, abbreviated, full of energy in the laying on of charcoal, this sheet anticipates Rodin's later "black" gouaches of the 1880s (see nos. 17, 18).

The allegorical figure of *Dawn* reclines to the lower right of the sculpture of Lorenzo de' Medici. Rodin studied the same figure from a more acute angle in a small, quick pencil sketch that accentuates the figure's jutting left knee (Musée Rodin, Paris. D.270). As with all the drawings in the series, here Rodin attends less to sculptural detail than to the play of light and shade and to those areas, such as the interstice between the legs of the figure, where the darkest shadows gather.

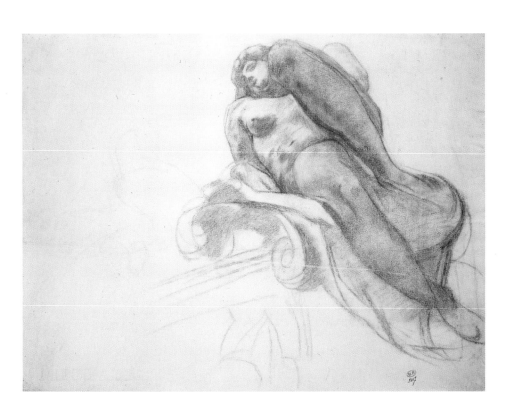

6. Auguste Rodin
Study after Michelangelo's "Day"
c. 1876
Charcoal on paper, 19 $\frac{1}{8}$ x 24 $\frac{11}{16}$"
(48.6 x 62.7 cm)
Musée Rodin, Paris. D.5118

7. Auguste Rodin
Study after Michelangelo's "Night"
c. 1876
Charcoal on paper, 19 $\frac{1}{16}$ x 24 $\frac{11}{16}$"
(48.4 x 62.7 cm)
Musée Rodin, Paris. D.5119

Exhibited in Florence only

These drawings are among four in the Musée Rodin (see also nos. 4, 5) after sculptures by Michelangelo in the Medici Chapel in Florence (see p. 40, figs. 3, 4). The two shown here are studies of the allegorical figures of *Day* and *Night* that dominate the tomb of Giuliano de' Medici.

Situating himself below the sculpture of *Day*, Rodin cursorily indicated the console on which the figure reclines, turning his attention instead to the muscles of the figure's back and to the torsion of its arms, head, and legs. To establish relief, he contrasted the bright highlights of bulging muscles with those recesses where the darkest shadows gather: beneath the left foot and at the point where the left side of the face meets the shoulder. Rodin's sculptures would soon include similar powerful, compressed figures, such as the struggling nudes of the base of the *Titans* vase (no. 9).

Although Michelangelo's sculpture of *Night* is more highly finished than *Day*, especially in the head and in the attributes surrounding the figure, Rodin was again interested primarily in the play of light and shade across the surface of the figure. Almost all detail is suppressed in the drawing, transforming the figure's face into a tapering triangle of dark shadow. The classical mask under her left shoulder is reduced to a pair of dark circles resembling large, empty eye sockets, while the owl nestled in the crook of her leg is only a shaded, curving line. Rodin's suppression of detail in his studies of Michelangelo's sculptures carried over into his own sculptures, finding fuller expression in works such as the *The Age of Bronze* (no. 3), where in the interest of intensifying the expressivity of the human body, Rodin eliminated "extraneous" attributes such as the fillet in the figure's hair and the spear he carried.

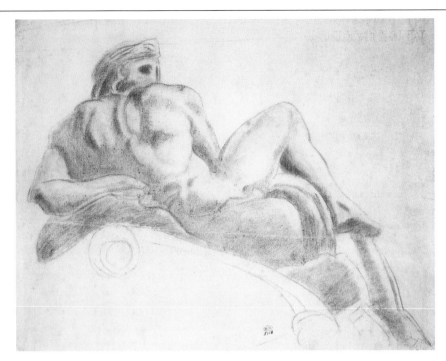

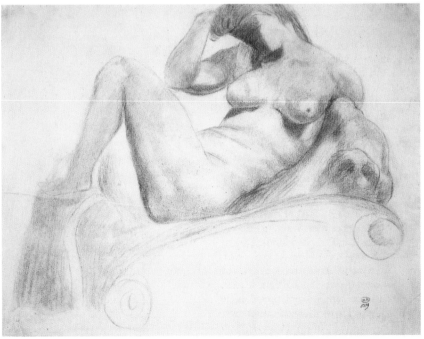

95

8. Auguste Rodin
Studies after Michelangelo
c. 1876
Eight sheets mounted
Graphite and ink wash on paper, 11 $^{13}/_{16}$ x 9 $^{3}/_{16}$"
(30 x 23.3 cm)
Musée Rodin, Paris. D.280–284 (recto),
D.285–288 (verso)

Exhibited in Philadelphia only

Rodin returned to Brussels from Italy in the spring
of 1876 and resumed work on the ambitious nude
sculpture *The Age of Bronze* (no. 3), begun before
his departure. At the same time, he sought to as-
similate what he had seen in Italy, especially the
lessons of Michelangelo's art. The task would oc-
cupy him for months if not years to come. As Rodin
later explained to Judith Cladel, on returning to
Brussels he executed numerous figure studies for
which he asked his models to assume Michelange-
lesque poses (Cladel 1903, p. 76).

The sheet shown here is composed of eight sepa-
rate sheets of sketches that have been cut up and
pasted down onto a single sheet. Several sketches,
including standing, seated, and reclining figures,
closely relate to or derive from poses of Michelan-
gelo models such as *David* and the Louvre *Slaves*.
Indeed, an annotation on the recto that reads
esclave may refer to a specific Michelangelo sculp-
ture. The seated figure of the recto sheet recalls a
Nude from the Sistine ceiling, while the reclining
nudes at top and bottom of the verso echo the al-
legorical figures from the Medici Chapel (see p.
40, figs. 3, 4). Rodin sought to understand the tor-
sion around the axes of the body that animates
many of Michelangelo's sculptures, and several of
the figures in the drawings twist violently at the
waist or shoulders. Other sketches include figures
whose hands jut out beyond the confines of the
body—poses not directly anticipated by Michel-
angelo's art but which would soon appear in such
works by Rodin as *Saint John the Baptist Preaching*
(no. 10). Certainly, the repeated depiction of the
standing male nude fed Rodin's conception of *The
Age of Bronze*, his first masterpiece in monumen-
tal scale.

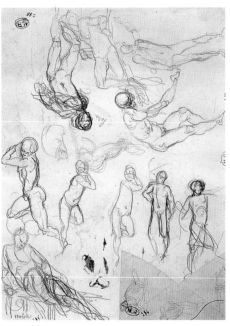

9. Auguste Rodin
Titans
c. 1877
Glazed earthenware, height 14 ¹/₂" (36.8 cm)
Signed: A. CARRIER-BELLEUSE
The Cleveland Museum of Art.
Leonard C. Hanna, Jr., Fund. 1995.71

In the fall of 1877, Rodin returned to live and work in Paris after six years in Brussels. While maintaining his own studio, he also hired himself out to other sculptors, including the fashionable and prolific Albert-Ernest Carrier-Belleuse (1824–1887), for whom he had worked on and off since 1864. In the meantime, Carrier-Belleuse had been appointed art director of the revitalized national porcelain manufactory at Sèvres, and much of Rodin's work for him concerned designs for porcelain objects. This base for a vase bears the signature "A. CARRIER-BELLEUSE," yet it bears little relation to the elegant style of Carrier-Belleuse's art, with its echoes of eighteenth-century refinement. Rather, as has long been recognized, the four nude males who support the vase are the work of Rodin (Janson 1968, pp. 278–80). Rodin likely modeled the four male figures in terracotta then assembled them around a circular plinth to form the *Titans* base. The base was almost certainly made at the Hautin, Boulenger & Co. factory in the town of Choisy-le-Roi (Hawley 1996, p. 6).

The figures reveal the growing impact of Michelangelo on Rodin's art following the trip to Italy, particularly in the intense plasticity of the powerfully muscled bodies, their jutting legs and arms shown under tremendous stress. The undiluted energy of the figures, struggling against their fate, recalls *The Rebellious Slave* of the Louvre (see p. 58, fig. 6) and the monumental male nudes of the Sistine ceiling, especially the figure directly over the prophet *Jeremiah*, who grapples with a massive garland of acorns on his back (fig. 1). Rodin had learned from Michelangelo's sculptures how to seek out repeated dramatic profiles within a figure so that tension and dynamism would be re-

tained even as the viewer moved around the sculpture. Here, he explores that experience by grouping four related nudes who, as the base of the vase turns, fall into unexpectedly complex patterns. In the early 1880s, Rodin would more fully explore problems of repetition and variation when he combined three identical casts of *The Shade* (no. 21) atop *The Gates of Hell*, their differing profiles presenting a provocative interplay of forms.

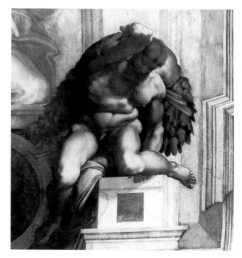

Fig. 1. Michelangelo, *Nude* (detail of the ceiling of the Sistine Chapel), c. 1510. Fresco. Sistine Chapel, Vatican, Rome

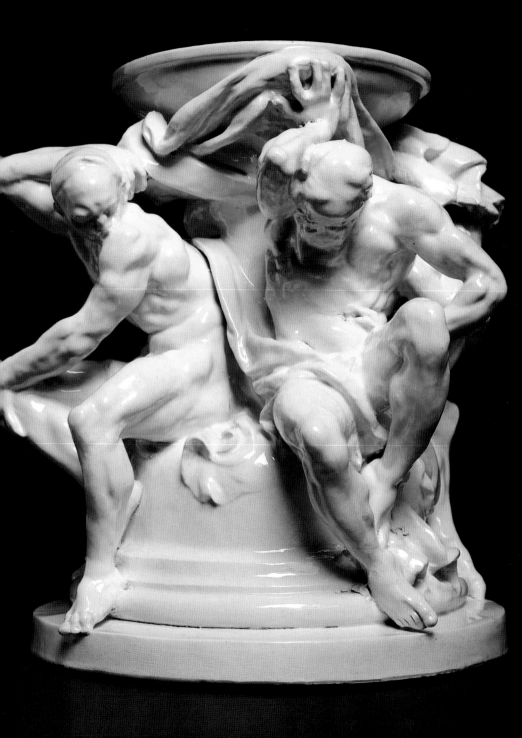

10. Auguste Rodin
Saint John the Baptist Preaching
1878
Bronze, height 79" (200.1 cm)
Signed: A Rodin
Foundry mark: Alexis Rudier / Fondeur Paris
Rodin Museum, Philadelphia. Bequest of Jules
E. Mastbaum. F1929-7-48
Tancock 1976, no. 65

Rodin returned from Brussels to his native Paris in 1877, still reeling from the false charges that he had used life casts in making *The Age of Bronze* (no. 3). He soon began work on *Saint John the Baptist Preaching*, a larger-than-life-size nude. The model was a peasant from the Abruzzi, named Pignatelli, who had no previous modeling experience but who nonetheless presented himself at the sculptor's studio. Rodin was impressed by his massive, muscled body, and doubly impressed when the man spontaneously took an unusual, wide-legged pose—as if in the middle of a giant stride—with both feet planted firmly on the ground. Rodin immediately thought of Saint John the Baptist and set to work.

With lips slightly parted, as if in mid-address, the saint beckons with his right hand as he strides forward, pointing an index finger upward, whence the Savior comes. The gesture is traditionally associated with the saint, as in Leonardo's depiction of John as a more youthful precursor. But Rodin also saw John as a simple man of the earth, and with his left hand the saint points to the ground.

Never before had Rodin achieved so complex a figure. The powerful torso is twisted tensely to the left—the head twisting even further—while at the same time the unusually widespread arms and legs incorporate ambient space into the composition. But the complexity Rodin achieves is psychological as well. The nude is a simple, earthbound peasant who at the same time expresses the visionary intensity of a prophet. While the surface finish retains a certain academic polish, Rodin had moved decisively beyond the mournful elegance and grace of *The Age of Bronze* to an expressivity beyond naturalism.

With this work Rodin was experimenting with a new working procedure by which he modeled individual body parts separately in clay, including arms, legs, torso, and head. Indeed, he exhibited a study for the head at the Salon of 1879. He would then combine the individual elements to form the complete figure. While the transitions among the various parts are smooth here, over the years Rodin became fascinated with exploring the expressive powers of disjunctions among such body parts. Sometime around 1900 he joined together a Michelangelesque torso of the model Pignatelli, made in preparation for *Saint John the Baptist Preaching*, with two widely spread legs from the same model, omitting the head and arms. This consciously awkward, truncated figure, which Rodin entitled *The Walking Man*, was long misunderstood to be a preliminary study for the Saint John sculpture. It is instead one of the most audaciously fragmentary works of Rodin's career. In 1911 a large-scale cast of *The Walking Man* was installed in the courtyard of the Palazzo Farnese, the French embassy in Rome, where for the first time, and to Rodin's intense satisfaction, a sculpture by Rodin confronted the architecture of Michelangelo (see p. 34, fig. 1).

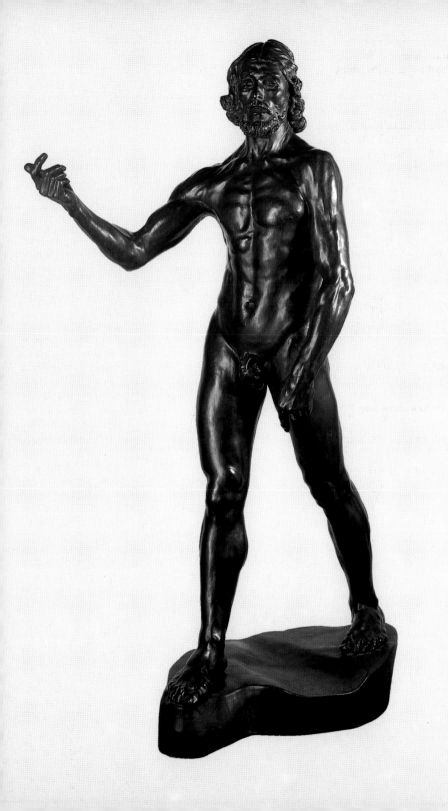

11. Auguste Rodin
Scene from the French Revolution
c. 1879
Black wax on wood, 8 x 15 x 1¹/₂"
(20.3 x 38.1 x 3.8 cm)
Philadelphia Museum of Art. Purchased
with Museum funds. 1970-4-1
Tancock 1976, no. 30

This small relief, so densely worked that it is difficult to interpret, may relate to a competition called by the Conseil Municipal of Paris in 1879 for the design of a monument to the French Republic, to be erected on the place du Château-d'Eau. In the end, Rodin did not enter the competition, choosing instead to participate in another competition of the same year for a monument honoring the defenders of Paris in 1870. Perhaps he felt that the latter competition offered more potential for the creation of a dynamic monument: his submission, *The Call to Arms* (no. 12), was one of the most tense and dramatic compositions of his career. The finished monument to the Republic, designed by competition winners Charles and Léopold Morice, incorporated some dozen reliefs depicting dramatic events in the history of the French Revolution. This relief may be a preliminary sketch for one such scene, created as Rodin, anxious to establish himself as a figure sculptor in the highly competitive Paris market, weighed his competition options.

When this work was exhibited in 1900, it was said to represent the enrollment of the volunteers in the revolutionary army of 1792. Whether or not that particular event is depicted, Rodin clearly chose to represent a large, milling crowd. A flag billows at left, and a sense of agitation and strong emotion pervades the scene, communicated more by the deeply worked surface, across which light flickers, than by specific detail. The piece provides a vivid and immediate demonstration of Rodin's working method in creating a multifigure relief composition. He kneaded small pellets of wax in his fingers, pressing them onto the wood support and into one another as he worked up a dense, animated surface full of deep hollows and projections. His fingerprints are everywhere incised into the wax. Indeed, the wooden support can hardly contain the composition, which seems ready to burst its boundaries. In this it anticipates *The Gates of Hell* (p. 46, fig. 5), which began in Rodin's mind as a series of discrete, contained, relief vignettes but which burst instead into boundless space.

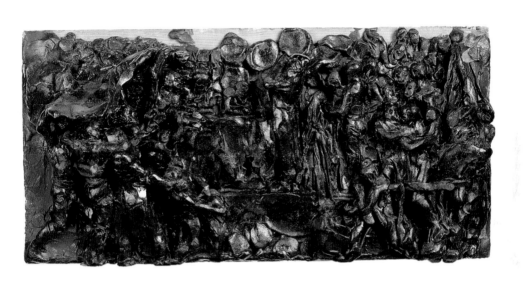

12. Auguste Rodin
The Call to Arms
1879
Bronze, height 43 ½" (110.5 cm)
Signed: A. Rodin
Foundry mark: ALEXIS RUDIER / Fondeur. PARIS.
Rodin Museum, Philadelphia. Bequest of Jules
E. Mastbaum. F1929-7-17
Tancock 1976, no. 66

Many sculptors in France during the Second Em-
pire (1852–70) and Third Republic (est. 1870)
depended for their livelihoods and reputations on
winning public competitions for the design of
monuments for the parks and squares of Paris and
other French cities. Decisions were most often
made on the basis of maquettes, which the artists
submitted to panels of judges that were often highly
conservative. With rare exception, in Rodin's day
monumental public sculpture was not a field for
innovation but for the replication of increasingly
banal sculptural formulas. Rodin himself often
entered such competitions early in his career, but
with little success. Later, he received several im-
portant commissions for public monuments, but
his proposals were so distinctive and unexpected
that they usually ended up embroiled in contro-
versy.

This dramatic figure group, known as *The Call
to Arms*, was Rodin's submission to an important
competition called by the Conseil Municipal of
Paris in 1879 for a monument commemorating the
courage of Parisians in defending their city during
the Franco-Prussian War in 1870. It was to be
erected at the rond-point de Courbevoie, to the
west of the city at what is now La Défense. The
eventual winner was Louis-Ernest Barrias; Rodin's
entry was eliminated quickly, although he had scru-
pulously followed competition guidelines calling
for two figures. Even so, it was among the most
vital works of his career thus far. He sculpted an
allegorical figure wearing a Phrygian cap, the Ge-
nius of Liberty, who with arms outstretched hurls
her defiance against the enemy. Leaning against her
is the nude body of a dying warrior, a broken sword
still clutched in his left hand.

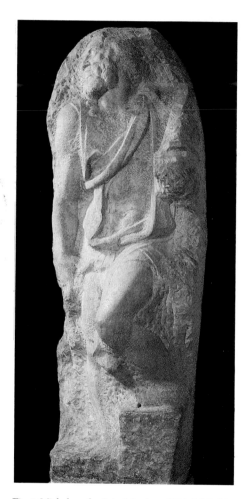

Fig. 1. Michelangelo, *Saint Matthew*, 1504–8. Marble,
height 106 ¾" (271.1 cm). Accademia, Florence

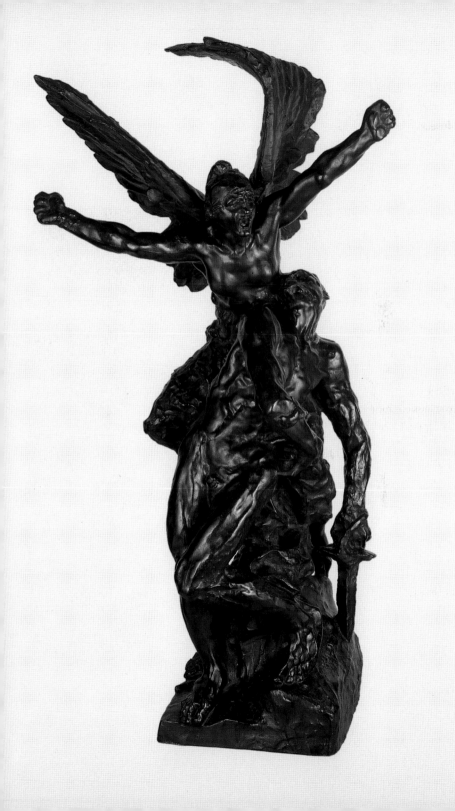

The group twists tautly upward, presenting the viewer with a series of dynamic profiles. Full of raw, nervous energy, the group is roughly modeled, with deep indentations establishing Liberty's eyes and yelling mouth and almost no articulation for the head of the warrior. The open mouth of Liberty immediately recalls François Rude's *La Marseillaise* on the Arc de Triomphe. At the same time, Michelangelo is a shaping presence in the work. The dying warrior, head bent back sharply, left knee jutting forward, strongly recalls not only the unfinished *Saint Matthew* of 1504–8 (fig. 1), but also the Christ of the *Pietà* in the Duomo in Florence. Here, Rodin moved decisively beyond the conventions of beauty, calling on his knowledge of Michelangelo in order to depict with new intensity the interplay of pathos and power.

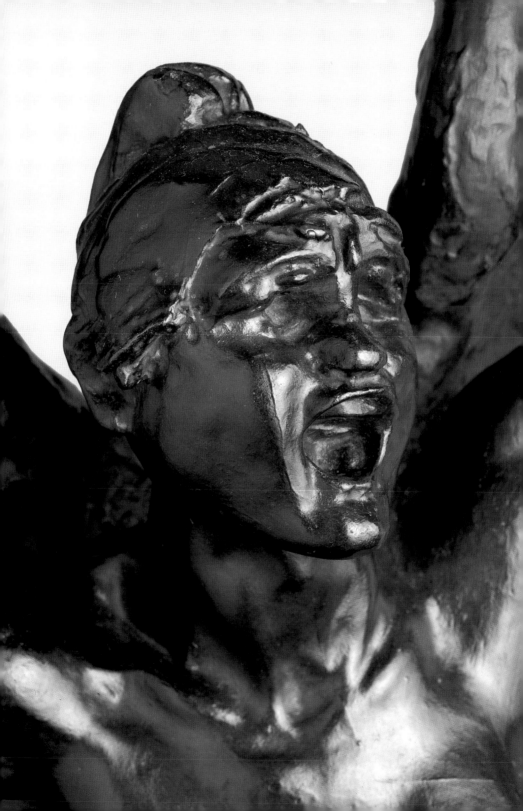

13. Auguste Rodin
Bellona
1879
Bronze on a marble base, height 30 ¹/₂" (77.5 cm)
Signed: A. RODIN
Foundry mark: ALEXIS RUDIER / FONDEUR PARIS.
Rodin Museum, Philadelphia. Bequest of Jules
E. Mastbaum. F1929-7-71
Tancock 1976, no. 107

Exhibited in Philadelphia only

In 1879, the year that his *Call to Arms* (no. 12)
failed to win a competition for a monument at La
Défense, Rodin lost another civic sculpture con-
test as well, this one for an allegorical bust of the
Republic for the *mairie*, or town hall, of Paris's
Thirteenth Arrondissement. It is easy to see why.
At a moment when France sought reconciliation
and peace, Rodin chose to represent the nation as
a fiercely belligerent woman warrior, dressed not
in the customary Phrygian cap but in a soldier's
helmet, twisting her massive neck to stare fero-
ciously at an approaching enemy. Almost immedi-
ately the figure received the title by which it is now
known, *Bellona*, the Roman goddess of war. The
model was Rodin's mistress, Rose Beuret, who also
had posed for the shrieking Genius of Liberty in
The Call to Arms. The work evokes a long tradi-
tion of representations of warrior women as well
as Michelangelo's intensely masculine female
figures of *Night* and *Dawn* from the Medici tombs
(see p. 40, figs. 3, 4) and the monumental Sibyls of
the Sistine ceiling (see no. 39). This beautiful cast
is remarkable for the richness of its polychrome
patination, which moves from black to brown to
green and plays off against the brilliant red of the
marble base from which this powerful head erupts.

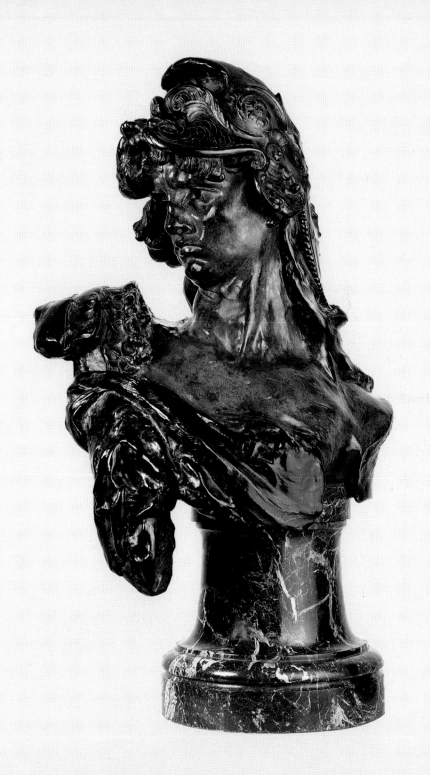

14. Auguste Rodin
Ugolino's Feast
c. 1870–80
Graphite, pen, and brown and black ink on
paper, 6 $^3/_{16}$ x 8 $^1/_{16}$" (15.7 x 20.5 cm)
Rodin Museum, Philadelphia. Bequest of Jules
E. Mastbaum. F1929-7-163

This sheet depicts one of the most horrifying stories told in Dante's *Inferno*, the account of the traitorous Count Ugolino of Pisa, who was himself
betrayed and locked in a tower to starve to death
with four of his sons. Frozen in the ice of the ninth
circle of Hell, Ugolino gnaws in rage at the skull
of his betrayer. Rodin had read Dante from his
youth, and he admired Jean-Baptiste Carpeaux's
great sculpture group *Ugolino*, shown at the Salon
of 1862.

This sheet, one of several so-called Dantesque
drawings, has been related to the *Gates of Hell*
commission, its frieze-like composition suitable for
one of the bas-relief panels that Rodin originally
intended for the project. A prolific draftsman,
Rodin kept his drawings around him, consulting
them even years after they were made. It has been
argued convincingly that many of these Dantesque
drawings may in fact predate the *Gates of Hell*
commission and that in 1880 Rodin reassessed
ideas he had sketched years before, in some cases
reinforcing the sheets (Varnedoe 1971, pp. 37–40).
Here, the nude figures are composed of rapidly
sketched circles and ovals. The facial features, also
simple circles and ovals, nonetheless reveal the
horror and terror of the onlookers. The expressive power of the figures is made more vivid by the
parallel pen strokes that establish shading—likely
a later reinforcement by Rodin. The figural density of the composition suggests that Rodin may
have been studying antique bas-reliefs.

110

15. Auguste Rodin
Study of Nudes with a Putto
c. 1880
Pen and black and brown ink on paper,
5 ⁷/₈ x 3 ³/₄" (14.9 x 9.5 cm)
Rodin Museum, Philadelphia. Bequest of Jules
E. Mastbaum. F1929-7-142

Beginning in 1864, Rodin was an assistant to the sculptor Albert-Ernest Carrier-Belleuse, who worked in an elegant and refined eighteenth-century mode. Several of Rodin's early independent sculptures were in a similar decorative vein. After returning to Paris from Brussels in 1877, Rodin again worked from time to time for Carrier-Belleuse, who was now the art director of the great French porcelain manufactory at Sèvres, responsible for the design of superbly refined and delicate porcelain *objets de luxe*. Thus, even as he struggled with some of his most ambitious sculptures, including *Adam* (no. 20), *The Shade* (no. 21), and other works deeply influenced by Michelangelo, Rodin also was called upon, and was able, to work in a diametrically opposed style. It was a mark of his versatility—and of his intensely practical training in sculpture—that he could turn from his own, broodingly Michelangelesque projects to graceful decorations, full of the intimate charm of the *ancien régime*.

This sheet derives from work done at Sèvres in preparation for the production of vases created there (see Varnedoe 1971, fig. 30). The principal motif is an embracing couple, attended by a joyous putto, who are caught in an exquisite love dance, limbs intertwined and smiling faces bent toward one another. This scene of Bacchanalian release is matched by the small line drawing at upper right, at right angles to the central figures, that shows a second dancing couple beneath a swag. At some point, Rodin strongly reinforced the outline of the principal male figure with a series of quick, dark strokes. This may have been in order to differentiate the ruddier male physique from the paler female body, a pictorial convention of the time. So vigorous and animated are the dark strokes, however, that they may show Rodin returning to the drawing at a later date to invest it with an intensity and tension more in keeping with his personal artistic inclinations.

113

16. Auguste Rodin
Satyr and Nymph
c. 1880
Pen and brown and black ink, and gouache over
graphite on paper, 4 $^{13}/_{16}$ x 3 $^{1}/_{2}$" (12.2 x 8.9 cm)
Rodin Museum, Philadelphia. Bequest of Jules
E. Mastbaum. F1929-7-167

Like *Centaur and Woman* (no. 26), this is one of
several drawings on mythological themes that
Rodin executed in the early 1880s. Frankly sexual
and often violent, these works are characterized
by angular drawing that delineates form, and by
the remarkable freedom with which washes of
gouache are applied over the drawn lines, accen-
tuating areas of the body that are undergoing par-
ticular stress or contortion. Here, the darkest ar-
eas are the chest of the satyr as he grasps the
nymph, and the nymph's back as she struggles to
free herself. While not related to specific sculp-
tures, the emotional pitch of such drawings ech-
oes the anguished intensity of figure groups such
as *Paolo and Francesca* that Rodin was creating
contemporaneously for *The Gates of Hell*.

17. Auguste Rodin
Maternity
c. 1880
Watercolor, ink, and gouache on paper,
6 $^1/_2$ x 5 $^1/_2$" (16.5 x 14 cm)
Rodin Museum, Philadelphia. Bequest of Jules
E. Mastbaum. F1929-7-165

Exhibited in Philadelphia only

This drawing is one of a group of studies by Rodin
known as the "black" gouache drawings. They date
from the early 1880s and are characterized by the
bold outlining of principal forms in ink and by the
use of dark gouache and spared paper to achieve
strong contrasts of light and shade. Like *Mater-
nity*, many of these drawings seem to have been
worked on in more than one campaign. Although
the mediums differ, the radical simplification of
form and the chiaroscuro effects achieved are not
unlike those of Rodin's earlier charcoal studies of
sculptures in the Medici Chapel (nos. 4–7). While
most of the black drawings turn on literary or alle-
gorical themes, and many are dark and sexually
violent, *Maternity* and *Mother and Two Children*
(no. 18) return to the traditional and pacific theme
of maternal tenderness, further suggesting the in-
fluence of Michelangelo. The theme of the Virgin
and Child was a constant in the art of Michelangelo,
one to which Rodin turned his attention when he
made his large drawing after *The Medici Madonna*
(no. 4). When he visited the Casa Buonarroti,
Rodin also would have seen Michelangelo's draw-
ing of *The Virgin and Child* (no. 44) and his marble
relief *The Madonna of the Stairs* (no. 18, fig. 1). In
all of these works, the animated, twisting body of
the baby is protected and controlled by the calm
authority of the mother. *Maternity* is a simpler
grouping of two figures, large and small: no longer
dependent upon a specific model, Rodin nonethe-
less retains a brooding intensity and sense of emo-
tional attachment that can be compared with that
of Michelangelo. Rodin would continue to explore
loving familial interaction in such sculptures as
Young Mother in the Grotto (no. 44, fig. 1) and
Brother and Sister.

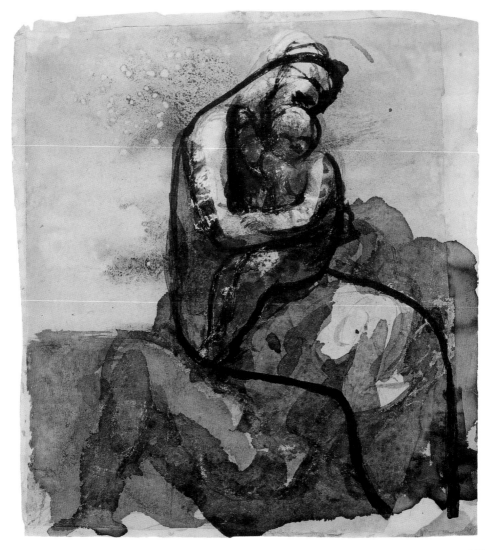

18. Auguste Rodin
Mother and Two Children
c. 1880
Pen and ink and gouache on paper, 7 $^1/_8$ x 5 $^1/_8$"
(18.1 x 13 cm)
Rodin Museum, Philadelphia. Bequest of Jules
E. Mastbaum. F1929-7-168

Exhibited in Philadelphia only

A seated female, seen in profile, holds a squirming infant on her lap while an older child clings to her from behind. The principal forms are loosely outlined in ink, while gouache imparts volume to the compressed figure group, and areas of spared paper establish the play of light across their forward arms and the woman's massive left thigh. The drawing is one of Rodin's so-called black gouaches. Often brooding, intensely worked, and radically simplified in form, these drawings have been related to Rodin's work on *The Gates of Hell* (p. 46, fig. 5), which was commissioned in 1880. Like the contemporary *Maternity* (no. 17), this sheet evokes the traditional theme of the Virgin and Child. Here, the large scale of the mother, the integration of the three bodies into one densely compact grouping, and the vivid sense of psychological interconnection recall the carved Madonnas of Michelangelo's early career. Specifically, the vertical format, in which the woman's head touches the very top of the sheet, and the figure's left-facing profile resemble Michelangelo's marble relief *The Madonna of the Stairs* (fig. 1), which Rodin would have seen at the Casa Buonarroti in Florence. There is no evidence that Rodin sketched the famous relief at the time of his 1876 visit to Italy. However, he had been trained in memorizing works of art, and this is only one of many occasions in which an echo of a Michelangelo composition emerged in Rodin's art, transformed, years after he had studied the original.

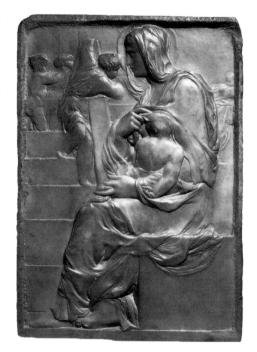

Fig. 1. Michelangelo, *The Madonna of the Stairs*, 1489–92. Marble, 21 $^3/_4$ x 15 $^3/_4$" (55.2 x 40 cm). Casa Buonarroti, Florence

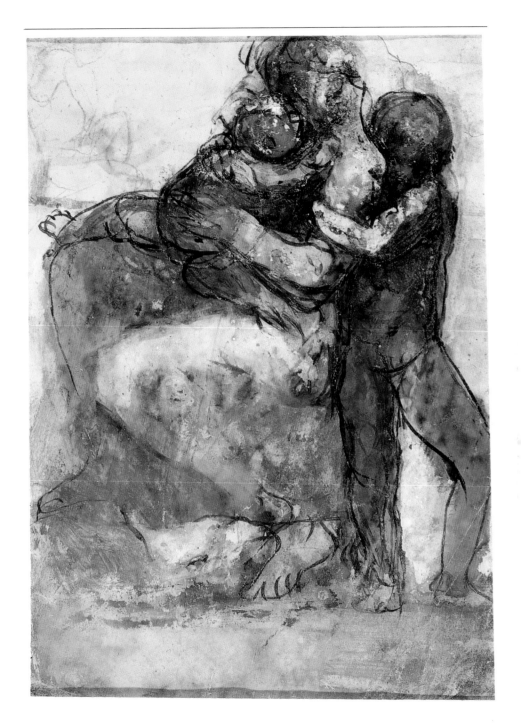

19. Auguste Rodin
The Thinker
1880
Bronze, height 27 ¹/₈" (68.9 cm)
Signed: A. Rodin
Foundry mark: ALEXIS RUDIER / Fondeur. PARIS
Rodin Museum, Philadelphia. Bequest of Jules
E. Mastbaum. F1929-7-15
Tancock 1976, no. 3a

Surely the most famous of all Rodin sculptures, *The Thinker* was conceived as the crowning element and focal point of the sculptor's magnum opus, *The Gates of Hell* (p. 46, fig. 5). Seated in the tympanum of the great doorway, this embodiment of thought dominates the composition. *The Thinker* was originally intended to represent the poet Dante devising his plan for *The Divine Comedy*, but that conception soon gave way to the more generalized nude figure without specific identification. The figure owes a debt to the *Belvedere Torso* (fig. 1) as well as to Michelangelo's *Jeremiah* (fig. 2), painted on the ceiling of the Sistine Chapel, and to his marble portrait of *Lorenzo de' Medici* (fig. 3) in the Medici Chapel in Florence. At the same time, Carpeaux's brooding *Ugolino* plays a significant role in shaping Rodin's conception of the art of Michelangelo. Like Carpeaux's *Ugolino*, Rodin's *Thinker* is involved in the process of intellection not only with his brain but with every strained muscle of his entire body. In Rodin's imagination, *The Thinker* soon took on a life of its own. Independent versions exist at twenty-seven inches high, as here, and at seventy-nine inches high, of which at least twenty bronze casts may be found worldwide, including one on Rodin's tomb at Meudon and another at the entrance to the Rodin Museum in Philadelphia (see p. 26, fig. 2).

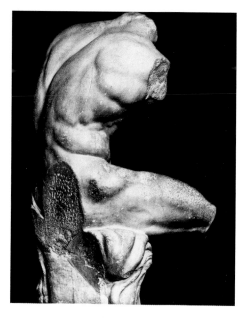

Fig. 1. Apollonius of Athens, *Belvedere Torso*, c. 150 B.C. Marble, height 62 ⁵/₈" (159 cm). Musei Vaticani, Vatican, Rome

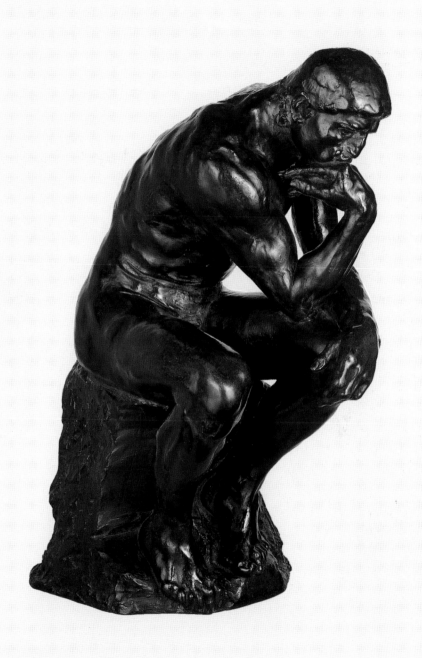

Fig. 2. Michelangelo, *Jeremiah* (detail from the
ceiling of the Sistine Chapel), c. 1510. Fresco.
Sistine Chapel, Vatican, Rome

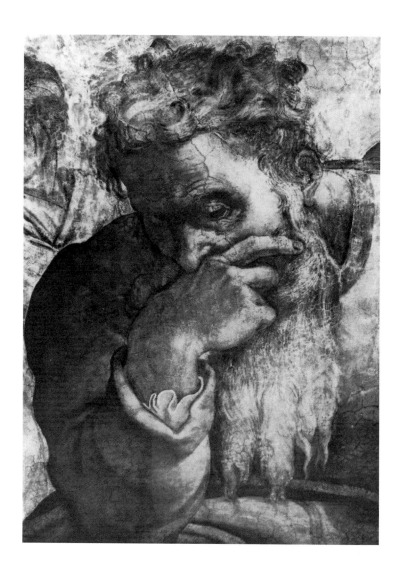

Fig. 3. Michelangelo, *Lorenzo de' Medici, Duke of Urbino* (detail of p. 40, fig. 4), 1520–34. Marble. Medici Chapel, Church of San Lorenzo, Florence

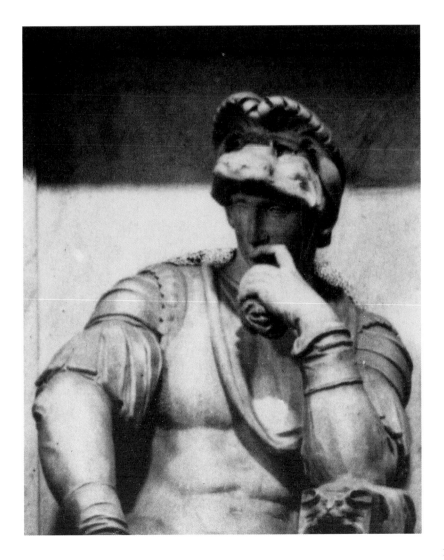

20. Auguste Rodin
Adam
1880
Bronze, height 75 ½" (191.8 cm)
Signed: RODIN
Foundry mark: ALEXIS RUDIER / Fondeur PARIS
Rodin Museum, Philadelphia. Bequest of Jules
E. Mastbaum. F1929-7-125
Tancock 1976, no. 4

Among the first works Rodin undertook upon his return from Italy in 1876 was a figure of Adam, which he later abandoned. The work was highly imitative of Michelangelo in style and represented Rodin's attempt to assimilate the impact of the Italian master. Four years later Rodin returned to the subject and, as critics immediately recognized when *Adam* was exhibited at the Salon of 1881, his debt to Michelangelo remained enormous. Around 1880, as Rodin moved further away from naturalism toward an expressive monumentality based on the human body, the Florentine's informing presence loomed ever larger. *Adam*, its companion *Eve* (no. 22), and *The Shade* (no. 21) are the primary evidence of the vital role that Michelangelo played in Rodin's imagination as he forged his individual style.

As often with Rodin, the physiognomy of his model was a direct spur to the form the sculpture would take. Here, the model was a circus strongman named Caillou, whose twisting pose and swelling musculature bespeak the bodily tension of the First Man awakening to consciousness. Of all the works by Michelangelo that Rodin saw in Italy, the figures in the Medici Chapel in Florence were those of which he spoke most passionately and from which he created some of his most dramatic drawings. Here the intense physicality of the figures of *Day* and *Night*, *Dawn* and *Dusk* (see p. 40, figs. 3, 4), informs the torsion of the heavily muscled figure, as does their somnolence. Also evident in the single extended finger of Adam's right hand is an allusion to the Adam of the Creation scene, painted on the Sistine ceiling, one finger extended to receive the touch of life. Indeed, when the plaster of *Adam* was shown at the Paris Salon of 1881,

Rodin titled it *The Creation of Man*. Finally, as Elsen has suggested, the left hand dropping like a plumb line straight down the front of the figure recalls the deadened limb of the Duomo *Pietà* in Florence (Elsen 1963, p. 49). "One does not analyze something on first seeing it," Rodin had written after first visiting the Medici Chapel in 1876 (Rodin 1985, p. 34). Now, four years later, the artist was capable of creatively selecting a range of impressions from Michelangelo's art, and of assimilating them to create his own, individualized, art.

Only as he worked on *Adam* did Rodin realize that it and a companion *Eve* (no. 22), on which he was also working, would make effective additions to *The Gates of Hell* (p. 46, fig. 5), the great commission based on Dante's *Inferno* that he had received in 1880. The two figures were intended to flank the doors, the ancestors whose fall from grace laid open the possibility of eternal damnation.

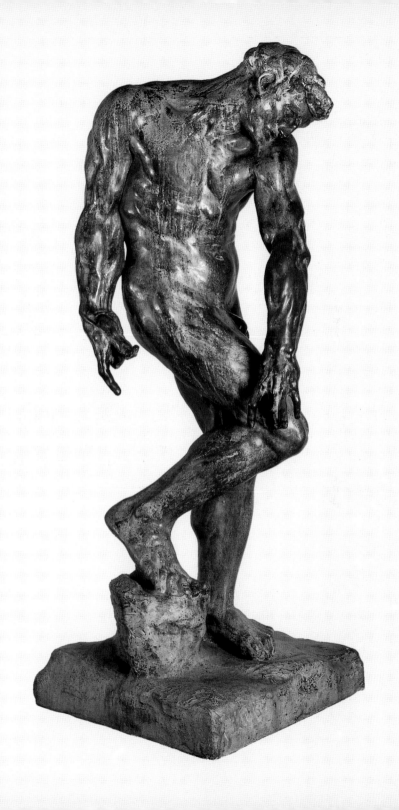

21. Auguste Rodin
The Shade
1880 (enlarged c. 1898)
Bronze, height 75 $^1/_2$" (191.8 cm)
Signed: A. Rodin
Foundry mark: ALEXIS RUDIER / Fondeur. PARIS
Rodin Museum, Philadelphia. Bequest of Jules
E. Mastbaum. F1929-7-124
Tancock 1976, no. 5

Less twisting and tense with movement than the
contemporary *Adam* (no. 20), this figure is more
blocklike and frontal, presenting an agitated pro-
file full of expressive exaggeration. The massive
upper body contrasts with the almost delicate curve
of the legs, emphasizing an impression that the
figure is sagging to the ground under its own
weight. Startlingly, the line formed by the right
shoulder and sharply turned neck is almost hori-
zontal, as gravity pulls the heavy head downwards.
The huge left arm drops too and yet seems, as if
with great effort, to begin to rise. The figure is
caught in some indeterminate state between sleep
(or death) and dim consciousness. Michelangelo's
Dying Slave (no. 3, fig. 1), which Rodin studied at
the Louvre, as well as the great nude figures of the
Medici tombs and the Pietàs, all inform the work.

At some point in the mid-1880s, Rodin decided
to incorporate not one but three identical casts of
this figure on the top of *The Gates of Hell* (p. 46,
fig. 5). There *The Three Shades* (fig. 1) represent
the souls of departed countrymen to whom Dante
speaks on his voyage. The three casts are seen from
the left, straight on, and from the right, each view
presenting a different, dramatic profile. Their down-
thrust left arms come together to point inexorably
to the drama of damnation unfolding below. Not
until about 1898 was the single figure of *The Shade*
enlarged to monumental scale, as seen here.

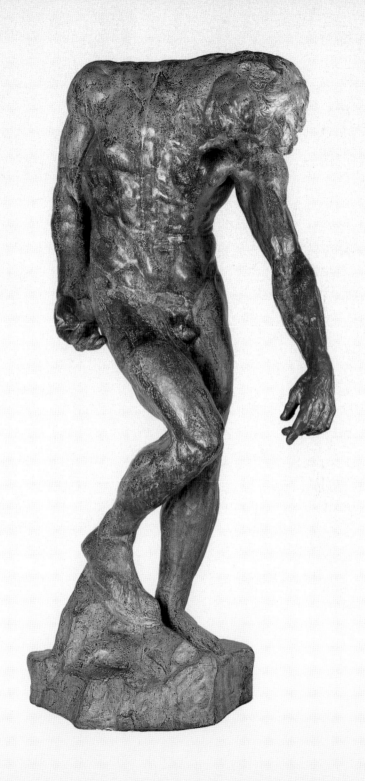

Fig. 1. Auguste Rodin, *The Three Shades*, c. 1886
(enlarged c. 1898). Bronze, height 75 ¹/₂" (191.8 cm).
Collection of the Iris and B. Gerald Cantor
Foundation, Los Angeles

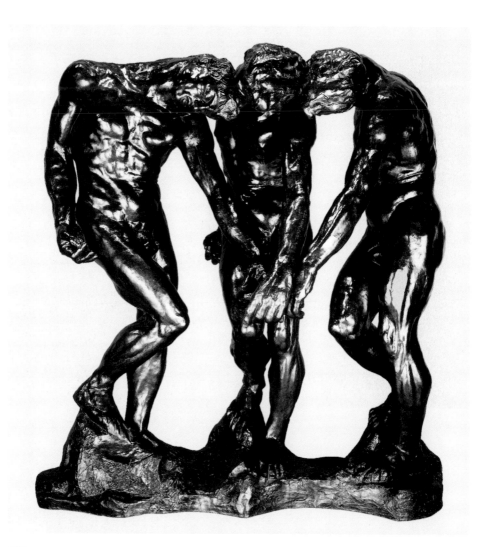

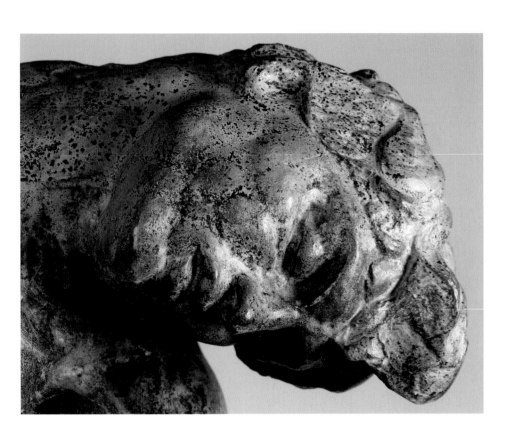

22. Auguste Rodin
Eve
1881
Bronze, height 67" (170.2 cm)
Signed: A. Rodin
Foundry mark: ALEXIS RUDIER / Fondeur Paris.
Rodin Museum, Philadelphia. Bequest of Jules
E. Mastbaum. F1929-7-127
Tancock 1976, no. 8

In 1880 Rodin determined to flank *The Gates of Hell* (p. 46, fig. 5), recently commissioned by the state, with colossal figures of Adam and Eve, and he successfully petitioned the government for an additional five thousand francs for each figure. Long before the posing sessions for *Eve* were finished, however, Rodin learned that his model was pregnant; she withdrew before the sessions had been completed, which may account for a certain generalization of the forms and for the rough, unfinished surface of some areas, notably the belly, whose changes Rodin had noted with curiosity before learning the cause. Whereas *Adam* (no. 20) twists tensely upward as he rises to consciousness, *Eve* sags toward the ground under the weight of her guilt, head held down in shame as she gathers her arms pitifully around her. As has often been noted, the abject pose is similar to that of Eve in Michelangelo's scene of *The Expulsion from Paradise* (fig. 1), painted on the ceiling of the Sistine Chapel. Although nudes were a fixture of academic sculpture, this is the earliest surviving life-size female nude in Rodin's work. He did not exhibit the figure as an independent sculpture until 1899, when, audaciously, he omitted a pedestal and placed it directly on the ground. This placement—an innovation with implications for modern sculpture—both reinforced the baseness of Eve's guilt and, in forcing the viewer to share space with the figure, emphasized the universality of her sin.

Fig. 1. Michelangelo, *The Expulsion from Paradise* (detail from the ceiling of the Sistine Chapel), 1509–10. Fresco. Sistine Chapel, Vatican, Rome

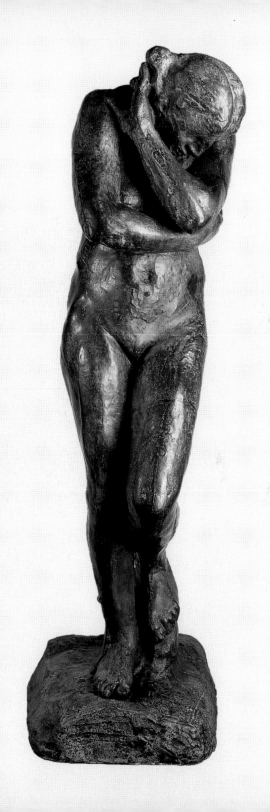

23. Auguste Rodin
Three Standing Men
c. 1880–82
Graphite, pen and brown ink, and brown wash
on paper, 5 x 3 ³/₄" (12.7 x 9.5 cm)
Rodin Museum, Philadelphia. Bequest of Jules
E. Mastbaum. F1929-7-164

Like *Ugolino's Feast* (no. 14), this drawing is likely
related to the 1880 commission for *The Gates of
Hell* (p. 46, fig. 5). The style is typical of nude stud-
ies from around that date, with the rapidly delin-
eated musculature of the male bodies accentuated,
in this case perhaps reinforced. Indeed, this
"flayed" style has been related to the *écorché* figures
of academic art training (Varnedoe 1971, p. 41).
While the subject matter of the drawing is uncer-
tain—the figures hold some indistinguishable ob-
ject—the grouping of three interwoven male nudes
anticipates *The Three Shades* (no. 21, fig. 1), which
Rodin invented by grouping three identical casts
of *The Shade* (no. 21) and placing them atop *The
Gates of Hell*.

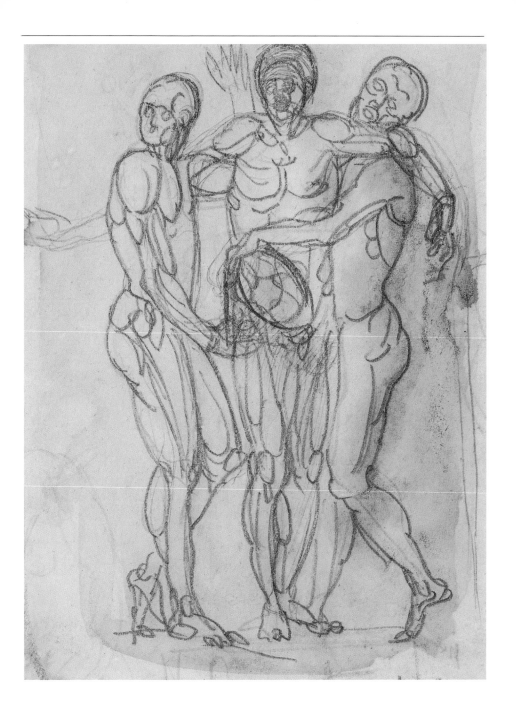

24. Auguste Rodin
The Crouching Woman
1880–82
Bronze, height 33" (83.8 cm)
Signed: A. Rodin
Foundry mark: ALEXIS RUDIER / FONDEUR. PARIS.
Rodin Museum, Philadelphia. Bequest of Jules
E. Mastbaum. F1929-7-70
Tancock 1976, no. 6

The model for this sculpture was Adèle Abruzzezzi, a favorite of Rodin's in the early 1880s, who would rest between sessions by squatting on the ground, unselfconsciously exposing herself to the viewer's direct gaze. Rodin regarded his best models as collaborators in whose natural poses and gestures he often saw his conceptions realized. In Adèle's crude posture he found a sculpture that is both complex and full of compact energy. At the same time, it may owe a debt to such works as the *Crouching Youth* in Saint Petersburg (fig. 1), attributed to Michelangelo, which Rodin would have known through a plaster cast on view in the Accademia in Florence. *The Crouching Woman* was originally conceived for *The Gates of Hell*, where it stands in the tympanum to the left of *The Thinker* (see p. 66, fig. 15). There, the muscular male, who symbolizes the life of the mind, contrasts with the rawly and blatantly sexual woman, seemingly without consciousness, who crouches to the earth, source of her inchoate fecundity. Later, Rodin combined this figure, nicknamed "the frog," with a work called *The Falling Man* to create another sculpture entitled *I Am Beautiful* (no. 25).

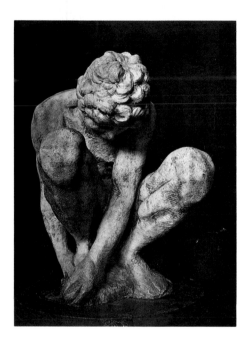

Fig. 1. Attributed to Michelangelo, *Crouching Youth*, 1520–34. Marble, height 21 1/4" (54 cm). The Hermitage Museum, Saint Petersburg

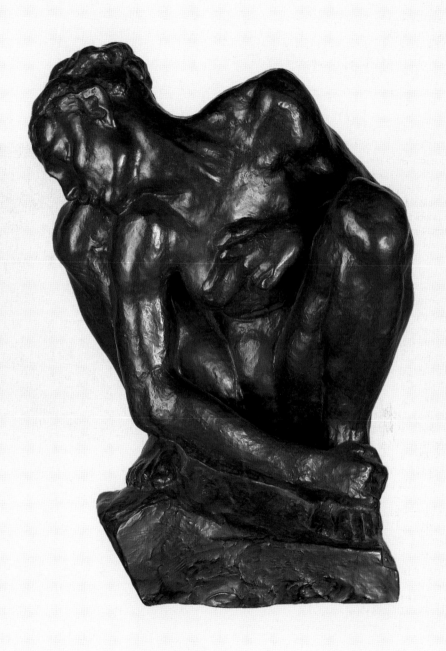

25. Auguste Rodin
I Am Beautiful
1882
Bronze, height 27 ³/₄" (70.5 cm)
Signed: A. Rodin
Foundry mark: ALEXIS RUDIER / FONDEUR. PARIS.
Rodin Museum, Philadelphia. Bequest of Jules
E. Mastbaum. F1929-7-6
Tancock 1976, no. 10

This extraordinary sculpture combines a version of *The Falling Man* with *The Crouching Woman* (no. 24) of 1881, two figures that Rodin had conceived independently for *The Gates of Hell* (p. 46, fig. 5). The combination involved certain small adjustments to their poses, notably the right arm of the female figure, which here hangs down rather than clasps its foot. The new group was then also incorporated into *The Gates of Hell*, in low relief, at the top of the right-hand pilaster. This process of combining seemingly unrelated figures to create new compositions was one of Rodin's most successful sculptural strategies as he worked on *The Gates*, allowing him to discover rich new possibilities in the repertory of human forms that he was developing. He then could give his inventions independent life as freestanding sculptures, incorporate them into the ongoing project of *The Gates*, or both.

On the front of the base of the sculpture, Rodin inscribed a verse by Charles Baudelaire about sexual passion and its rejection, which in translation reads: "I am beautiful as a dream of stone, but not maternal; / And my breast, where men are slain, none for his learning, / Is made to inspire in the Poet passions that, burning, / Are mute and carnal as matter and as eternal" (Charles Baudelaire, "Beauty," from *Flowers of Evil*, trans. in *Baudelaire, Rimbaud, Verlaine*, ed. Joseph M. Bernstein [New York: Citadel Press, 1947], p. 24).

Lifted into the air by the passionate man, the woman pulls herself into a coldly defensive posture in order to repel him. Rodin discovered a new range of meanings in the unselfconscious pose that his model adopted as she relaxed between sessions.

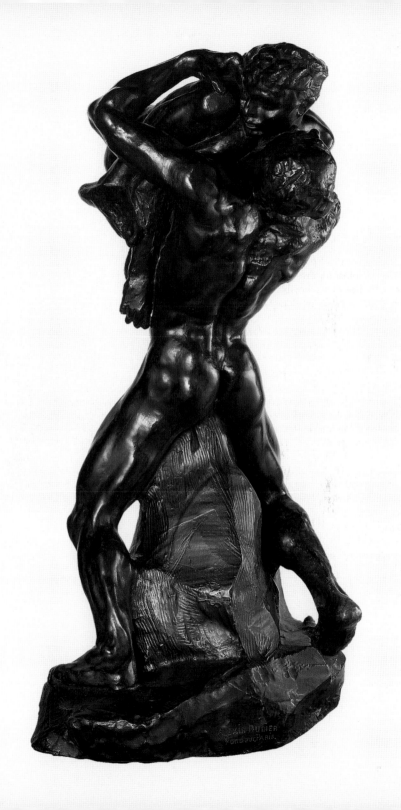

26. Auguste Rodin
Centaur and Woman
c. 1885
Pen and brown ink, brown wash, white gouache,
and graphite on paper, mounted on paper,
4 $^{13}/_{16}$ x 3 $^{1}/_{2}$" (12.2 x 8.9 cm)
Inscribed: l'aube retour du Sabbat
Rodin Museum, Philadelphia. Bequest of Jules
E. Mastbaum. F1929-7-166

During the early 1880s Rodin made numerous drawings, heavy with gouache, on literary and mythological themes. Dense and often dark, these sheets are full of violence and intimations of unbridled, animalistic lust. Here, a rearing centaur carries off a struggling woman whom he has cast across his back; it perhaps illustrates the wedding feast of the Lapiths and the Centaurs, or Nessus abducting Deianira, the wife of Hercules. The enigmatic inscription, "the dawn returns, the Sabbath," implies an allegorical significance. Rodin cut out the figures from one sheet and pasted them down on another, perhaps because he was dissatisfied with a larger composition, or perhaps to reinforce the angular intensity of the outline. While such *découpages* are more often associated with his later works, Rodin seems to have used the procedure from the mid-1880s to isolate and refine compositional motifs. Here the sense of rapid movement and contorted struggle is reinforced by several slashes of watercolor added to the support sheet above the head of the centaur. The drawing was included in *Les Dessins d'Auguste Rodin*, an influential album of reproductions published in Paris by the Maison Goupil in 1897.

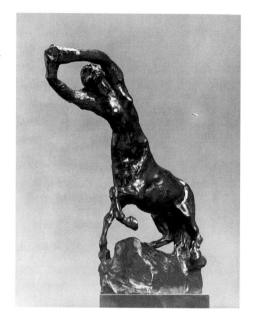

Fig. 1. Auguste Rodin, *The Centauress*, by 1887. Bronze, height 18 $^{1}/_{8}$" (46 cm). Rodin Museum, Philadelphia. Bequest of Jules E. Mastbaum

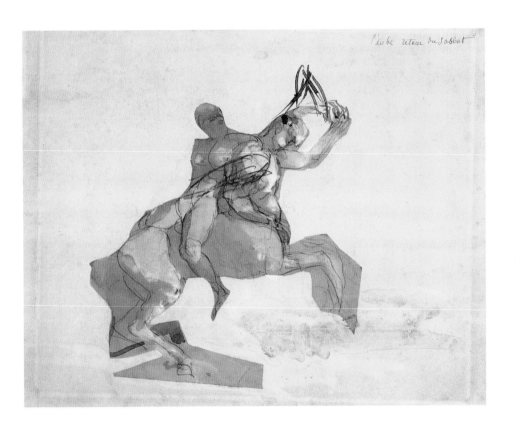

l'aube retour du Sabbat

27. Auguste Rodin
Illustrations for Charles Baudelaire's "Vingt-sept poèmes des fleurs du mal" (published 1888)
1886–88
Printed book illustrated with twenty-five collotypes, 7 $^3/_8$ x 4 $^7/_8$" (18.7 x 12.4 cm)
Rodin Museum, Philadelphia. Bequest of Jules E. Mastbaum. F1929-7-210

Charles Baudelaire (1821–1867) was one of Rodin's favorite poets. Baudelaire's sensuality, insight into human character, and eroticism—all congenial to Rodin's own personality—deeply infused much of the sculptor's work of the 1880s, not least *The Gates of Hell* (p. 46, fig. 5). In 1882 Rodin inscribed a verse from Baudelaire's "La Beauté" on the base of his sculpture group *I Am Beautiful* (no. 25), and also incorporated the group into *The Gates*. In later years, critics often compared the poet and sculptor.

In 1886 Rodin received a commission from the French publisher Gallimard to illustrate a selection of poems from Baudelaire's *Les fleurs du mal*; it was published two years later. Rodin created twenty-five images for the slim volume, six of them based on sculptures created in these same years. Rodin often reassessed earlier work in the light of new circumstances, and some of the drawings are variants or reworkings of earlier studies, including examples of the so-called Dantesque drawings. While the majority of the drawings are linear sketches that were drawn directly on the pages of the book (now in the Musée Rodin, Paris), three gouache drawings in the so-called dark style also were added to the volume. While the drawings only indirectly refer to the poems they accompany— rather than illustrating Baudelaire's words, the images establish a commonality of mood—as a whole, they constitute what Varnedoe has termed "a fitting summation of the drawings of the 1880's" (Varnedoe 1971, pp. 68–69).

The poem "L'Irrémédiable" and its accompanying gouache drawing are illustrated here. The poem is rich in imagery of titanic battles and the human fall into damnation. A Michelangelesque male nude slumps in a posture of guilt and despair

not unlike that of Rodin's *Eve* (no. 22), itself a variation of Michelangelo's depiction of *The Expulsion from Paradise*, painted on the Sistine ceiling. Rodin's drawings exerted a great influence on young artists around the turn of the century, less through exhibitions than by means of superbly crafted reproductions in volumes such as this that allowed for the wide dissemination of Rodin's graphic styles.

LXIV

L'IRRÉMÉDIABLE

—

Une Idée, une Forme, un Être
Parti de l'azur et tombé
Dans un Styx bourbeux et plombé
Où nul œil du Ciel ne pénètre ;

Un Ange, imprudent voyageur
Qu'a tenté l'amour du difforme,
Au fond d'un cauchemar énorme
Se débattant comme un nageur.

28. Auguste Rodin
Head of a Man
c. 1890
Graphite on paper, 6 $^{15}/_{16}$ x 4 $^{3}/_{8}$"
(17.6 x 11.1 cm)
Signed: AR
Rodin Museum, Philadelphia. Bequest of Jules
E. Mastbaum. F1929-7-145

In 1884 Rodin received a commission from the city of Calais to design a monument to the five burghers of the city who in 1347 had saved it from siege by the English by offering themselves as hostages. One of Rodin's greatest achievements in sculpture, *The Burghers of Calais* depends for much of its power on the intensity of expression on the faces of the men as they march out of the city to meet their fate (see fig. 1). The viewer "reads" mingled anguish, fear, pride, and courage in the set of a chin, the turn of a head, the haunted gaze of the eyes. Until he completed the monument in 1895, Rodin struggled to understand the expressive potential of the human face, and the ways in which it registers strong emotion. While this remarkably straightforward and immediate drawing of an upturned face is not a direct study for *The Burghers*, it is contemporary with the project and demonstrates Rodin's intense absorption in the physiognomy of the face. The nostrils, the line of the nose, and the left cheek are darkly shaded with bold hatching lines, suggesting that Rodin was looking at the figure from below, with light falling from the upper right. Whether Rodin was sketching from a model or from a sculpture is not clear. The large, empty eyes express a sense of dread or awe, as if the figure were staring at an apparition, while the drawing's dramatic frontality invests the head with hieratic severity.

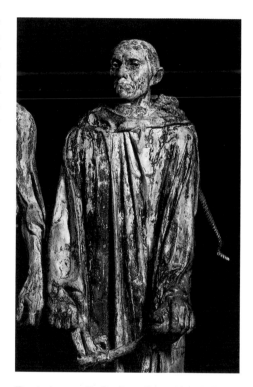

Fig. 1. Auguste Rodin, *Jean d'Aire* (detail of *The Burghers of Calais*), 1884–95. Bronze. Rodin Museum, Philadelphia. Bequest of Jules E. Mastbaum

29. Auguste Rodin
Profiles of a Cornice
c. 1900
Pen and brown ink and gouache on paper,
8 $^{11}/_{16}$ x 7 $^{1}/_{16}$" (22.1 x 17.9 cm)
Musée Rodin, Paris. D.3397

Exhibited in Philadelphia only

Unlike Michelangelo, Rodin was not a practicing architect. Trained as an ornamental sculptor, however, he was experienced at working with architects and realizing the subtlest details of a building's decor. His most important sculptural achievement, *The Gates of Hell* (p. 46, fig. 5), is an architectonic structure that establishes and audaciously maintains tension between rectilinear architectural elements and the writhing human forms that threaten to submerge them. Although at several points the figures break through the aedicular form of *The Gates*, the strongly accentuated profiles of its cornice, moldings, and other framing members ultimately control and contain the incipient chaos.

Late in life Rodin was able to investigate, both in writing and in drawing, his longstanding fascination with architecture, especially French Gothic and Renaissance architecture. He sketched individual buildings (see no. 32) and filled hundreds of sheets with studies of the most refined and complex architectural details. Although the model for the cornice depicted here is not known, its form is essentially classical, if somewhat attenuated in proportion, and it likely dates from the sixteenth century. At the center of the vertical sheet is a lightly sketched profile of the cornice; to the right is a parallel sketch, with details added and the profile darkened in order to accentuate its principal rhythms. Shading establishes the plastic volume. The resulting composition vibrates with energy and an abstract graphic intelligence that recalls Michelangelo's similar investigations of architectural details, such as his study of pilaster bases for the Medici Chapel (no. 40).

145

30. Auguste Rodin
The Athlete (First Version)
1901–4
Bronze, height 15 ³/₄" (40 cm)
Signed: A. Rodin
Philadelphia Museum of Art. The Samuel S.
White 3rd and Vera White Collection. 1967-30-73
Tancock 1976, fig. 57-2

31. Auguste Rodin
The Athlete (Second Version)
1901–4
Bronze, height 16 ⁷/₈" (42.9 cm)
Signed: A. Rodin
Foundry mark: Alexis RUDIER. / Fondeur. PARIS.
Rodin Museum, Philadelphia. Bequest of Jules
E. Mastbaum. F1929-7-4
Tancock 1976, no. 57

The model for both versions of *The Athlete*, some-
times known as *The American Athlete*, was a young
man from Philadelphia named Samuel Stockton
White 3rd, a gymnast and award-winning body-
builder. Justly proud of his physique, White pre-
sented himself to Rodin in 1901, offering his ser-
vices as a model. When the sculptor, who enjoyed
the spontaneity of amateur models, asked the
Princeton- and Cambridge-educated White to as-
sume a pose, the eager youth seated himself as *The
Thinker* (see no. 19). Rodin suggested that he adopt
a less self-conscious pose, and two closely related
small-scale sculptures resulted from the sittings that
began in 1901 and continued when White returned
to Paris in 1904.

Rodin presented this cast of the first version to
White himself, who in turn bequeathed it to the
Philadelphia Museum of Art. In 1926 a cast of the
second version was acquired by Jules Mastbaum,
founder of the Rodin Museum in Philadelphia, and
today both casts are displayed there, facing one
another. In this configuration, they subtly evoke
Michelangelo's marble sculptures of Giuliano and
Lorenzo de' Medici (figs. 1, 2), which stand oppo-
site one another in the Medici Chapel in Florence.
More than any other works, the Medici tombs
impressed Rodin on his visit to Florence. In both
versions of *The Athlete*, the legs are spread and
the figure leans slightly forward, his powerful right

arm resting on his thigh. In the first version, the
model looks slightly downward, his head cocked
tentatively as if listening to Rodin's conversation;
though no pensive finger is raised to lip, the posi-
tion of the head recalls that of Lorenzo. In the
better-known second version, the figure turns his
head abruptly to the right, as if his attention had
been caught by something across the room, just as
Giuliano turns his head sharply to the left.

146

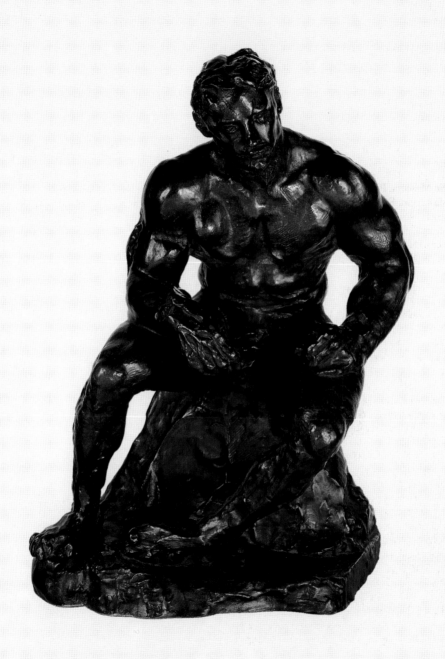

Fig. 1. Michelangelo, *Giuliano de' Medici, Duke of Nemours* (detail of p. 40, fig. 3), 1520–34. Marble. Medici Chapel, Church of San Lorenzo, Florence

Fig. 2. Michelangelo, *Lorenzo de' Medici, Duke of Urbino* (detail of p. 40, fig. 4), 1520–34. Marble. Medici Chapel, Church of San Lorenzo, Florence

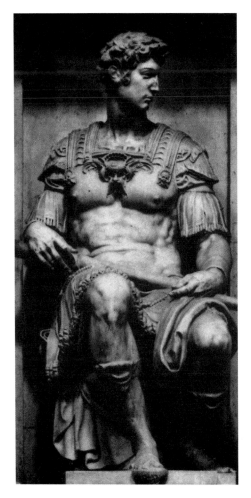

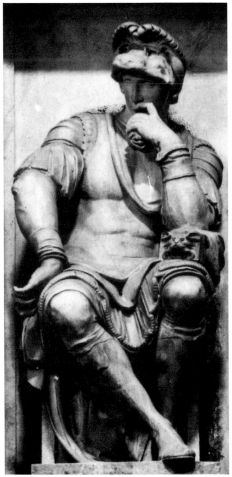

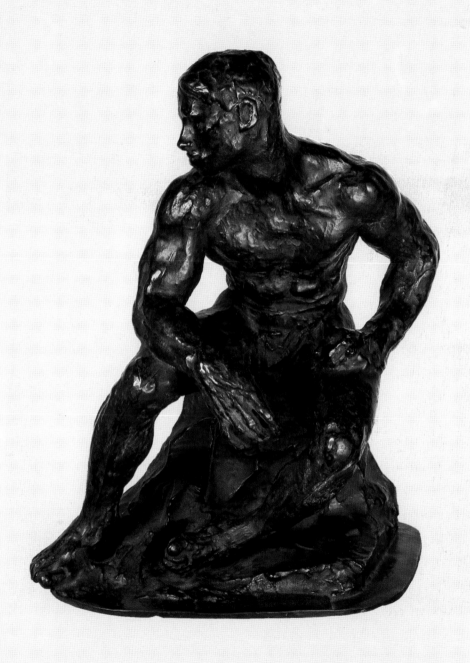

32. Auguste Rodin
Architectural Drawing (Facade of a Palace)
c. 1905
Pen and black ink on paper, 7 $^1/_8$ x 8 $^{15}/_{16}$"
(18.1 x 22.7 cm)
Signed: AR
Rodin Museum, Philadelphia. Bequest of Jules
E. Mastbaum. F1929-7-179

Rodin was fascinated by the interpenetration of
seemingly antithetical artistic styles, seeing the
blend as lively and full of character. He viewed the
Renaissance as the mingling of pagan rationalism
and Christian spirituality, late in life characteriz-
ing Michelangelo himself as "the result of all
Gothic thought" (Rodin 1984, p. 92). Rodin was
also passionately interested in the history of French
architecture. He loved the Gothic period at its most
flamboyant, and even as he headed to Italy in 1876
he stopped to admire Reims Cathedral. More un-
usual for the day, he also was passionate about the
architecture of the sixteenth century, when French
Gothic forms intermingled in a highly original
manner with the more regular classical forms,
based on antiquity, that were being imported from
Italy. Much of Rodin's leisure time over many years
was spent sketching the architecture of these peri-
ods, often paying particular attention to less well-
known examples (Geissbuhler 1971, pp. 141–56).

The subject of this drawing seems to be a large
château of the sixteenth century, like Chambord
or Chenonceaux in the Loire valley. Such build-
ings are characterized by the classically regular
alignment of fenestration, both horizontally and
vertically, and by the still-medieval use of turrets
to animate the skyline. Here, Rodin's hand moves
rapidly across the page, jotting down small ink
notations, almost like shorthand, that establish the
principal vertical and horizontal elements of the
facade. As schematic as the flickering style may be,
Rodin nonetheless manages to evoke the structural
logic of the building.

33. Auguste Rodin
Les Cathédrales de France
c. 1910–14
Emended proofs for one hundred thirty-six
lithographic facsimiles of drawings, with
retouchings in graphite, 12 $^7/_8$ x 9 $^7/_{16}$"
(32.7 x 24 cm) each
Rodin Museum, Philadelphia. Bequest of Jules
E. Mastbaum. F1929-7-211

The only book that Rodin published during his
lifetime was a volume devoted to French architecture,
particularly the great Gothic cathedrals. It
appeared in 1914 under the title of *Les Cathédrales
de France* and included the sculptor's thoughts on
the the beauties of French medieval architecture,
as well as reproductions of drawings that he had
made in situ as he traveled through France around
1910 and 1911, preparing the volume. These in-
cluded facade elevations, turrets and towers, and
numerous profiles of columns and cornices, some
of which achieved an almost abstract, geometric
quality that was at the same time lively and full of
the distinctive nervous energy of the artist's figure
drawings (see Geissbuhler 1966, pp. 22–29).

Rodin lavished great attention on the produc-
tion of the book. The Philadelphia volume con-
tains trial proofs of 136 lithographic facsimiles of
Rodin's illustrations, attesting to the high quality
of reproductive printing early in the century. They
are printed on the *vieux Japon* paper that was re-
served for a special limited edition of the book.
All the sheets are signed or initialed by the artist,
indicating his approval, and in several cases (in-
cluding the sheet illustrated here), the artist has
made his corrections in pencil. Often hard to see,
these subtle markings guided the printers in their
work.

34. Daniele da Volterra
Italian, c. 1509–1566
Portrait of Michelangelo
1564–66
Bronze, height 23 ⁵/₈" (60 cm)
Casa Buonarroti, Florence. Inv. 61

When Rodin's *Man with the Broken Nose* (see no. 2) appeared at the Paris Salon of 1878 in its third exhibition (but shown for the first time in its mask version, as originally conceived), the artist's contemporaries began to make comparisons between it and the portrait bust of Michelangelo by Daniele da Volterra. General comments such as those of Louis Ménard in *L'Art* ("a mask... that recalls the head of Michelangelo"; Ménard 1878, p. 277) were buttressed by the interpretation of Eugène Véron, who based his reading of Rodin's work entirely on this analogy: the "resemblance is provided by the nose, broken in Michelangelo's case by Torrigiano, and by the forehead and the features; there is thoughtfulness and nobility in the handsome head, and it is not without purpose when someone looks like a great man" (Véron 1879, pp. 813–14). A version of Daniele da Volterra's bust of Michelangelo (fig. 1), limited to the head and shirt collar (and thus closer to Rodin's mask), was exhibited during the same months of 1878 at the Trocadéro in Paris, in a vitrine at a retrospective of earlier art held on the occasion of the Exposition Universelle. Eugène Piot, owner of the work and promoter of the market for Renaissance art in Second Empire Paris, devoted a great deal of space to it in his review of the exhibition in the *Gazette des Beaux-Arts*: to him the head in question appeared to be the original bronze (and not the cast repeatedly mounted on an ill-fitting bust) of Michelangelo's self-portrait, which the artist's servant Antonio del Franzese discussed in a letter of 1570 to the Duke of Urbino. He praised its extreme realism ("certain parts, those that encircle the eyes for example, have a precision of detail and a delicacy of touch that leave not the slightest doubt that the living

model was present at the moment in which the portrait was executed"; Piot 1878, p. 598) and waged a polemical campaign on its behalf in the Italian press, which found it hard to discover Michelangelo's physiognomy in the work.

It was thus not difficult to establish a link between the *Portrait of Michelangelo* and the *Man with the Broken Nose* in 1878. Moreover, the like-

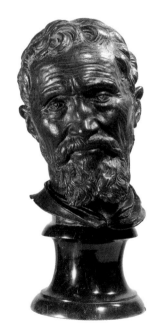

Fig. 1. Daniele da Volterra, *Portrait of Michelangelo*, 1564–66. Bronze, height 11 ¹³/₁₆" (30 cm). Musée du Louvre, Paris

Fig. 2. *Portrait of Michelangelo*, by Daniele da Volterra, and *Two Putti (Candle-bearing Genii)*, attributed to Donatello, from the *Gazette des Beaux-Arts* (Courajod 1890, p. 415)

ness of Michelangelo, with its broken nose, its weary, thoughtful expression, and short beard divided at the chin, was the striking image that in France accompanied the celebration marking the four hundredth anniversary of the artist's birth: both Daniele da Volterra's bust and Giulio Bonasone's profile portrait, engraved in 1545 and included in the 1746 Gori edition of Ascanio Condivi's *Vita di Michelagnolo Buonarroti* (Life of Michelangelo), were reproduced prominently in commemorative issues of the *Gazette des Beaux-Arts* and *L'Art*, the two most important art periodicals in France at the time. The bust, which had not been exhibited in the Michelangelo exhibition at the Accademia in Florence in 1875, could nonetheless be seen elsewhere in the city, at the Casa Buonarroti. Another example, with some variants in the drapery and beard (both attributed to Giambologna), was in the Bargello. It was from this version that the cast in the library of the École des Beaux-Arts in Paris was made (Müntz [1889], p. 134).

In France, however, the portrait by Daniele da Volterra had been known even earlier (in 1817 Stendhal had called it the most accurate portrait of the master; Stendhal 1854, p. 396), and in the 1860s it had visual currency even before word got out about the upcoming Michelangelo centenary. In April 1864, at the same moment that Rodin's plaster model of the broken-nosed workman for the mask of the *Man with the Broken Nose* was offered to (and refused by) the Salon of 1865, Eugène Piot put his collection up for sale, in which the bust by Daniele da Volterra, which had come from the Bolognese collection of Count Bianchetti, was prominent (with an asking price of ten thousand francs), although it went unsold. In the catalogue, Piot did not launch into speculations of attribution and, unlike what he was to write some fifteen years later, insisted not on the bust's realism but on its psychological fidelity, a rare opportunity offered to his contemporaries to gain insight into the thoughts of the great artist ("The gaze is steady... The overall expression of the physiognomy conveys a profound melancholy... Michelangelo's entire soul radiates over his countenance in this bronze, which is worthy of him in every way, as a portrait and as a work of art"; quoted partly from "Vente Piot" 1864, p. 140, and partly from Courajod 1890, pp. 413, 416). The following year, another example of the bronze portrait, from the Beurdeley collection, mounted on a larger portion of bust than the piece in the Piot collection, was shown in a highly publicized exhibition of works in private collections organized at the Palais des Champs-Elysées by the Union Centrale des Beaux-Arts Appliqués à l'Industrie. On this occasion, in a lengthy article, Paul Mantz, who published the first reproduction of the piece, dwelt on the impenetrable melancholy of the figure in the portrait. He attempted to interpret the work within the context of the tragedy of the artist: "Here we recognize the old master, saddened by his long struggle with the ideal. Here we find his violent and tender genius, whose whole life was an eternal solitude, and who, having every form of art and all its languages at his disposal, could not be consoled by the sense of his artistic power" (Mantz 1865, p. 330). In 1872 the work went to the collection of Maurice Cottier (Mantz 1872, p. 395) and after 1878, it entered the Musée Jacquemart-André, Paris (Moureye-Gavoty 1975, no. 141). Piot's version was bequeathed to the Louvre in 1890 (see fig. 2).

The direct derivation of the mask of the *Man with the Broken Nose* from the bust by Daniele da Volterra was maintained for the first time in 1953 by Joseph Gantner (who mistakenly assumed that in the 1860s the model was already in the Louvre; Gantner 1953, pp. 16–18, pls. 2, 3), and this opinion was immediately accepted ("[Rodin] merely created a hack job based on the famous portrait mask of Michelangelo"; Praz 1995, p. 438). Today this interpretation is generally rejected: John Tancock drew attention to various remarks by Judith Cladel (who for a long time was close to the artist), who proposed as points of reference an "ancient" Greek Shepherd and the plaster cast of *The Knife Grinder* in the Louvre (Tancock 1976, p. 473). Moreover, a drawing in the Musée Rodin, Paris (D.410), showing an antique profile bust has been provocatively compared by Goldscheider (Goldscheider 1989, p. 43) to the profile of the *Man with the Broken Nose*. In the catalogue of the

Fig. 3. Reproduction of *Profile Portrait of Michelangelo*, a 1545 engraving by Giulio Bonasone (Italian, c. 1510–after 1576), from *L'Art* (Ballu 1875, "Centenaire," p. 78)

Fig. 4. Auguste Rodin, *Man with the Broken Nose (Portrait of M. B. . . .)*, 1875. Marble, height 22 $^{13}/_{16}$" (58 cm). Musée Rodin, Paris

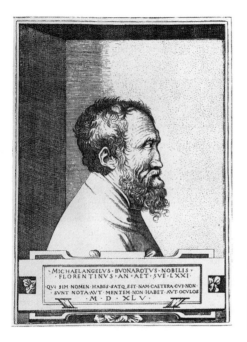

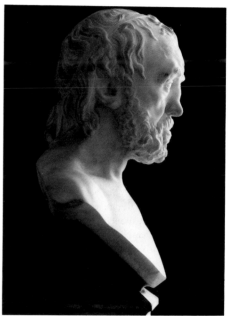

Paris exhibition devoted to copies made by nineteenth- and twentieth-century artists of works in the Louvre, the Rodin portrait was placed in the category of very free "hommages" (Paris 1993, *Copier*, p. 440). Ruth Butler has emphasized its similarity to the Hellenistic type of the "Blind Homer" (which is particularly close to Rodin's mask in its sorrowful expression and sunken face) and to a portrait of *Chrysippus* in the Louvre from which the mask's forehead wrinkles seem to be taken (Butler 1993, p. 45). Access to these works would have been easy: they were exhibited in the Louvre's archaeological collections, and a photograph of the *Chrysippus* has been found in the archives of the Musée Rodin. To these antecedents one can add, for the modeling of the locks of hair that fall over the temples, the *Pseudo-Seneca* represented by a marble copy in the Louvre (and sold as a plaster cast by the Atelier des Moulages; *Moulages* 1900, p. 19, no. 403), which was widely used in art schools as a model of an expressive head. The presence of Daniele da Volterra's portrait of Michelangelo on the Paris scene in the 1860s and the attention paid to it in critical discussions offer some explanation for the more obvious similarities with Rodin's mask (the hollow temples, jutting cheek bones, skin drooping over the cheeks, framing of the hair) on which Rodin superimposed the original touches that characterize the mask as a portrait of powerful facial individuality (the marked frontal asymmetry of the nose, forehead wrinkles, the full upper lip). Thus it is possible that Rodin, wishing to copy a model of antique beauty but thwarted by the fracture of the nose (as the artist himself recounts), made use of an image of a famous sculptor from the past who had suffered the same fate (the episode of the blow that the young Michelangelo received from his rival, the sculptor Pietro Torrigiani, had been retold in, among other sources, the new French edition of Michelangelo's poetic works; Lanneau Rolland 1860). The situation is appreciably altered when one considers the bust version of the *Man with the Broken Nose* (fig. 4). This work, shown for the first time in 1872 in Brussels (Beausire 1989, p. 61) in a plaster version with the title *Bust of M. B.* . . . (the initials relate to the nickname of the subject, called [Monsieur] "Bibi" in a letter of 1871 [Rodin 1985, p. 32] and "Bèbè" by T. H. Bartlett [Bartlett 1965, p. 20], and coincide, intentionally or not, with Michelangelo's initials), exhibits facial traits that are more symmetrical and, when seen in profile, appear curiously close to Giulio Bonasone's portrait of Michelangelo (fig. 3).

Today the bust in the Casa Buonarroti is generally considered (Cecchi 1994) to be a head by Daniele da Volterra mounted on a bust by Giambologna. It is surprising that no Florentine journalist noticed the resemblance between the *Portrait of Michelangelo* and the *Mask of the Man with the Broken Nose* when Rodin exhibited the sculpture (entitled *Bronze Head* and priced at four hundred francs) in Florence in 1880 at the international exhibition organized by the Società Donatello (Florence 1880, p. 21, no. 166), an event that has been overlooked by Rodin scholars.

35. Attributed to Michelangelo
Italian, 1475–1564
Male Figure
c. 1495
Wax, height 19 ⁵/₁₆" (49 cm)
Casa Buonarroti, Florence. Inv. 521

Exhibited in Florence only

Charles De Tolnay at first identified this wax figure with the model for Michelangelo's lost *Hercules* from Fontainebleau (De Tolnay 1964, pp. 134–35, figs. 2, 3) but later considered it a copy of a lost original dating from the period of the *Holy Family* (Doni Tondo) in the Uffizi in Florence (De Tolnay 1969, pp. 231–32). The piece, which for a long time had been thought to be a study for *David*, was very well known in the sixteenth century, so much so that it was frequently copied in drawings and cast into bronze statuettes, and it was depicted beside the master in an anonymous painting from the early seventeenth century (now in the Casa Buonarroti) that shows Michelangelo in his studio (Procacci 1965, pl. 122, and pp. 188, 194). In the nineteenth century, its fortune declined: no engraved or photographic reproductions were made of it, and the 1875 French edition of Angiolo Fabbrichesi's guide to the Casa Buonarroti describes the work, located in the fourth cabinet of the Study, with many errors (the missing arm is moved from right to left, and he mistakenly claimed the piece was made of terracotta; Fabbrichesi 1875, p. 21, no. 1). It was compared unfavorably to another figure of *David* in wax exhibited in the fifth cabinet in the same room (p. 22, no. 10), which is noteworthy for being the earliest conception for the colossal *David* that was to be erected in the Piazza della Signoria in Florence (now in the Accademia, Florence), and as such it was shown for the admiration of visitors to the Casa Buonarroti (in Louis Gonse's article for the Michelangelo quadricentennial, the "study for the David" is recognized with surprise among the "priceless pearls" in a museum that is "intimate and hardly equaled"; Gonse 1875, p. 384).

The only way Rodin could have known the work

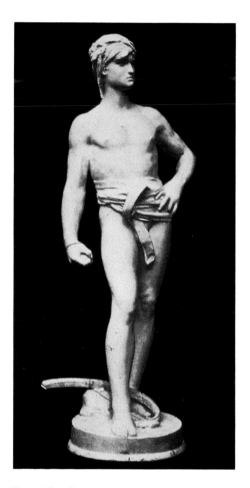

Fig. 1. The plaster version of Antonin Mercié's *David Preparing for Battle*, as shown at the Paris Salon of 1876

Fig. 2. Auguste Rodin, *Group of Three Figures*, c. 1895. Plaster, height 11 ⁵/₈" (29.5 cm). Rodin Museum, Philadelphia. Bequest of Jules E. Mastbaum

Fig. 3. Auguste Rodin, *Orpheus and Eurydice*, 1893. Marble, height 50" (127 cm). The Metroplitan Museum of Art, New York. Gift of Thomas F. Ryan, 1910

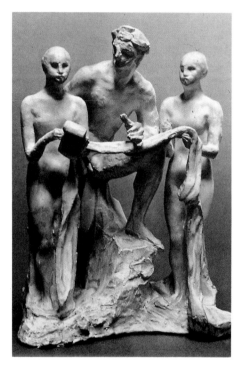

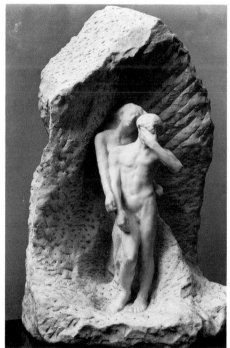

is if he had seen it in the galleries of the Casa Buonarroti, a possibility that is difficult to rule out given the barrage of publicity that the museum received in French publications on the quadricentennial. A trace of this statuette, or of other similar pieces, can be discerned in Rodin's work in the heads that are too large for their bodies, as in the figures in the tympanum of *The Gates of Hell* (see p. 46, fig. 5), where the problem of viewing the work from below may have suggested similar distortions. In addition, the quality of the modeling is reflected in some of Rodin's figures that date from the 1890s (*Group of Three Figures* [fig. 2]; *Woman Combing Her Hair* [Alexandre 1900, no. 21]; *Pomona*) in which the muscular tension appears on the surface without excessive relief or too-precise delineation, together with a somewhat muted softness that is diametrically opposed to the stylized anatomical exactness of the sculptural Florentinism of Antonin Mercíe (who, in his *David Preparing for Battle* [fig. 1], exhibited in the 1876 Paris Salon, echoed the model of Michelangelo) and to the work of Paul Dubois, a sculptor in vogue in France during the 1870s and 1880s. A passage by Judith Cladel from 1908 describes this particular quality of Rodin's modeling: unlike the "photographic crispness of modern statuary that tears out the inner structure, brutally, like a shock or an explosion," there are groups, particularly those of small size in which "the contours are complex and reveal themselves slowly," that cannot be separated from the environment that surrounds them by "dry delineations" but "live and vibrate with their own resonance" in this atmosphere (Cladel 1908, p. 9). Even more inspiring to Rodin, of course, would have been his encounter with the marble *David* in the Accademia in Florence. It was not, however, particularly favored by the French critics, who feared it still displayed characteristics of fifteenth-century naturalism (Guillaume 1876, p. 64) and accused it of having technical deficiencies: "The head is a little too large, and the whole figure does not hold together very well" (Ballu 1875, "Centenaire," p. 79); and "His *David* is ponderous" (Rousseau 1869, p. 454). The influence of *David* on Rodin is easily shown, for example, in the figure of Orpheus from Rodin's *Orpheus and Eurydice* (fig. 3)—a reworking of a group made as a study for his *Gates of Hell* (Beausire 1986, p. 99, fig. 112)—which was translated into marble as a single figure in 1894 with unfinished elements that are decidedly Michelangelesque. The echo of the colossal *David* was not limited to its pose: Rodin adopted similar proportions (even putting a gigantic head on an adolescent body) and attempted the same chiaroscuro resolution in the musculature.

36. Michelangelo
Male Nude Viewed from the Back
(Study for "The Battle of Cascina")
c. 1504–5
Pen and ink on paper, 16 $^{1}/_{16}$ x 11 $^{3}/_{16}$"
(40.8 x 28.4 cm)
Casa Buonarroti, Florence. Inv. 73 F

This drawing is a study for the central group of bathers in the fresco of *The Battle of Cascina*, intended for the Palazzo Vecchio in Florence but never completed: a sketch (Uffizi, 613E) for the composition of the fresco allows us to identify this figure with a fair degree of accuracy amid the group of nude males who are rushing toward the background in retreat on the left. In the later version, however, Michelangelo suppressed this figure, as is shown by the *grisaille* copy of the lost cartoon of *The Battle of Cascina* (Leicester collection, Holkham Hall, England). Johannes Wilde (Wilde 1932, pp. 41–45, figs. 1, 2) first recognized the derivation of this nude from a sarcophagus from late antiquity illustrated with the Labors of Hercules: the different musculature and profoundly altered proportions cannot support the hypothesis that the nude was copied directly from this model; rather, it must have been a free retranscription of an earlier sketch (Hirst 1988, p. 16, no. 5).

Despite its beauty, this drawing was almost entirely unknown in the nineteenth century: its spare abstraction did not connect it easily with the awesomeness of the Michelangelo of the *Moses* or the Sistine Chapel. Thus, it was not included in the selection of ten reproductions of works in the Casa Buonarroti for the *Album michelangiolesco dei disegni originali riprodotti in fotolitografia* that the Florentine publishing house Smorti issued for the quadricentennial of Michelangelo in 1875. Fabbrichesi's guide to the Galleria Buonarroti, in an edition that appeared the same year, made no mention of it. The drawing began to be known after the first Alinari photographic survey of the Casa Buonarroti in 1893. Entitled *Anatomical Study of the Nude*, the sheet was reproduced in thirty-by-

forty-centimeter format (Alinari 1893, n.p.). It is not without significance that Bernhard Berenson, in the early years of this century, during a period of worldwide reconsideration of Renaissance painting undertaken also in the light of research about modern artists (Degas and Cézanne turn up repeatedly in his discussion), drew attention to Michelangelo's youthful sheets of drawings like this one, in which the nude "had every time to be rediscovered and conquered once more," with the dangers "of timidity, almost of dryness," that this procedure involved (Berenson 1903, vol. 1, p. 177).

If we accept the hypothesis that Rodin visited the Casa Buonarroti in the early months of 1876, the *Male Nude*, with its supple muscular texture and its "lack of interest in the turning of the figure in space" (Hartt 1970, p. 28, no. 2), could have suggested something in the definition of the back of *The Age of Bronze* (fig. 1). Rodin's work—executed in Brussels according to the eyewitness account of Judith Cladel, during a period (from June 1875 to December 1876) that encompassed his trip to Italy (Cladel 1937, pp. 47–48)—is closely linked to his study of Michelangelo, particularly in paraphrase, on the front, of the Louvre *Dying Slave* (as has been observed beginning with Gantner 1953, pls. 4, 5), a sculpture that was much admired by French artists in the nineteenth century from Delacroix to Cézanne and studied particularly during the 1850s and 1860s (by Edgar Degas, Gustave Moreau, and above all, by Jean-Baptiste Carpeaux in various drawings; Paris 1993, *Copier*, p. 310, no. 207; p. 286, no. 190; p. 281, no. 185). On the back, Rodin, like the young Michelangelo, seemed obsessed with a musculature obtained through a synthetic chiaroscuro design, capable of

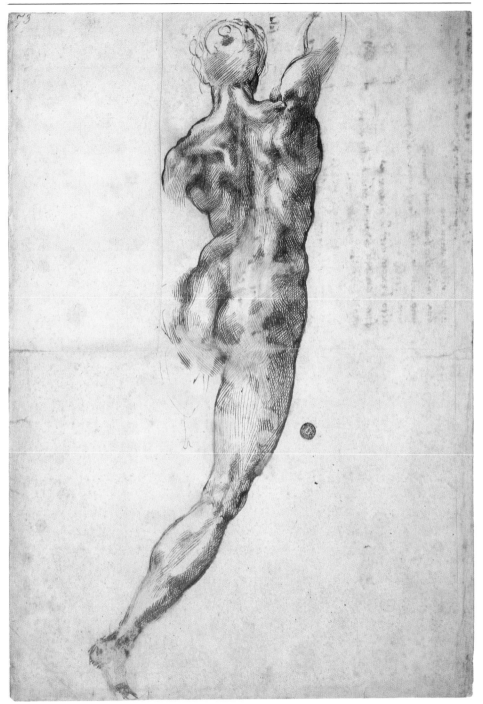

Fig. 1. Auguste Rodin, *The Age of Bronze* (no. 3, back view)

Fig. 2. Michelangelo, *Standing Male Nude Viewed from the Back*, c. 1501. Pen and ink on paper, 14 15/16 x 7 3/8" (37.9 x 18.7 cm). Graphische Sammlung Albertina, Vienna

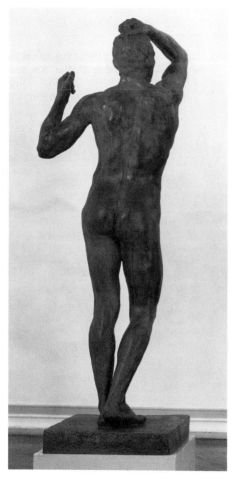

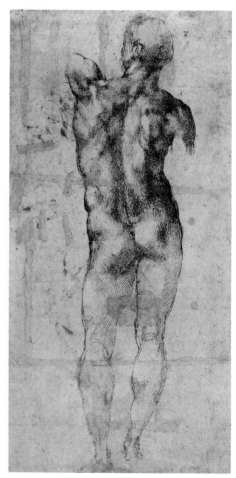

suggesting force and suppleness at the same time. A look so focused on the constructive mechanics of the body and capable of excluding from the observed work those various historic and literary values so dear to nineteenth-century taste should not be surprising in the French sculptor. In fact, we know from a statement Rodin made in 1904 that his voyage of 1876 through the museums of Italy was undertaken to clear up the problems that remained unresolved during his work on *The Age of Bronze*. Unfortunately, we have no direct record that would give us proof with regard to *The Dying Slave*, but Rodin's story about how he viewed an *Apollo* in the Naples museum is striking: "Whereas in surface everything seemed summary, in reality all the muscles were properly constructed, and the details could be distinguished individually" (Rodin 1906, p. 193). His attention was dominated by the remaining unresolved problems in the statue he began in Brussels and for some of them (how to render the muscular chiaroscuro without insisting too much on the figure's anatomy, for example), this drawing of the *Male Nude* could supply some very concrete answers. If the bridge between *The Age of Bronze* and Michelangelo's nude remains completely hypothetical and perhaps depends too much on a fleeting glimpse of the drawing in a crowded room in the Casa Buonarroti, another drawing (fig. 2), which is also a study for *The Battle of Cascina*, was more accessible because it had already been photographed (Braun 1877, p. 4, no. 33) and could have driven Rodin's work in the same direction. It is interesting, moreover, to try to relate *The Age of Bronze*, through the similar motif of the raised arm (which seems to be resting on a pole) and the overall pose of the body—especially

in its graphic transformation in *L'Art* in 1877 (vol. 3, part 2, p. 198)—to a Michelangelo drawing in the Louvre showing a male nude seen frontally (inv. 689 verso). It was shown in a photograph at the Florence quadricentennial exhibition (*Relazione* 1876, p. 217), exhibited (and therefore readily seen) in the galleries of the Louvre (Reiset 1878, p. 37, no. 111), and featured prominently in the monographic issue devoted to the four hundredth anniversary celebrations that the *Gazette des Beaux-Arts* published in January 1876 (Blanc 1876, p. 19).

37. Michelangelo
**Male Nudes and a Cornice (Studies for the
Ceiling of the Sistine Chapel)**
1508–9
Black chalk and charcoal on paper, with later
additions in pen and ink, 16 $^5/_{16}$ x 10 $^{11}/_{16}$"
(41.4 x 27.1 cm)
Casa Buonarroti, Florence. Inv. 75 F

This sheet, in which the overdrawings in pen are generally considered to be later and not in Michelangelo's hand, dates from the design phase of the frescoes of the Sistine Chapel ceiling. The figure sketches, including the large one occupying the upper half of the paper, are studies intended to fix the poses of the *Ignudi* (nude figures) that serve as framing devices at the corners of the compartments in the ceiling. Michelangelo had by then decided upon the basic scheme for the figures, although the individual poses still had to be worked out more fully. The order of the sketches thus allows us to follow the formation and evolution of the artistic concept in the draftsman's imagination. In one instance only was the studied pose transferred, with but a few changes, from the sheet to the completed fresco: in the little figure that is closest to the bottom at center ("where the contrappostural pose that offers an illusion of a more 'natural' simplicity is repeated and therefore individualizes the only element that could lend itself to be included in the fresco"; Barocchi 1962, p. 25), we can recognize the nude to the right of the prophet *Isaiah* in the Sistine ceiling. The cornice lightly sketched at the upper left was in all probability drawn first (Hirst 1988, p. 32, no. 11) and is connected to the studies showing the ceiling's architectural frame. Acorns—which allude to the della Rovere family, to which Pope Julius II, the ceiling's patron, belonged—are discernible in the frieze.

Like the previous sheet (no. 36), this one was not reproduced until the 1893 Alinari photographic survey of the Casa Buonarroti. Drawings of a similar nature, the so-called *pensieri* (thoughts) —small chalk figures that reveal the inventiveness of Michelangelo's creative process—which became particularly prized by twentieth-century sensibility, therefore have some relationship to the investigations of Rodin. A significant similarity in the design process can be noted in Rodin's studies of the model in Michelangelesque poses (no. 8), created immediately after his return from Italy. Particularly in the most summary figures—and beyond vague resemblances of pose—the search for the motif is conducted exclusively through outlines, which create tensions, torsions, and contrasts (see fig. 1). In this regard, Kirk Varnedoe emphasized how one of the two directions in Rodin's drawings may be characterized by a conceptual not a visual mode, producing series of sketches in which "the imaginative drawings begin as airless, shadowless delineations" (Varnedoe 1981, p. 153). This is not an obvious case of the direct influence of Michelangelo's drawings on Rodin; the analogy is

Fig. 1. Auguste Rodin, *Studies after Michelangelo* (no. 8, detail of D. 286)

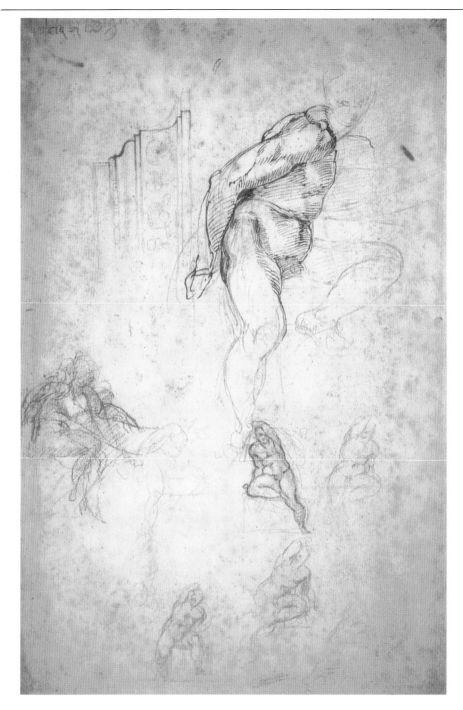

Fig. 2. Auguste Rodin, *Study for a Door with Eight Panels*, c. 1880. Pen and ink, charcoal, wash, and gouache on paper, 21 $^{15}/_{16}$ x 17 $^5/_8$" (55.7 x 44.7 cm). Musée Rodin, Paris

explained by Rodin's understanding of Michelangelo's conceptual process (in particular, the manner in which he first roughs out the pose as a study in contrasts and balances), which originated in his attention to the *sculptor* Michelangelo, who had a sometimes unacknowledged influence on nineteenth-century artists. In this sense Rodin's next step is even more interesting: the practice of studying the nude in Michelangelesque poses allowed him to use the model not only as an arena to verify anatomical or expressive details but also, thanks to the antinaturalistic and mannerist attitudes that this involved, to facilitate its codification as emblem. Thus, his reading of Michelangelo became indispensable when he began to alter the allegorical intent of *The Gates of Hell*. For example, in the fourth sketch for the architectural grouping (fig. 2)—a plan still dominated by the paradigm of Ghiberti's *Gates of Paradise* for the Baptistry in Florence—nudes are placed at the corners of the panels as they are in the compartments of the Sistine Chapel ceiling. The models drawn from life in 1876 in poses that recall those of the *Ignudi* in their artfulness have been transformed into types, so that they can be either multiplied or reduced within a complex decorative structure. We are similarly confronted with the same emblematic process of the reduction of the human body into a Michelangelesque pose in the repetition of the three *Shades* placed together on the upper cornice of *The Gates of Hell* (see p. 46, fig. 5).

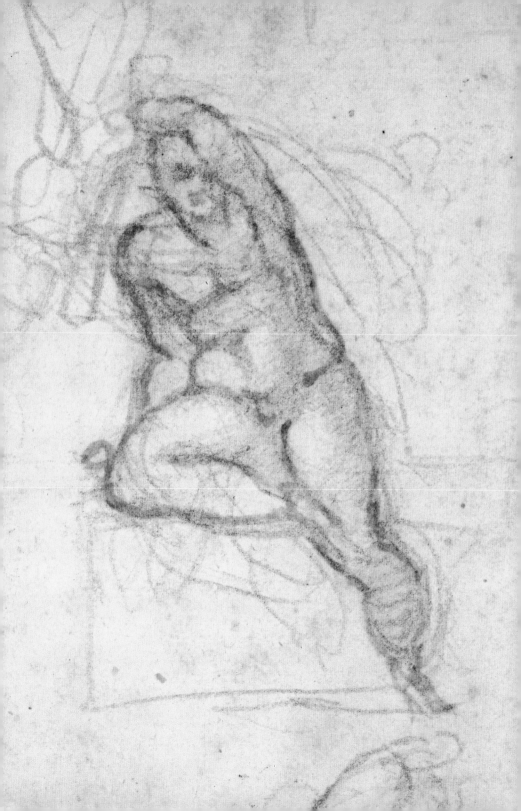

38. Michelangelo
**Two Nudes (Study for the Ceiling
of the Sistine Chapel)**
1508–9
Black chalk and charcoal on paper, 11 ⁷/₈ x 8 ³/₈"
(30.1 x 21.3 cm)
Casa Buonarroti, Florence. Inv. 33 F

This sheet shows two studies, each produced very differently, for the *Ignudi* on the Sistine Chapel ceiling. The larger figure above can be associated (Steinmann 1905, p. 595, no. 14) with the nude youth located to the upper left of the prophet *Daniel* (see fig. 1), which in the completed fresco, however, exhibits notable differences in the placement of the two arms and the inclination of the head. The second figure is not identifiable, executed as it is with lines that are so schematic that

they recall an area of development of Michelangelo's imagery that even predates the drawings known as the *pensieri* (thoughts). This drawing did not have visual dissemination in the nineteenth century, and its difficulty (for the upper nude, just a few charcoal strokes were used to capture the pose) has created a quandary for scholars in this century: Bernhard Berenson did not feel "competent to decide whether this kind of scrawl could have been done by M[ichelangelo]" (Berenson

Fig. 1. Reproduction after Michelangelo's *Ignudo* (detail from the ceiling of the Sistine Chapel), from the *Gazette de Beaux-Arts* (Mantz 1876, p. 129)

ÉTUDE DE CARIATIDE POUR LA SIXTINE.
(Croquis de la Casa Buonarroti).

Fig. 2. Drawing of a seated male nude, formerly attributed to Michelangelo, from the *Gazette des Beaux-Arts* (1876, p. 293)

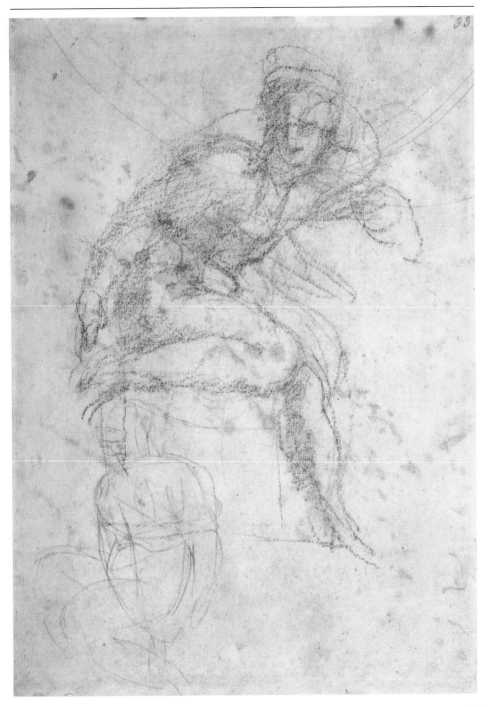

Fig. 3. Auguste Rodin, *Studies after Michelangelo* (no. 8 recto)

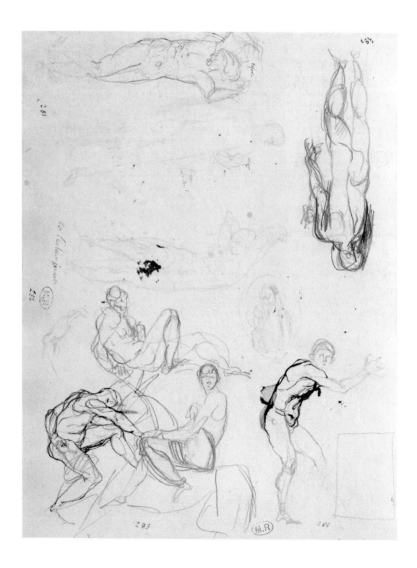

Fig. 4. Auguste Rodin, *Titans* (no. 9)

1938, vol. 2, p. 227), while Paola Barocchi recognized in it one of the more typical of Michelangelesque studies, "in which the artist roughs out the poetic idea with great vigor, without specifying details, thus implying in the confusion of the lines a multiplicity of possibilities for their outcome" (Barocchi 1962, p. 27).

Even if this drawing had caught Rodin's eye during his trip to Italy in 1876, it is frankly improbable that the artist would have isolated it and committed it to memory from among the hundreds of sheets exhibited in the Casa Buonarroti. The nude youths on the Sistine Chapel ceiling affected Rodin's imagination in a very significant way, however, particularly after his visit to the chapel in Rome and his return from Italy. Reminding himself of them was very easy: these were the details from the Sistine Chapel that were the most often reproduced in the publications that marked the quadricentennial of 1875 (see figs. 1, 2). Paul Mantz's article in the *Gazette des Beaux-Arts* devoted six illustrations to them, three of which were full page (Mantz 1876, pp. 119–59), and they were the figures that were most consistently reproduced from the entire ceiling in the major photographic catalogues (Alinari 1881, pp. 214–21; Brogi 1889, pp. 57–58). The photographic archive of the Musée Rodin in Paris (nos. 11868 and 11869) preserves photographs of two *Ignudi* (one to the left of *Jeremiah*, the other, to the right of the *Libyan Sibyl*) from the first compartment of the ceiling. These models soon entered Rodin's repertory. At first, the artist developed their poses graphically (see fig. 3); he then translated them into sculpture, transforming them into Titans, highlighting their contortions and muscular shapes, and using four of them (like

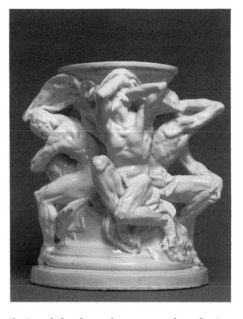

the *Ignudi* that frame the scenes on the ceiling) to form the *Titans* base (no. 9 and fig. 4), realized in ceramic by the Hautin, Boulenger & Co. factory at Choisy-le-Roi and signed by Rodin's employer, Albert-Ernest Carrier-Belleuse. Comparison with a contemporary and much-admired work based on the same prototypes, René de Saint-Marceaux's *Genius Guarding the Secret of the Tomb* of 1879 in the Louvre (Butler 1981, p. 41), demonstrates by contrast the disconcerting novelty of Rodin's procedure, totally devoted to searching out a new grammar for the representation of the body, one that did not turn back from the risks of exaggeration and rhetoric.

39. Michelangelo
Studies for the Libyan Sibyl
c. 1511
Red chalk on paper, 11 ³/₈ x 8 ⁷/₁₆" (28.9 x 21.4 cm)
The Metropolitan Museum of Art, New York.
Purchase, Joseph Pulitzer Bequest, 1924.
24.197.2

Exhibited in Philadelphia only

The recto of this sheet includes a series of studies from a fairly advanced phase (that is, when the pose had already been determined) for the *Libyan Sibyl* on the ceiling of the Sistine Chapel (fig. 1). In the fresco she is depicted placing the book of prophecy on a writing table behind her, while gazing in the direction of the altar of the chapel, from which the source of the light that illuminates her face comes. For the principal figure on the recto, Michelangelo posed and drew from life, as was his practice, a male model, from which he studied the complex *contrapposto* of the torso, the twist of the head, and the gesture of the arms. On the rest of the sheet, the artist elaborated a number of details: the face at the bottom left, with what Berenson described as a "Goethelike profile," transcribes in more abstract terms the features that in the larger figure had been copied realistically from the model; the other details (a new study of the left side of the torso, an outline of the forearm, a detail of the hand, and three of the foot) are, according to Frederick Hartt, "taken up by detailed analyses of the fulcra of the figure, on which colossal weights are brought to bear"; Hartt 1970, p. 84, no. 87). On the verso are three sketches in black chalk (fig. 2): two are related to the *Libyan Sibyl*; the third is a small figure, probably associated with the studies for the tomb of Julius II. During the past few decades, the principal studies of Michelangelo's drawings (Dussler 1959, p. 183, no. 339, fig. 39; De Tolnay 1975–80, vol. 1, no. 156 recto; Hirst 1988, p. 42, no. 16) have expressed no doubt in attributing the entire sequence on the recto of this sheet to Michelangelo, but in the past the small sketches surrounding the main figure have raised some questions. In an extensive pas-

sage written in 1938, Berenson examined the possible objections to Michelangelo's authorship of the entire page: there is no logic to the sequence of the sketches; the three-fold repetition of an already worked-out motif like the toes, is absurd; the width of the ear and the "overdone" shading of the torso are suspect. The conclusion that could be drawn from these ("It could be argued that the author of

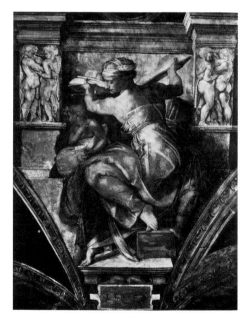

Fig. 1. Michelangelo, *Libyan Sibyl* (detail from the ceiling of the Sistine Chapel), 1509–10. Fresco. Sistine Chapel, Vatican, Rome

176

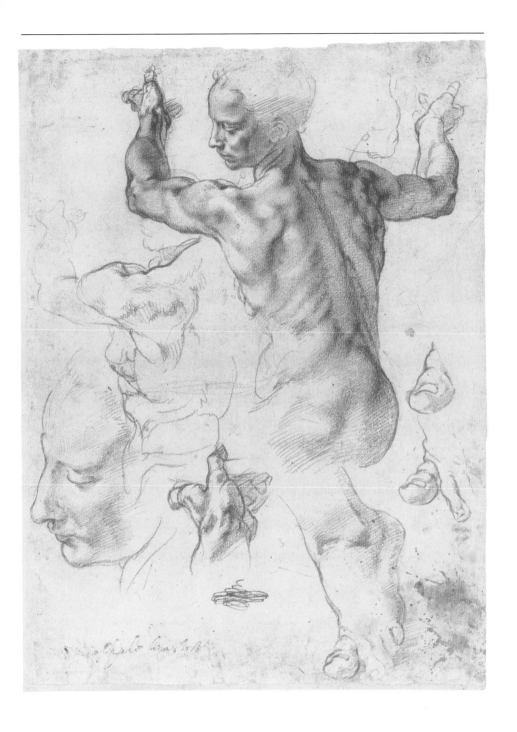

Fig. 2. Michelangelo, *Studies for the Libyan Sibyl*,
c. 1511. Black chalk on paper (no. 39 verso)

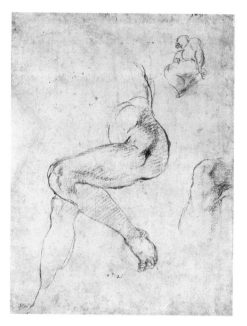

these studies was one of those contemporary copy-
ists or rather forgers who, picking up a sheet of
M[ichelangelo]'s with an empty side, took advan-
tage of it to fill it with brilliant imitations that would
sell as originals") was, however, overthrown by a
reasoning based upon what was in plain view, in-
volving more general considerations on the style
of the artist: "When I hold this leaf at a certain
distance from the eye I get a feeling that it is all by
M[ichelangelo] because it has his tactile values, his
line, his touch" (Berenson 1938, vol. 2, p. 195).

The drawing, unknown throughout the nine-
teenth century, was published for the first time in
1909, in a Braun photograph, in the catalogue of
Michelangelo's drawings by Karl Frey (Frey 1909–
11, pl. 4). At that time the drawing was in Madrid
in the collection of Aureliano de Beruete, a painter,
art historian, and collector of drawings and paint-
ings. The earlier history of the sheet is still shrouded
in mystery. Although the flourish in pen visible at
the lower center is not, as De Tolnay maintained,
the mark of the seventeenth-century collection of
Everhard Jabach (De Tolnay 1975–80, vol. 1, no.
156 recto: the Jabach seal traced on many of the
drawings by Michelangelo in the Louvre is in fact
easy to decipher, and far less elaborate), it is iden-
tical with the collector's mark that appears on a
number of the drawings from the collection of the
seventeenth-century Italian painter Carlo Maratta,
purchased in 1775 for the Academia de San
Fernando in Madrid from the widow of his stu-
dent Andrea Procaccini (Bédat 1968, pp. 413–15;
Pérez Sánchez 1978, p. 85). How this sheet made
its way into the possession of Beruete, whose heirs
sold it in 1924 to the Metropolitan Museum of Art
(Burroughs 1925), is not known.

Rodin, who died in 1917, could not have known the drawing itself during the years of his most intense passion for the work of Michelangelo. However, as early as the second half of the nineteenth century, early drawn copies of the sheet were widely known: one of those copies, done in the early seventeenth century and in the collection of the Uffizi, had been reproduced in an Alinari photograph as far back as the early 1870s (Alinari 1873, p. 99, no. 3681); another, owned by the grand dukes of Saxony, had been photographed by Braun (Braun 1887, p. 446, no. 107), and the photograph was in all likelihood displayed at the Michelangelo exhibition of 1875, one of the sixteen photographs that had been donated by the government of Saxe-Weimar to the Accademia of Florence (*Relazione* 1876, p. 217), where it might well have been seen by Rodin during his first Italian journey. As already observed concerning the connections between the nude study for *The Battle of Cascina* (no. 36) and *The Age of Bronze* (no. 3), the distinctive play of light and dark on the backs of large figures by Rodin from *Saint John the Baptist Preaching* (no. 10) to *The Kiss* could have been prompted by his study of Michelangelo's drawings dating from the artist's early period to that of the Sistine Chapel. Moreover, the particular characteristics of the drawing, which reveal Michelangelo's intent to study the way that physical force is expressed in all of the limbs, right down to the most minute joints (the toes, the spread of the hand), are reminiscent of a similar concern of Rodin, that of charging with expressivity every single detail of the body, a central theme of the critical treatment of the French sculptor, beginnning with the celebrated passage by Gustave Geffroy of 1889: "One might

well think that he was solely concerned with anatomical structure, with the positioning and placement of the muscles, the course of the veins, the texture of the skin, and in fact he was greatly concerned with all that. Yet, at the same time that he was devoting all his determination to that indispensable task, mastered by so few, he was obsessed by the idea of assembling all that scattered life in a summary of such power and such sharp clarity that a single glance would be sufficient to grasp the union of thought and temperament, an organism at rest or in action. . . . And it was thus that from the most scrupulous analysis there should emerge the greatest synthesis" (Geffroy 1889, pp. 63–64).

40. Michelangelo
Bases of Pilasters (Studies for the New Sacristy of San Lorenzo in Florence)
c. 1520–25
Red chalk and pen and ink on paper, 11 ¹/₈ x 8 ⁷/₁₆"
(28.3 x 21.4 cm)
Casa Buonarroti, Florence. Inv. 10 A

This sheet, which shows a fragmentary plan for the convent of San Lorenzo on its verso, presents three moldings of bases in the composite order that are unanimously considered studies for the pilasters of the New Sacristy of San Lorenzo (Medici Chapel) in Florence. In the study at lower right, Michelangelo amused himself by inserting an eye and lightly drawing a beard, thus playing with the anthropomorphic ambiguity of the profile. On the upper part of the sheet a famous inscription is written in Michelangelo's hand: "Night and Day are speaking and saying, We have with our swift course brought to death the Duke Giuliano; it is just that he take revenge upon us as he does, and the revenge is this: that we having slain him, he thus dead has taken the light from us and with closed eyes has fastened ours so that they may shine forth no more upon the earth. What would he have done with us then while he lived?" (translated in Hartt 1969, p. 173). In the text he staged an imaginary conversation between the two allegorical figures at the feet of the statue of Duke Giuliano (p. 40, fig. 3) upon the subject of death as victory (and dominion) over the inexorable cycle of time. According to Frederick Hartt, "these jottings were apparently intended to crystallize in the artist's mind portions of the allegorical structure [of the Medici Chapel] to which he was giving plastic embodiment" (Hartt 1969, p. 173).

These lines, transcribed by the nineteenth-century art historian Gaetano Milanesi, were published for the first time in a short and intense text by the Italian sculptor Giovanni Dupré on the Medici tombs, which was then collected in a commemorative volume brought out for the Michelangelo quadricentennial (*Ricordo* 1875, pp. 69–74)

and immediately translated into French by Albert Ballue for an issue of *L'Art* in 1875 (Dupré 1875). The wide circulation of the magazine, the reputation of the author (who at the time was the most famous Italian sculptor and a corresponding member of the École des Beaux-Arts in Paris), and the hint of dark tragedy in Michelangelo's words al-

Fig. 1. Frontispiece to the monographic 1876 issue of the *Gazette des Beaux-Arts*, dedicated to Michelangelo

el cielo

elaterra

e chi elamorte parlano edichono noi abiano chelnostro veloce chorso chio d...

... allamorte elducha guliano e be gusto ... eno facci vederta chome fa

e laudecta e questa ... mondo moi morto lui lui chosi r r ... chlotra la

luce armoi e choglio chi chiusi aserrato enostri ch no ri spledo piu so...

pra la terra ... avrebbe dinoi ... ch fasto mostra viver

j cesto detesta sesta

Fig. 3. Drawing by Auguste Rodin comparing
the profile of a woman to that of an architectural
detail, from Cladel 1908, p. 143

un regard d'inventeur, un regard où je lis tout à la fois de la malice,
la joie du grand esprit qui pénètre d'un degré dans la connaissance
et le sublime enfantillage qu'apparaît cet effort devant l'immensité
de l'inconnu; mais,
n'est-ce point à ces
petits triomphes de
l'intelligence, qua-
lifiés d'enfantillages
par le vulgaire, que
nous dûmes de tout
temps l'avancée de
l'humanité et nos
croyances fécondes
dans le progrès ?
... — Je crois
bien que la moulure
gothique, la belle
moulure onduleuse
qui confère à l'ar-
chitecture sa sou-
plesse, sa qualité de
vie, qui, en quelque
sorte, l'illumine, ils l'ont trouvée par l'interprétation du corps
humain. Cette moulure est absolument douce et saillante et, comme
le corps humain, ne présente aucune solution de
continuité. Vous allez comprendre... »
 Ayant vainement essayé de marquer un
contour du bout de son parapluie sur le sol, il
s'empare de mon carnet de notes, esquisse le profil d'un torse
féminin et souligne chaque accent de ce profil, le nez, le menton,
le sein, les convexités légères du flanc, du ventre; puis il résume et
concentre l'ondulation de cette ligne en un second croquis, plus

low us to assume that Rodin knew this text before
he left for Italy. In pieces published in France mark-
ing the anniversary, the emphasis on the sculptures
in the Medici Chapel was very pronounced. It was
there that the height of Michelangelo's work was
thought to have been reached ("What can we say
about these colossal statues, if not that Michelan-
gelo has put his soul into them? Since his creation,
man has produced nothing greater"; Ballu 1875,
"Centenaire," p. 82). More problematic for nine-
teenth-century taste was the criticism of its archi-

tectural content: If one overcame the emotion that
at first impact the atmosphere with its air of sa-
credness evoked, and if one refused to transform
it into a sanctuary for suffering humanity as in the
dialogue of Émile Ollivier of 1872 (Ollivier 1872),
it could sometimes seem contaminated with the
overabundant embellishment of "completely ca-
pricious ornamental details of grotesque masks and
totally new invention" (Quatremère 1835, pp. 293–
94). It could appear as an example of that fasci-
nating but uneven and antiharmonious simplicity

that Stendhal had already pointed out in a famous passage of 1817 in his *Histoire de la peinture en Italie* ("This is one of those places in the world where one can feel closest to the genius of Buonarroti. But the day you find this chapel pleasing, you will not be a lover of music"; Stendhal 1854, p. 354), or as an amateurish architectural exercise, a travesty of the master's predominant sculptural concerns, according to the judgment of Charles Garnier, architect of the recently opened Théâtre de l'Opéra in Paris: "Michelangelo is no architect; he makes architecture, which is something quite different, and even, most often, the architecture of a painter and sculptor, which means color, volume, and imagination, but which reflects insufficient study and an incomplete education. The concept may be strong and grand, but its execution is always weak and naive" (Garnier 1876, pp. 190–91).

The underlying meaning of Michelangelo's drawings of architectural profiles (which were in all probability exhibited, and in great number, in 1876 at the Casa Buonarroti) must have come to Rodin's mind when he began to design the architectural framework for *The Gates of Hell* (p. 46, fig. 5). In the model executed jointly with the architect Nanier (Elsen 1981, "Gates," p. 70), which was immediately recognized as a reworking of sixteenth-century Florentine sources (Mirbeau 1980, p. 46), the decorative characteristics of the base, pilasters, and cornice of the tympanum were unified with the narrative rhythm of the complex sculptural program, the framing of which was not to detract from the movement and drama of the work. From his experience with *The Gates*, Rodin developed a passion for such architectural details

as column bases, pilasters, and capitals, which he recorded in quick sketches executed during his visits to Gothic and Renaissance monuments (and which would appear in 1914 in the collected drawings entitled *Les Cathédrales des France*; fig. 2 and no. 33). These sketches are often simple profiles but are drawn with such tension and linear fluency that they suggest a comparison with drawings of the contours of the female body (Varnedoe 1981, p. 189). Rodin himself, in a statement to Judith Cladel, attempted to explain by a historical excursus the architectural profile/woman relationship ("The lovely undulating profile that gives architecture its suppleness, its living quality, which in some way illuminates it, they [Gothic and Renaissance architects] discovered from their rendering of the human body. This profile is absolutely smooth and flowing, and just like the human body, offers no interruptions"; Cladel 1908, p. 143), and then he made a sketch in which he clarified the subject for the interviewer (fig. 3).

41. Michelangelo
Two Studies of an Ancient Statue of Venus
1520–25
Black chalk on paper, 7 $^7/_8$ x 5 $^{13}/_{16}$" (20 x 14.7 cm)
Casa Buonarroti, Florence. Inv. 41 F

In this sheet Michelangelo joins two side views of a torso of an antique Venus that was well known in Rome in the sixteenth century. The same model was copied in drawings by Girolamo da Carpi and Giovanni Ambrogio Figino (Agosti and Farinella 1987, p. 75), and Johannes Wilde discovered the same torso in a drawing attributed to Domenico Beccafumi in the Louvre (inv. 255) and in the background of a portrait by Bronzino in Ottawa (Wilde 1953, p. 80, no. 44). Michelangelo drew this torso many times: the front appears in a drawing in the British Museum, London (1859-6-25-570), while the back is found in two other sheets (Casa Buonarroti, inv. 16 F; British Museum, 1859-6-25-571). The inclusion in this series of a drawing in the Musée Condé in Chantilly (inv. 29) is, however, more problematic. The two sheets in the Casa Buonarroti and the two in the British Museum attest to Michelangelo's desire to represent the sculptural object from the four principal points of view. Their generally accepted dating is the middle of the third decade of the sixteenth century, which corresponds to the period when Michelangelo was executing the nudes for the Medici tombs.

Unpublished throughout the nineteenth century and much of the twentieth, this sheet was almost certainly unknown to Rodin, unless he saw it during his hypothetical visit to the Casa Buonarroti in 1876. The presence of the drawing here attests to the unreconcilable distinctions between the importance that ancient sculpture and that of Michelangelo assumed in Rodin's imagination. Reading the artist's extensive interviews in chronological sequence provides a precise idea of how classical art was understood as a paradigm for the greatest naturalism ("He believes that Greek sculpture is the

perfection of realism, nature simply and comprehensively copied by the strongest, healthiest, and clearest eyes and hands"; Bartlett 1965, p. 89). He later characterized it as the greatest possible attainment of the harmony and vitality of the human body (Rodin 1984, pp. 10–12). Ultimately, he regarded classical sculpture as giving birth to sublime forms which, even if idealized, were capable of retaining the direct imprint of natural observations ("[The Greeks] condescended to copy the restrained gesture of the moment in order to understand and render, by the harmony and weight of group movements, by accurate modeling, in definitely fixed forms, the eternity of life"; Dujardin-Beaumetz 1965, p. 184). Against this conception of classical sculpture, a Michelangelo who was occasionally "Gothic," antinaturalistic, and unhappily dedicated to discord, constituted the most notable (even if inadequate) alternative.

Even if Rodin, in his modeling, often put himself to the test with a female torso whose mutilation made it seem like an object with distinct archaeological characteristics (as in the "Seated Woman" series; Elsen 1981, "Sculptures," pp. 139–41), his sculptural intent appears focused upon rendering surfaces charged with tensions, as if to suggest an archaic and painstaking procedure of shaping, as opposed to the broad modulation in Michelangelo's drawing. Significantly, this would appear in torsos created by the next generation of sculptors (Alphonse Legros, Émile-Antoine Bourdelle, Eugène Druet, Jacques-Ernest Bulloz, and Aristide Maillol, according to the valuable sequence proposed in Le Normand-Romain 1990), who were concerned with rethinking this theme on the basis of more advanced desires for pure volumes.

184

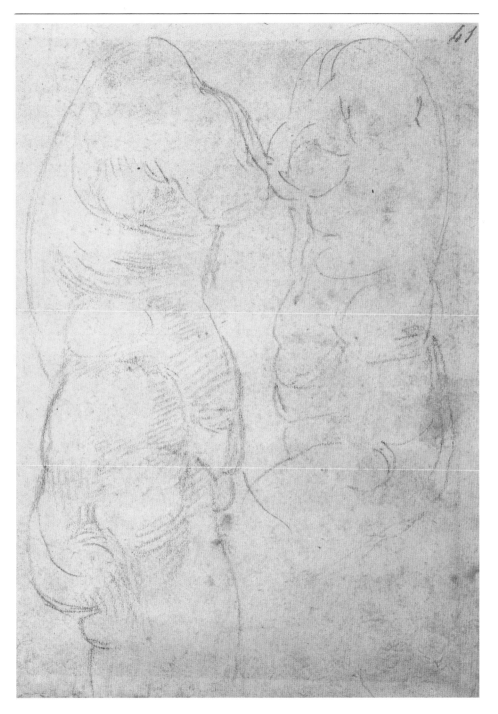

42. Michelangelo
Studies of Legs
1524–25
Pen and ink on paper, 10 $^5/_{16}$ x 10 $^1/_2$ "
(26.2 x 26.6 cm)
Casa Buonarroti, Florence. Inv. 10 F

This sheet is connected to a series of studies of anatomical details, of which all except one (British Museum, London, 1859-5-14-821) are preserved in the Casa Buonarroti. Because it is impossible to connect these drawings to an actual project of Michelangelo's, Johannes Wilde has found in them the artist's desire to reconsider the living model in preparation for a new sculptural effort, which he identified with that of the allegorical nudes for the Medici Chapel in Florence: the drawing technique is used to render the variations in volume of the human body in order "to convey the impression of softness and hardness, tension and relaxation" (Wilde 1953, p. 81). Paola

Barocchi has interpreted these drawings as modeling studies (corresponding to the "remarkable expansion" of the sculptural project for the Medici Chapel) rather than as pure and simple anatomy (Barocchi 1962, p. 93).

This drawing was circulated visually, thanks to the photograph included in the *Album michelangiolesco* of 1875 (Smorti 1875, no. 2). Its reproduction was evidently intended for an audience of artists, and its subject could easily have been linked with contemporary academic teaching in which instruction in anatomy constituted one of the crucial parts. When Rodin reached Italy, Michelangelo's reputation as an anatomist was high: in Paris

Fig. 1. *Michelangelo Studying Anatomy*, an engraving after a painting by Antonio Ciseri (Italian, 1821–1891), from Gotti 1875, vol. 1, p. 25

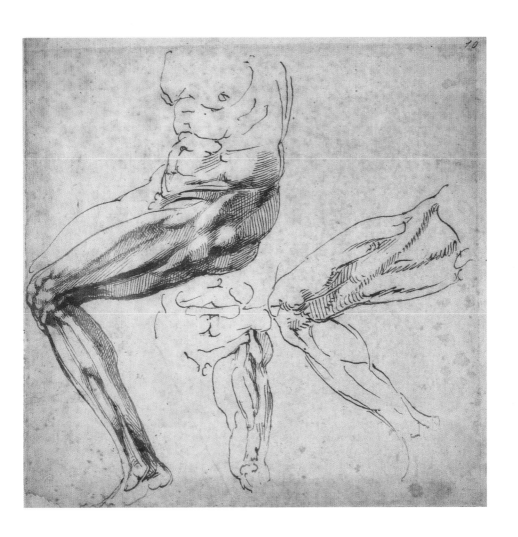

Fig. 2. Joseph Fisher (British, 19th century), *Michelangelo Studying Human Anatomy with Antonio della Torre*, 1852. Etching published in Fisher 1852, pl. 1

the anatomical figure with skin removed (*écorché*) traditionally attributed to him was on view at the Musée Haguier of the École des Beaux-Arts alongside the classics in this genre by Baccio Bandinelli and Théophile Caudron (Müntz [1889], p. 43), and Aurelio Gotti opened a chapter of his biography of Michelangelo with the engraving of *Michelangelo Studying Anatomy* by Antonio Ciseri (fig. 1). All the studies published for the quadricentennial discussed the special character of the master's anatomical renderings, and in France, following the wave of extreme Romantic adoration (for example, by Stendhal and Delacroix), this topic had particular resonance. An emblematic example of this is the position of Charles Blanc, founder of the *Gazette des Beaux-Arts*. He reproduced various ana-

tomical studies (fig. 4) and described with rapture the drawing that depicted Michelangelo and Antonio della Torre intently studying a cadaver with a candle inserted in its chest ("there is something tragic about this drawing"; fig. 2), preserved at Oxford and possibly shown in Florence among the selection of photographs donated by the British government (*Relazione* 1876, p. 217; since 1852 there had existed a facsimile reproduction of it in an etching by Joseph Fisher [Fisher 1852, pl. 1]). His interpretation seemed, however, aimed at limiting enthusiasms for the unequivocally naturalistic. Michelangelo could thus teach the practice of anatomy to artists, not from the lectern but from "living muscle, because it varies from one person to the next in intensity, in suppleness, in strength,

Fig. 3. Auguste Rodin, drawing of three nude figures, from the magazine *Archives de Thérapeutique*, 1899

Fig. 4. *Study for the Dead Christ* (Graphische Sammlung Albertina, Vienna), an anatomical study attributed to Michelangelo, from the *Gazette des Beaux-Arts* (Blanc 1876, p. 21)

and in grace, because it is subject to a thousand nuances due to the vicissitudes of life and the specific changes that existence brings about in the infinite number of those to whom it gives life." But the artist's greatness consisted in his having surpassed a simply anatomical description of the nude, and thus was proof of the necessity, in the sixteenth as well as the nineteenth centuries, of an intellectual, "irreproachable correction, without which many of the figures we find so praiseworthy... would appear simply as freaks of nature, as monstrous distortions of the truth" (Blanc 1876, pp. 20–21). Rodin himself, in a statement to William Brownell published in 1892, when his own fascination with Michelangelo had already been replaced by more tranquil, classicizing passions, recalled the master's anatomical practice in terms of preliminary study ("He used to do a little anatomy evenings and used his chisel next day without a model. He repeats endlessly his one type"; Brownell 1980, p. 80), a sort of apprenticeship of secondary importance when compared to the more intellectual moment of the invention of a motif.

It is therefore very likely that from this series of Michelangelo drawings something passed into Rodin's drawings of the early 1880s, for example, *The Damned*, reproduced by Dargenty in *L'Art* (Dargenty 1883, p. 33); the *Two Wrestlers* in the Musée Rodin, Paris (D.1946); and the group of men reproduced by André Mycho in the *Archives de Thérapeutique* in December 1899 (fig. 3), in which the figures are clearly represented with the muscular tissue (more or less done with shading), and the contours suggest tension and repose rather than depict accurately their anatomical structure.

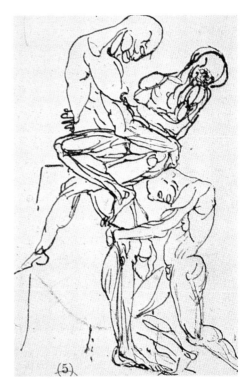

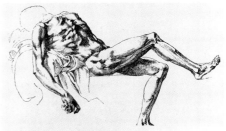

43. Attributed to Michelangelo
River God
c. 1525
Wax, height 8 $^{11}/_{16}$" (22 cm)
Casa Buonarroti, Florence. Inv. 542

This small, incomplete figure, which in an upright position Thode regarded as a study for a thief on the cross (Thode 1913, p. 281, no. 590), and Wilde, a rough sketch for the *"Bearded" Slave* in the Accademia in Florence (Wilde 1928, pp. 661–71), is now generally considered to be a river god, a preparatory study for the life-size *Four Rivers*, which Michelangelo intended to add to the Medici Chapel in San Lorenzo in Florence but never realized. Surviving from this project, in addition to the preliminary drawings, is a large model, also incomplete, of unfired clay and other materials (now in

the Casa Buonarroti; fig. 1), which, along with a few other original pieces, was shown at the 1875 exhibition at the Accademia (*Relazione* 1876, p. 216) in an installation that remained long after the show had closed (the models are documented in the Brogi photographic catalogues of 1879 [p. 113] and 1889 [p. 111]). When Rodin visited the exhibition in the early months of 1876 (after the second half of February, according to Butler's calculations [Butler 1993, p. 92], or the beginning of March according to Rodin [Rodin 1985, p. 33]), this model must have seemed a fascinating testi-

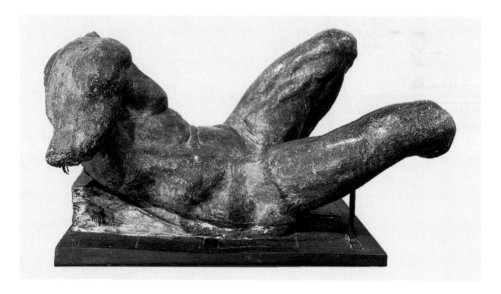

Fig. 1. Michelangelo, *River God*, c. 1524. Wood, clay, wool, and tow, length 70 $^7/_8$" (180 cm). Casa Buonarroti, Florence

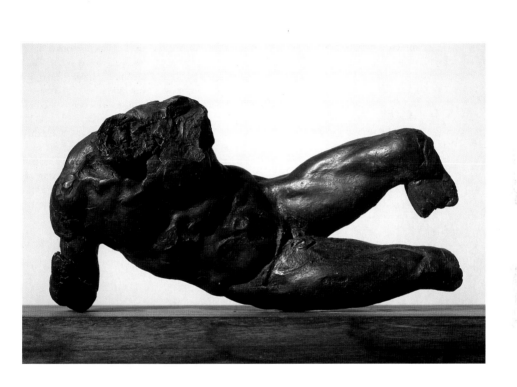

Fig. 2. Auguste Rodin, *Studies after Michelangelo*
(no. 8, detail of D.283)

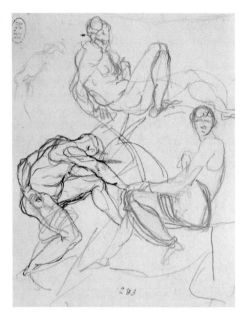

mony to Michelangelo's work on the much-admired figures in the Medici Chapel: a sketch of the same pose and, above all, an attempt to imitate the same anatomical construction, with undulating lines that suggest the masses of muscles, is found in a drawing in the Musée Rodin in Paris (fig. 2) from the series in which the nude is drawn from life in Michelangelesque poses. On the occasion of the quadricentennial, this small wax model was shown in an altered form in the fifth cabinet of the Study of the Casa Buonarroti: there was no thought given, however, to mounting onto the "small male torso," which was then considered doubtful as an autograph work of Michelangelo, the "fragment of a right thigh" and the "fragment of an arm" catalogued in Fabbrichesi's guide under separate numbers (Fabbrichesi 1875, p. 22, nos. 11, 15, 16) and which were reassembled only after 1896 (Procacci 1965, pl. 104, pp. 189–90).

It was, nevertheless, this presentation of Michelangelo's sculptural studies of incomplete figures and separate parts of the body, arranged in cabinets, that made the show significant from the perspective of Rodin. To the nineteenth-century eye, accustomed to understanding the sculptural figure in terms of the harmonious relationships of the individual parts, the fragments in the Casa Buonarroti must have seemed difficult and unpleasant, of interest only as scholarly curiosities. To Rodin, on the contrary, they must have offered unexpected encouragement. In them the artist could detect an intimation of that expressive autonomy of the individual anatomical details that a few decades later would astonish and fascinate his contemporaries. The German poet Rainer Maria Rilke, for example, wrote in 1903, "Rodin, know-

Fig. 3. Plaster casts of sculptural studies
by Auguste Rodin, at his studio at Meudon

Fig. 4. Sculptural studies (*bozzetti*) attributed
to Michelangelo, from the collection of Ernst
Hähnel. Plaster casts of these studies were
shown at the Accademia in Florence during the
1875 Michelangelo quadricentennial celebrations
and were later donated to the Casa Buonarroti

ing through the education which he has given himself that the entire body consists of scenes of life, of a life that may become in every detail individual and great, has the power to give to any part of this vibrating surface the independence of a whole" (Rilke 1965, p. 124). Rodin, as a modeler, could moreover attest for himself to the little-known aspect of modeling of a sculptor whose myth was closely linked to the opposing practice of direct carving. It does not seem far-fetched to consider the Casa Buonarroti cabinets as a parallel to those of Meudon, where Rodin stockpiled fragments (arms, hands, legs, feet) broken off from plaster figures or modeled independently and then cast in plaster (fig. 3). An important study by Albert Elsen (Elsen 1981, "Sculptures") drew attention to them as part of a phase of fundamental transition toward forms that became increasingly synthetic and concentrated. Finally, it should be noted that for the 1875 quadricentennial, plaster casts of the studies thought to be by Michelangelo (from the sixteenth-century collection of Paul von Praun, but then belonging to the sculptor Ernst Hähnel) were shown with great success in Florence at the Accademia (see fig. 4), and after the close of the exhibition were donated to the Casa Buonarroti (these events are reconstructed by Stefano Corsi in Florence 1994, pp. 60–61). For the most part fragments (arms, legs, torsos, mutilated figures), they encouraged the focus of attention on the individual body parts (Gaborit 1990, pp. 89–90) and could aid in understanding the characteristics of Michelangelo's anatomical construction.

44. Michelangelo
The Virgin and Child
c. 1525
Black chalk, red chalk, white lead, and pen and
ink on paper, 21 $^{5}/_{16}$ x 15 $^{5}/_{8}$" (54.1 x 39.6 cm)
Casa Buonarroti, Florence. Inv. 71 F

This famous small-scale cartoon of *The Virgin and Child* is not a preparatory study for any piece by Michelangelo that was executed as sculpture or painting. This fact, which is complicated by the lack of comparable drawings and by the unusual technique, has caused considerable variations in its proposed dating, which ranges from 1506 (Thode 1913, p. 29, no. 63) to 1535–40 (Hartt 1970, p. 308, no. 438). Moreover, beginning with its attribution by Berenson to Giuliano Bugiardini (Berenson 1903, vol. 1, pp. 249–51), doubts have been raised that it is by Michelangelo, with regard to the work as a whole and more specifically concerning the very finished coloring in the child, which to other scholars (Brinckmann 1925, no. 20; De Tolnay 1975–80, vol. 2, no. 239 recto) is the result of later retouching. Today the cartoon is considered the work of Michelangelo's hand and is generally dated to the 1520s through comparison with a sheet in the British Museum, London (1859-5-14-818), that has a series of *pensieri* on the reverse that can be dated to this period (Wilde 1959, p. 381). Careful examination of the drawing (executed on a support made by gluing two pieces of paper together) allows us to see how Michelangelo first traced the Virgin's face, intent on observing the child, in profile, but then he turned the head to the left, thus giving her an absent expression. Next he concentrated on the figure of the child: using red chalk the artist retraced (with many second thoughts) its outlines and defined its modeling; highlights in white lead and finishing touches in black ink increased its plasticity to create an effect of pictorial illusion (Hirst 1988, p. 88, no. 36).

This work, as Paola Barocchi (Barocchi 1962) showed, was already well received in the nineteenth

century, with important early commentaries pointing to the obvious parallels with the modeling effects of Michelangelo's sculpture (Rumohr 1827–31, vol. 3, p. 96; Burckhardt 1860, p. 878) and its surprising refinement ("the minute attention to detail that recalls the drawings of the old masters"; Piot 1863, p. 140). At the time of the quadricentennial, when it was exhibited in frame number 15 in the second gallery of the main floor of the Casa Buonarroti (according to Fabbrichesi 1875, p. 10), this small cartoon was praised not only by the Italians, who because of its extraordinary execution unanimously drew attention to it from among the masses of questionable studio drawings (Gotti 1875, vol. 2, p. 192; Fabbrichesi 1875, p. 10), but also and especially by the French. The usual astonishment before the relief effect created by the shading ("a priceless treasure boldly drawn in black chalk and highlighted in red chalk for the divine Bambino, caressed with passion and pushed to the furthest limits of perfection"; Leroi 1875, "Publications," p. 141) was accompanied by reflections concerning the tragic expression on the Virgin's face ("She has a proud look and a sort of sulkiness about the lips that bespeak dark thoughts, sinister forebodings, as it were, the anxiety of an exceptional motherhood.... She looks elsewhere, as if she were afraid of abandoning herself to the grace of her maternal cares, as if her mouth were not made for smiling"; Blanc 1876, p. 14).

If the chiaroscuro rendering of the child's body is very close to certain effects sought by Rodin (for example, the action of light that flows like a sheet of water over the highly polished marble surfaces of his small groups), this cartoon was certainly not one of the drawings by Michelangelo that Rodin

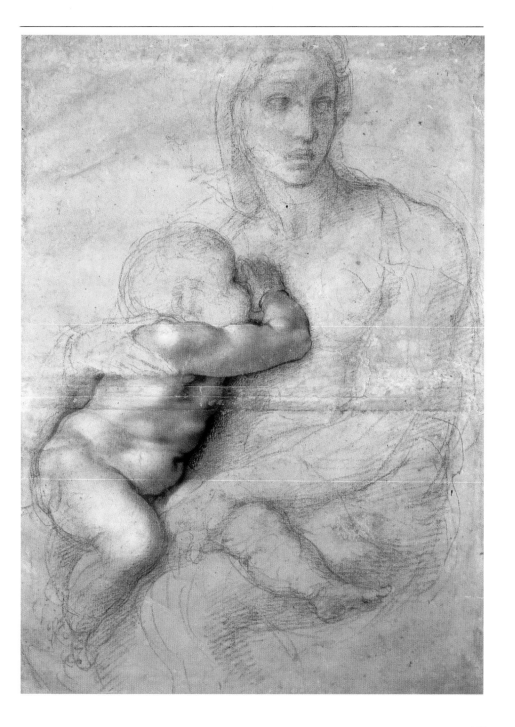

Fig. 1. Auguste Rodin, *Young Mother in the Grotto*, 1885. Plaster, height 14" (35.6 cm). Rodin Museum, Philadelphia. Bequest of Jules E. Mastbaum

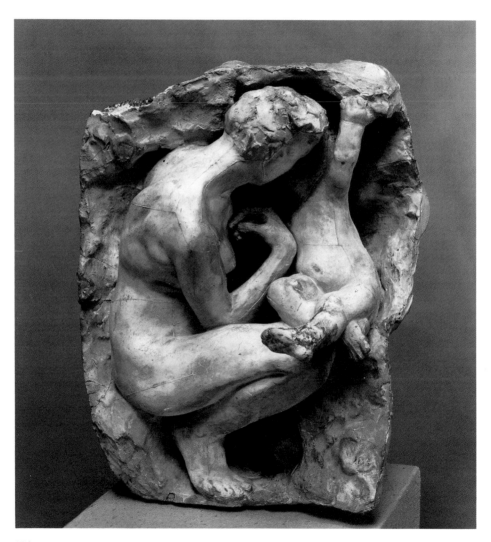

liked most: its dominant characteristic, that tragic absence of personal rapport between mother and child, was foreign to his concerns, since he concentrated on bodies that touch and intertwine, fixing relationships that are both physical and emotional. In motherhood in particular, be it tranquil (as in the *Young Mother in the Grotto* in the Rodin Museum in Philadelphia; fig. 1) or distressed (as in the drawing executed for *The Gates of Hell* and entitled *Limbo*; Dargenty 1883, p. 34), Rodin, physically and psychologically, emphasized that "coherence of the figures, that concentration of the forms, that quality of clinging together" that Rilke in a famous passage (Rilke 1965, p. 124) had recognized as the foundation of Rodin's sculptural inspiration.

45. Michelangelo
Allegorical Group
c. 1528–30
Terracotta, height 16 ¹/₈" (41 cm)
Casa Buonarroti, Florence. Inv. 192

Exhibited in Florence only

For most Michelangelo scholars, this sketch is con-
nected to the commission, initiated in 1508 but
resolved only in the late 1520s, of a *Hercules and
Cacus* in marble to be installed as a pendant to the
David in the Piazza della Signoria in Florence. It is
by no means certain, however, that the subject rep-
resented in this little model in the Casa Buonarroti
is in fact *Hercules and Cacus* (like that of the statue
by Baccio Bandinelli, who later took up the com-
mission for the piece), or *Hercules and Antaeus* (a
sketch of which Michelangelo gave to the sculptor
and goldsmith Leone Leoni), or even *Samson Slay-
ing a Philistine* (the subject into which Michelan-
gelo intended to transform the marble from the
statue that Bandinelli had scarcely roughed out
when it was entrusted to Michelangelo after the
fall of the Medicis in 1528). According to Johannes
Wilde (Wilde 1978, pp. 108–9), however, this
model was conceived for a group that was intended
for the entrance to the tomb of Pope Julius II (a
project of 1527–30), where it would have been a
pendant to the *Victory* now in the Palazzo Vecchio
in Florence.

This study was on display the year Rodin visited
Florence, in the fourth cabinet in the Study of the
Casa Buonarroti (Fabbrichesi 1875, p. 21, no. 3),
but it lacked the two heads, the arm, and another
small fragment (see fig. 2), which were laid out in
the same cabinet. These pieces were put back to-
gether in 1926 by Enrico Massai, according to
Wilde (Wilde 1928, pp. 653–66). At the time of
the 1875 quadricentennial, a wax model of *Her-
cules Fighting Cacus*, displaying similar losses and
belonging to the South Kensington (now the
Victoria and Albert) Museum in London, could
be seen in a photographic reproduction at the

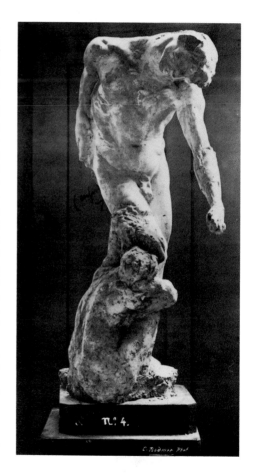

Fig. 1. Auguste Rodin, *The Shade with the
Caryatid*, after 1898. Plaster (disassembled).
Archives of the Musée Rodin, Paris

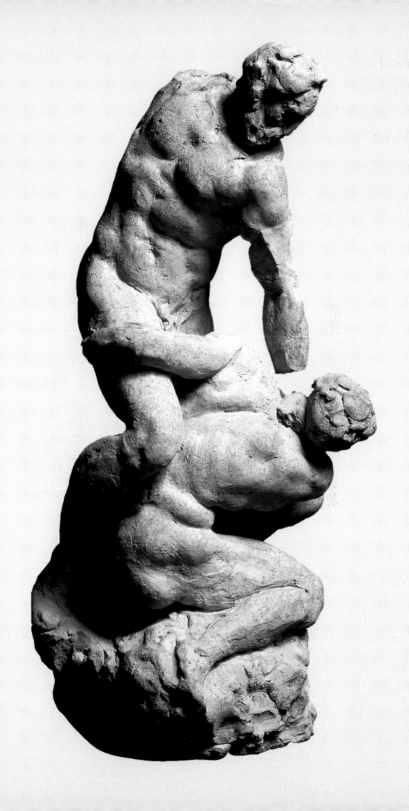

Fig. 2. Michelangelo, *Allegorical Group* (no. 45)
before being restored in 1926

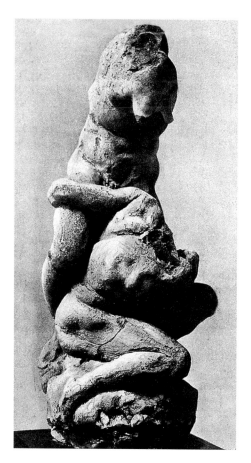

Michelangelo exhibition at the Accademia in Florence, together with twenty other photographs given by the British government (*Relazione* 1876, p. 217; Gotti 1875, vol. 2, p. 241).

Whether viewed in the original or in the reproduction from London, this small allegorical group would certainly have been the study by Michelangelo that Rodin most preferred: the French artist must have been struck by its contracted gesture, charged with muscular and emotional tension but completely devoid of any sense of movement (the nineteenth-century mutilations in this sense only intensified its anatomical compactness), which he would adopt in many of his sculptural groups in the 1880s, from *I Am Beautiful* (no. 25) to *Possession*. Moreover, to a sculptor accustomed to thinking of a statue as a continual piling up of outlines, the nature of Hercules' pose, with its hewed and deeply cut contours, would not be forgotten by Rodin, as can be seen in his *Meditation*. A reminiscence of Hercules' gesture in its inevitable accomplishment, as if obeying some higher power, occurs almost literally in *Adam* (no. 20), the sculpture that Judith Cladel (the Rodin biographer who knew the artist best) considered closest to the lesson that Rodin learned from Michelangelo in Italy (Cladel 1953, p. XII: the direct descendant of a figure of Adam, later destroyed, that was "so close to Michelangelo that it almost seems like a caricature"). In a later assemblage (after 1898, as is documented by photographs in the archives of the Musée Rodin in Paris; fig. 1 and Elsen 1981, p. 114), *The Shade*, whose immediate source is *Adam*, is even mounted on the *Fallen Caryatid* (a recollection of Michelangelo's *Victory* in the Palazzo Vecchio in Florence could also have contributed

Fig. 3. Plaster maquettes made by Auguste
Rodin in the manner of Phidias (left) and of
Michelangelo (right), from Gsell 1911, pl. 37

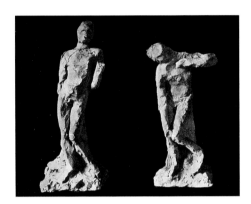

to the inspiration for this assemblage), resulting in a work that is not dissimilar to this study by Michelangelo. In addition, an incomplete plaster of *Ugolino* (1876–77), now at Meudon, seems to recapture the forced bending of the leg and contortion of the figure being overcome; the compression of the joints in this figure was studied in many drawings for the "Ugolino" series, particularly in one from the end of the 1870s that is now in the Musée des Beaux-Arts in Lyons (Judrin 1981, p. 197).

The play of compressions and distortions that is so remarkable for its inventive immediacy in this sketch should be linked to Rodin's famous demonstration of the differences between Phidias and Michelangelo that he gave to Paul Gsell in 1911. On that occasion Rodin executed two small clay models (fig. 3) in which he attempted to summarize the formal characteristics of Greek art and those of Michelangelo: the figure he used to explain Michelangelo—distinguished by a commanding gesture of the arm that stretches down-

ward, by the curving forward of the head, and by the acute bending of the legs in the same direction—was intended to demonstrate how the body's construction could be generated by the simultaneous introduction of two contrasting planes. This would "create a gesture that is at once violent and constrained" (Rodin 1984, p. 90), a feeling amplified by the intensity of the effort that constricts the limbs. Despite the passing of thirty-five years, the impact of the art of the Florentine sculptor, whose importance Rodin had rejected more than once in favor of ancient art and of a naturalism like that of Donatello (Brownell 1980, p. 81; Cladel 1908, p. 83), was invoked once more as he stressed his perplexity (and budding enthusiasm) regarding the anatomical mechanics of disconcerting anticlassicism: "When I went to Italy myself, I was disconcerted before the works of Michelangelo since I had my mind full of the Greek models I had studied passionately at the Louvre. At every turn, Michelangelo's figures contradicted the truths I thought I had finally acquired. 'Well!' I said to myself, 'why this incurvation of the torso? Why this raised hip? Why this lowered shoulder?' I was quite confused" (Rodin 1984, p. 92).

46. Michelangelo
Studies for a Risen Christ
c. 1530
Black chalk on paper, 15 x 9 $^{15}/_{16}$"
(38.1 x 25.2 cm)
Casa Buonarroti, Florence. Inv. 61 F

Some scholars have related this drawing to the Christ in *The Last Judgment* in the Sistine Chapel (for Berenson, for example, who did not consider it a work in Michelangelo's hand, it is a "scrawled variation" of this figure; Berenson 1938, vol. 2, p. 228, no. 1665A). The tendency today, however, is to associate it with a group of studies datable to the early 1530s for a never-executed *Resurrection*, which includes the better-known sheets with a similar subject in the Louvre (inv. 691 bis), the Royal Library at Windsor (12767), and the British Museum, London (1887-5-2-119). The pose of the Christ in the Casa Buonarroti drawing, with one arm extended below with the hand open toward the ground, the other arm raised (evidently to hold a banner), is quite close to that of a more detailed (and thus later) charcoal drawing in the British Museum (1895-9-15-501) in which the attitude and movement of the body already match those of the Christ in the *The Last Judgment*. This later sheet, which in the 1870s was part of the Malcolm collection, was shown in Paris in May and June of 1879 in a celebrated exhibition of Old Master drawings at the École des Beaux-Arts (*Maîtres anciens* 1879, p. 17, no. 67), and was in all likelihood seen at that time by Rodin. Another sheet with a scene of *The Resurrection* (British Museum, 1860-6-16-133) was reproduced in 1876 in the special Michelangelo issue of the *Gazette des Beaux-Arts* (Mantz 1876, p. 161).

The Casa Buonarroti drawing, which for the Michelangelo quadricentennial had been listed in both Fabbrichesi's guide (Fabbrichesi 1875, p. 10) and Gotti's catalogue (Gotti 1875, vol. 2, p. 192) as a *pensiero* for the *The Last Judgment*, does not seem to have any direct relationship to Rodin's investigations, except for that means of representing action, so prized by the French sculptor, in which the person depicted acts in a manner almost independent of his own will and seems to obey an inscrutable, superior power. This trait, which Octave Mirbeau had already recognized in the 1880s with regard to the groupings in *The Gates of Hell* (Mirbeau 1980, p. 48), would soon become one of the commonplace observations about Rodin in German (Kassner 1980, p. 102) and Italian (Benelli 1901, p. 161) criticism, although without ever suggesting a comparison with Michelangelo. The aforementioned Windsor drawing in which Christ, to the dismay of the bystanders, issues from the tomb ("with the action and look of being unconscious, a somnambulist"; Berenson 1903, vol. 2, p. 108)—which already existed in a Braun photograph in the 1880s—seems closer, instead, to Rodin's activities in connection with *The Gates of Hell* (p. 46, fig. 5), where the figures similarly seem to conquer gravity and float free of the ground. The Windsor Christ, with his two arms stretched toward heaven, recalls such Rodin sculptures as *The Prodigal Son*; one might also be able to relate it to a number of Rodin drawings made in connection with *The Gates of Hell*, such as a nude male figure in the Musée Rodin (D.5584; repro. in Elsen 1981, p. 170).

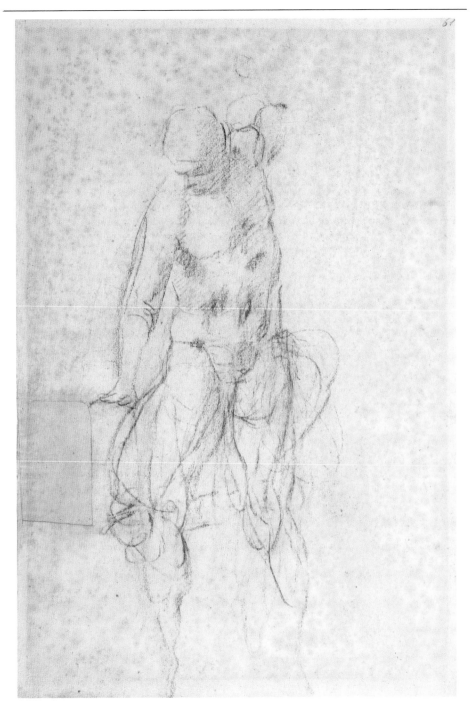

47. Attributed to Michelangelo
Male Torso
1530–40?
Terracotta, height 9 $^1/_{16}$" (23 cm)
Casa Buonarroti, Florence. Inv. 539

Exhibited in Philadelphia only

Published without attribution in the 1875 catalogue of the Casa Buonarroti (Fabbrichesi 1875, p. 22, no. 12), this small terracotta torso, lacking head, arms, and legs, was exhibited beginning in the 1860s in a cabinet in the Study of the Casa Buonarroti alongside a wax study of *David* and another small anatomical fragment considered to be by the master's hand. Ignored for the most part in the succeeding bibliography, this torso was discussed anew in 1954 by Charles De Tolnay (De Tolnay 1954, p. 157, no. 4, fig. 201), who posited that because of the high degree of finish of the modeling, it "does not show the texture of the original models of Michelangelo." The proposals that it be interpreted as a model for the *"Beardless" Slave* in the Accademia in Florence (Hartt 1987, p. 62) or as a sculptural trial for a figure in *The Last Judgment* (Goldscheider 1962, no. 40) have not been pursued. During Rodin's lifetime, with the exception of Thode's exhaustive catalogue (Thode 1913, p. 281, no. 591), this piece was not discussed nor was it in visual circulation apart from its continual exhibition at the Casa Buonarroti. It was not even referred to in the bibliography relating to the four hundredth anniversary of the artist's birth, and there were no photographic reproductions of it in the nineteenth or the early twentieth centuries.

It is tempting to relate this small torso to similar fragmentary sculptures by Rodin (known to the public beginning with the bronze shown in his joint exhibition with Claude Monet at the Galerie Georges Petit in Paris in the summer of 1889; Paris 1989, p. 104, no. 28)—a provocative act of faith when one considers that the Michelangelo sculpture was totally devoted to pure plastic considerations. One of these torsos, today in the Rodin

Museum in Philadelphia (fig. 1), shows mutilations similar to those of the sculpture in the Casa Buonarroti, with a comparable treatment of the well-defined muscular contours and the slight twist of the body. The fortune of Michelangelo's fragments, already well documented in the 1870s after the success of the exhibition of casts from the Hähnel collection in the autumn of 1875 at the Accademia in Florence (Florence 1994, pp. 60–65), obviously influenced the critical discussion of Rodin's fragments (see no. 43). The tendency to fragment sculpture in order to draw from it, through the incomplete torso, greater plastic concentration, found a precedent in the Michelangelo legend in the mind of Rodin. In conversations with Paul Gsell in 1911, Rodin recalled how "he [Michelangelo] himself used to say that only those works that could be rolled from the top of a mountain without breaking anything were good. In his opinion, anything broken off in such a fall was superfluous" (Rodin 1984, p. 91).

This perspective was seconded in the reaction of Rodin's contemporaries to his incomplete work. To the literary seduction by the fragment, to which Yvanhoé Rambosson appeared susceptible in a text published in the special issue of *La Plume* devoted to Rodin in 1900 ("a beautiful thing that has been used and broken, how much more human it is and closer to our heart for having suffered, and to how great an extent is there added an indefinable sensation of melancholy pity to the impression of pure beauty, a sad and human side which amplifies our emotion"; Rambosson 1900, pp. 72–73), was soon added an interpretation that was more consciously sculptural, documented, amid other occurrences, in a letter by Rainer Maria Rilke to Clara Westhoff

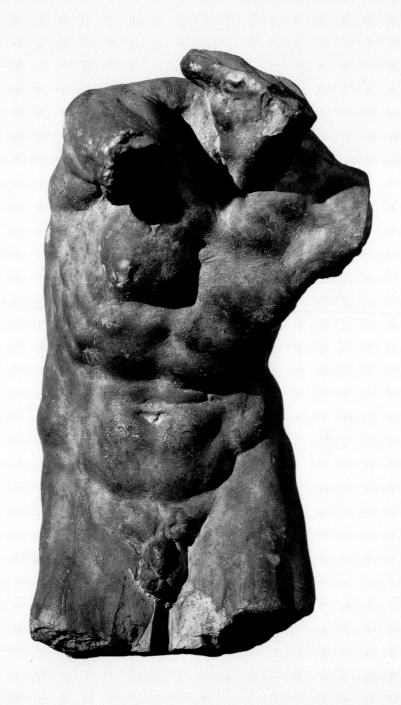

Fig. 1. Auguste Rodin, *Torso of a Man*, c. 1885.
Plaster, height 10 ¹/₂" (26.7 cm). Rodin Museum,
Philadelphia. Bequest of Jules E. Mastbaum

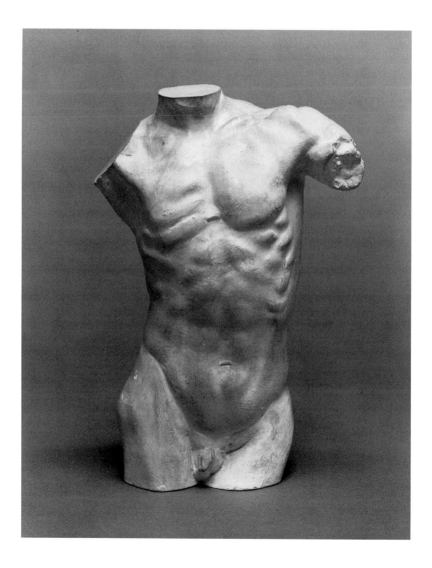

of September 1902, about the first impression he had on entering Rodin's studio at Meudon, which was full of piled-up incomplete plasters: "Acres of fragments lie there, one beside the other. Nudes the size of my hand and bigger, but only bits, scarcely one of them whole.... And yet the closer you look the deeper you feel that it would all be less complete if the separate bodies were complete. Each of these fragments is of such a peculiarly striking unity, so possible by itself, so little in need of completion, that you forget that they are only parts" (quoted in Butler 1980, p. 114).

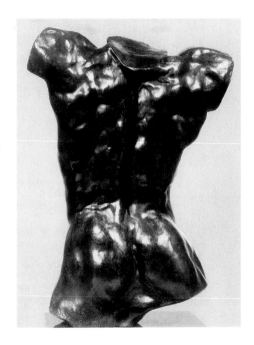

48. Michelangelo
Studies for a Pietà
1533–35
Black chalk on paper, 15 $^{11}/_{16}$ x 11 $^{1}/_{8}$"
(39.8 x 28.2 cm)
Casa Buonarroti, Florence. Inv. 69 F recto

As Carl Justi recognized in 1908 (Justi 1908, vol. 2, p. 156), these two studies for a Pietà (the dead body of Christ and beneath it, an outstretched arm, which some critics interpret as that of the Virgin supporting him, and others, that of an angel with a sponge) can be connected to a painting of a similar subject by Sebastiano del Piombo that was commissioned in 1533 by Don Ferrante Gonzaga as a gift to Francisco de los Cobos, secretary to the Holy Roman Emperor Charles V. As he had already done in the past, Michelangelo must have created the composition for Sebastiano, an artist with whom he felt strong bonds of friendship. Neither the Casa Buonarroti drawing nor the finely shaded and more finished rendering in the Louvre (inv. 716; fig. 2) was ever sent to its intended recipient (to whom perhaps a more detailed drawing, if not an actual cartoon, was dispatched; Hirst 1988, p. 122, no. 50), and thus, they remained the property of Michelangelo and his heirs.

During Rodin's visit to Florence, this drawing was exhibited in frame number 14 in the second room of the main floor of the Casa Buonarroti (according to Fabbrichesi 1875, p. 10). Its favorable reception by Rodin's contemporaries, always open to appreciating dramatic anatomical invention, is documented by the early discussion of it by Paolo Emiliani Giudici in the *Gazette des Beaux-Arts* in 1862 (Emiliani Giudici 1862, p. 481), and above all, by its reproduction in the *Album michelangiolesco* issued for the quadricentennial by the Florentine publisher Smorti (Smorti 1875). It is known that the attention Rodin paid to the Michelangelo of the late sculpted Pietàs, with their tragic and sorrowful grandeur and their monumental bodies in poses of limp abandon—particularly,

the *Pietà* now in the Museo del Opera del Duomo in Florence—would become the subject of one of the most suggestive recollections of his trip to Italy (amid the incense and wax candles "the greatness of this sculpture... the skill of its overall design, the power of this art... compelled the public [those attending the mass] to silence"; Cladel 1908, p. 132) as well as an important reflection on the *non finito*, the unfinished, in Michelangelo ("Art no

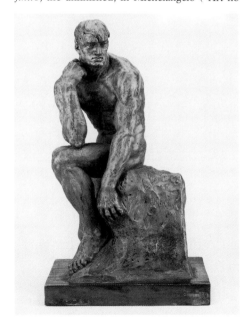

Fig. 1. Auguste Rodin, *Study for a Seated Man (Study for "The Sailor")*, c. 1874–75. Wax, height 14 $^{1}/_{2}$" (36.8 cm). The Nelson-Atkins Museum of Art, Kansas City, Missouri. Purchase: Nelson Trust

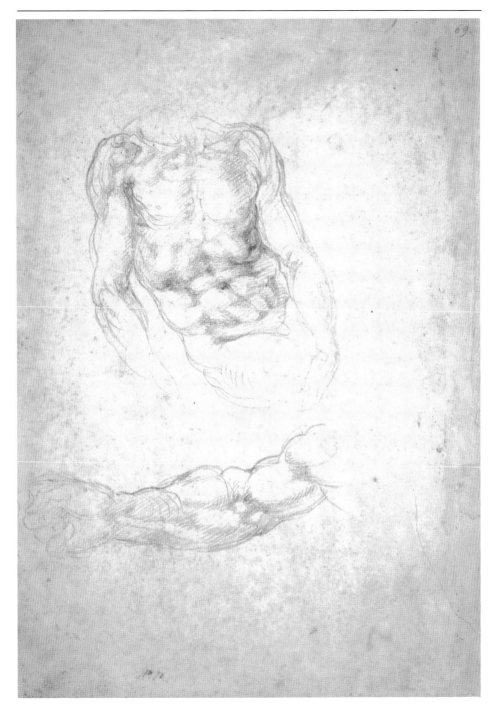

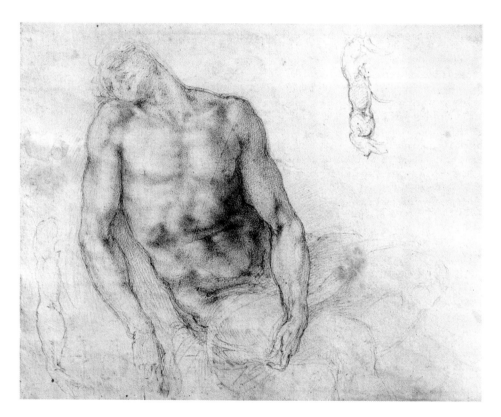

longer satisfied him. He [Michelangelo] longed for the infinite"; Rodin 1984, p. 101). Rodin acquired a photograph of the marble *Pietà* probably during his trip to Italy, which is preserved in the photographic archives of the Musée Rodin in Paris (Ph 890). The limp arm of the dead Christ was literally quoted in the arm of the wounded warrior sustained by the Genius of Liberty in *The Call to Arms*

(no. 12), while the anatomy of the slumping torso and particularly of the strained and dramatic angle of the left leg were also repeated (a characteristic he recalled in the late interviews with Gsell as among the most important in Michelangelo's art, which could suggest "the holiness of exertion and suffering"; Rodin 1984, p. 101). It would not have been difficult for Rodin, once he returned to Paris,

Fig. 3. Detail of the plaster version of Rodin's
The Three Shades (see no. 21, fig. 1), as exhibited
at the Société Nationale in 1902

to verify these elements in the cast of the Florence
Pietà at the École des Beaux-Arts—where in 1878,
the plaster copies of works from the Renaissance
that had been preserved in the Atelier des Mou-
lages arrived from the Louvre ("Académie" 1878,
p. 48), and the copies made on the occasion of the
quadricentennial, from Florence (Mastrorocco
1989, p. 167)—but also in the drawing of the
Louvre *Pietà*, exhibited at the museum during the
same years (Reiset 1878, p. 42, no. 125). The el-
egant anatomy of the Michelangelo drawing could
thus have contributed to the construction of the
torsos of the male nudes (from *Adam* [no. 20] to
The Shade [no. 21]) that Rodin executed toward
the end of the 1870s, while the wax *Study for a
Seated Man* in Kansas City (fig. 1) seems closer to
the rough anatomical definition of the drawing in
the Casa Buonarroti.

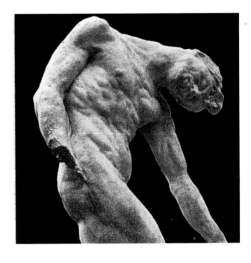

The Louvre drawing was reproduced in a very
fine Braun photograph (Braun 1876, p. 4, no. 55),
in existence by the first half of the 1870s, which
had been exhibited in Florence during the 1875
centenary. The series of photographs of Michelan-
gelo drawings, hung at the Accademia alongside
plaster casts and sculptural studies (*bozzetti*), made
a deep impression on visitors (to many they seemed
the best part of the show) and exposed them to
the extraordinary reproductive ability of this new
technological medium (the carbon print) that could
guarantee to the most illustrious graphic works an
international circulation with a fidelity unknown
in standard engraving. A passage from Charles
Blanc, written immediately after he returned from
Florence, beautifully captures this enthusiasm and
offers it for the possible temptation of artists: In
front of the Braun photographs "one could say that
the drawing of the master is completely in it, that
one is in the presence of Michelangelo himself, that
one touches with the fingers the lines of his pen,
his marks of black or red chalk, his ink or his bistre,
his revisions, his hatchings that are firm or soft,
emphatic or slight, and even the nature of the pa-
per he used.... One could say that the sheet had
just come, still warm, from the artist's hands or
that it had just be been removed from the portfo-
lios in the Casa Buonarroti in Florence" (Blanc
1876, p. 26).

49. Michelangelo
Study for "The Last Judgment"
c. 1534
Black chalk on paper, with pen and ink revisions
in a later hand, 16 $^9/_{16}$ x 11 $^{11}/_{16}$" (42 x 29.7 cm)
Casa Buonarroti, Florence. Inv. 65 F

This drawing is the most important surviving documentation for the design of *The Last Judgment*. As has long been noted, it relates to the first phase of the conceptualization of the great fresco in the Sistine Chapel, when Michelangelo still intended to incorporate works that were already there—Perugino's altarpiece below (Wilde 1936, pp. 7 ff) and, above, two of Michelangelo's own ceiling lunettes depicting the ancestors of Christ (Frey 1909–11, no. 20)—attempting "to overpower them with the swirling masses of his images" (Barocchi 1962, p. 178, no. 142). Compared to the more detailed sketches of sections of the fresco that are preserved in the British Museum, London (1895-9-15-518), and the Musée Bonnat in Bayonne, France (inv. 1217), here the elaboration of the imagery is at a more primitive stage, and the sole purpose of the drawing is to define the masses of the various groups and study their distribution (except for that of Christ and a male nude on the left, none of the other poses was retained). However, as Berenson noted in 1903, "the general arrangement is already as good as fixed, with the essential difference, however, that this first sketch promises a work of greater clearness, unity and compactness, and of far more continuity of rhythm than that finally decided upon" (Berenson 1903, vol. 1, p. 220).

The sheet's critical reception during the 1875 quadricentennial is of some importance: discussed already in France in a note by Paolo Emiliani Giudici in the *Gazette des Beaux-Arts* (Emiliani Giudici 1859, p. 190) and in Eugène Piot's "souvenirs de voyage" in the *Cabinet de l'Amateur* (Piot 1863, p. 140), the "rapid thoughts in black chalk" (as Aurelio Gotti characterized them in his 1875 Michelangelo catalogue; Gotti 1875, vol. 2, p. 192)

were considered by Paul Leroi one of the pinnacles of the "miraculous suite of drawings" for the Sistine Chapel on display at the Casa Buonarroti (Leroi 1875, "Publications," p. 141), and they were honored with a large-scale reproduction in the extremely popular *Album michelangiolesco* published that same year by Smorti (Smorti 1875). This photograph gives us assurance that the drawing entered into the visual consciousness of the period.

In this reproduction, or in its installation at the Casa Buonarroti, which remained unchanged for many years after the quadricentennial exhibition (Fabbrichesi 1886, p. 10, frame 13, no. 65), the sheet could have been seen by Rodin during his trip to Italy in early 1876. What obviously connects this sketch to the French sculptor is the final conception for *The Gates of Hell* (fig. 1), where clumps of figures, often similarly grouped, rise and fall or give support to each other as they seek contact in a space dominated by a force set in motion by the figure of the Judge, similarly placed within the composition itself. The earliest visitors to *The Gates* had no doubts on that score: "We must go back to Michelangelo to find an idea as noble, as beautiful, as sublime," Octave Mirbeau wrote in 1885 (Mirbeau 1980, p. 46). The following year Félicien Champsaur was convinced that one could not look at *The Gates* without thinking in one way or another of Michelangelo (Champsaur 1980, p. 50).

During his trip to Rome in 1876, Rodin certainly saw Michelangelo's fresco of *The Last Judgment*, which he would have been able to examine again in Paris in the copy made by Xavier Sigalon in 1833 (which from 1862 was displayed in the former church of the Augustines, annexed to the École des Beaux-Arts; Müntz [1889], p. 288) and in a

Fig. 1. Auguste Rodin, *The Gates of Hell*,
1880–1917. Bronze, height 250 ³/₄" (636.9 cm).
Rodin Museum, Philadelphia. Bequest of
Jules E. Mastbaum

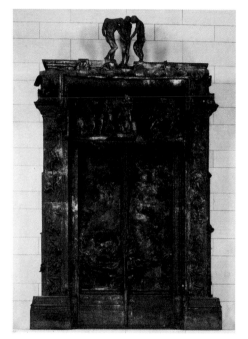

considerable number of engraved reproductions
(the latest being those printed by J. Claye and pub-
lished in the *Gazette des Beaux-Arts* in 1876).
Rodin's passion for this work is further docu-
mented by his acquisition of a photographic re-
production of it (by an unidentified photographer,
with the number 11945) showing the detail of the
Seven Deadly Sins.

This interest would not have seemed out of place
at the time. In the cultural climate of nineteenth-
century France, *The Last Judgment* was considered
the hallmark of the sublime and titanic aspects of
Michelangelo's genius ("a colossal work, that rises
like a world, in the annals of painting"; Delacroix
1837, p. 54) with its risk of manneristic exaggera-
tions ("Here he intentionally enlarges the body, and
inflates the muscles; he is prodigal of foreshort-
enings and violent postures, converting his person-
ages into well-fed athletes and wrestlers engaged
in displaying their strength"; Taine 1867, p. 290).
In the passage dedicated to the fresco published
in the quadricentennial issue of the *Gazette des
Beaux-Arts*, which in all likelihood Rodin read, Paul
Mantz criticized the too-calculated shrewdness of
Michelangelo's painterly means ("The imagination
is overwhelmed by the absolute rigor of his ges-
ture and the faultless precision of his drawing; but
in order to be touched, the soul does not need to
know so much. It prefers to have something left to
be figured out, and the drama, overly written, to
be lessened"; Mantz 1876, p. 174), which by con-
trast brought into a new light the very fresh inven-
tiveness of the drawings.

For Rodin, a passionate reader of Dante since
the early 1870s (as he himself told Victor Frisch;
Frisch and Shipley 1939, p. 413), the connection

between Dante's *Inferno* and Michelangelo's *Last Judgment* must have come after he was commissioned, in August 1880, to create a portal with stories inspired by Dante's *Inferno*, and in particular, after he abandoned the idea of following the precedent of Ghiberti's *Gates of Paradise* on the Baptistry in Florence, which were divided into individual panels. The Dantesque interpretation of *The Last Judgment*, which was already current in sixteenth-century criticism (by Giorgio Vasari, Benedetto Varchi, and Pietro Aretino; as reconstructed in Vasari 1962, vol. 1, p. 76, vol. 3, p. 1304) was taken up again in nineteenth-century French travel and art commentaries, starting with a famous passage in Stendhal ("Like Dante, Michelangelo does not merely give pleasure; he intimidates, he overwhelms the soul with the weight of suffering.... Like Dante, his style is the most severe ever encountered in the arts, the most antithetical to the French style.... In Michelangelo, as in Dante, the soul is frozen by this excess of seriousness. We behold the figure of a person who is about to witness some object of horror"; Stendhal 1854, pp. 376–77). It was restated with particular vehemence in the 1850s and 1860s (*The Last Judgment* is a "Divine Comedy in action" [Lafayette 1852, p. 350], or "a Dantesque poem in paint" [Lamartine 1868, p. 290]), and again, on various occasions, at the time of the quadricentennial of 1875. Just when the contract for *The Gates of Hell* was signed, a long article appeared in the *Revue des Deux Mondes* that closely linked the names of Dante and Michelangelo as representative of a moral integrity that could be transformed into a ruthless judgment against their contemporaries (Klaczko 1880).

50. Michelangelo
Study of a Kneeling Male Nude
After 1542
Charcoal on paper, 10 ⁵/₈ x 6 ¹¹/₁₆" (26.9 x 16.9 cm)
Casa Buonarroti, Florence. Inv. 54 F

This drawing, which shows a kneeling nude seen from behind in the act of supplication, has generally been linked to the figures in *The Last Judgment* in the Sistine Chapel (Steinmann 1905, p. 606, no. 74; Frey 1909–11, no. 276), although it is not possible to find an exact correlation for it among the figures in the large fresco. Paola Barocchi has thus proposed disassociating this sheet from the group of preparatory drawings for *The Last Judgment*, and on the basis of stylistic criteria, has dated it later (around 1542): thus, this image would constitute "a transition from the sculptural torment of the Sistine chapel fresco to the pensive spirituality of his later drawings" (Barocchi 1962, p. 183, no. 146).

The presence of a reproduction of this drawing in the Smorti photographic album (Smorti 1875, no. 6) is probably due to an interest in anatomical examples of the nude, which Rodin, in a statement made late in his life, maintained he did not share ("What should be admired in the drawing of Michelangelo is not the lines in themselves, the audacious foreshortenings and the skillful anatomy, but the thundering and desperate power of this Titan"; Rodin 1984, p. 42). Thus, instead of looking to Rodin's kneeling figures in theatrical and poignant gestures (*Kneeling Fauness, The Prodigal Son*), Michelangelo's drawing should be compared to the dramatic muscular composition of the backs of a number of the figures made for the *The Gates of Hell*: for example, the back of *The Falling Man*, reused with slight variations in the group *I Am Beautiful* (no. 25 and fig. 1), displays the same intention to unify the muscles of the back, buttocks, and legs in an analogous manner consisting of sinuous contours built up in relief.

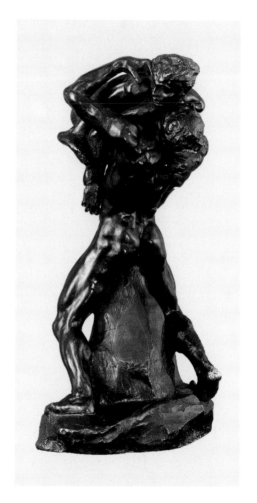

Fig. 1. Auguste Rodin, *I Am Beautiful* (no. 25)

216

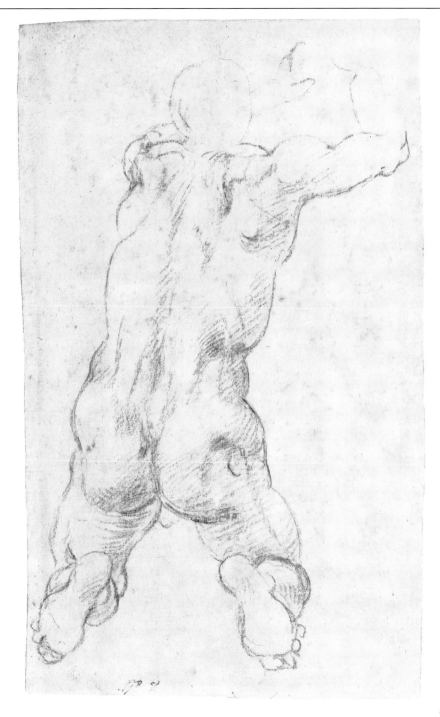

51. Michelangelo
Study for the Porta Pia
c. 1561
Black chalk, pen and ink, wash, and white lead
on paper, 17 $^7/_{16}$ x 11 $^1/_{16}$" (44.2 x 28.1 cm)
Casa Buonarroti, Florence. Inv. 106 A

Exhibited in Philadelphia only

This sheet is part of a series of studies for the Porta Pia in Rome, all of which are preserved in the Casa Buonarroti except for one drawing at Windsor Castle. This project for the city gate had been commissioned by Pope Pius IV in 1561, and its completion dragged on until 1565, after the death of the artist. Although the drawing cannot be identified with any of three "extravagant and very beautiful" designs (*modelli*) that, according to Vasari's account (Vasari 1962, vol. 1, p. 111), were presented to the pope for his final decision (the definitive plan called for pilasters instead of columns), it can be considered the most advanced of those that have come down to us. The sheet is composed of five pieces of paper glued together, which have (both on the recto and verso) figure drawings that have not been universally ascribed to Michelangelo. Although in the past the revisions in white lead and wash were consistently attributed to a hand other than Michelangelo's, the tendency today is to view these interventions as later thoughts by the artist himself. The prized "picturesque and broad effect that softens the forms" (Berti, Cecchi, and Natali 1985, p. 230) essentially serves to hide chalk lines from the first draft and to suggest the luminous and chromatic qualities of brick and travertine, the materials used to build the monumental gate (Hirst 1988, p. 156, no. 63).

Rodin's contemporaries had great difficulty interpreting Michelangelo's architecture, as it was so antithetical to the elegant neo-sixteenth-century eclecticism in vogue at the time. In this regard, the harsh condemnation delivered by Charles Garnier, architect of the recently completed and widely celebrated Paris Opéra, is very significant (see above, p. 183). Michelangelo's architectural drawings suf-

fered greatly in the literature and reproductions of the period in comparison to his figure sketches: a sheet as noteworthy for its complexity of development and chiaroscuro invention as the project for the Porta Pia did not receive any attention (Fabbrichesi's catalogue of the Casa Buonarroti preferred the more precise designs for the Medici tombs of San Lorenzo; Fabbrichesi 1875, pp. 9–11) with the slight exception of Aurelio Gotti's catalogue of Michelangelo (where the "rough sketch for a grandiose gate" was, however, not yet connected to the artist's work on the Porta Pia; Gotti 1875, vol. 2, p. 183).

At the time of Rodin's first trip to Italy, he was an artist already very much concerned with architecture, and during his 1876 visit to the Casa Buonarroti, this drawing could very well have had a special attraction for him. Something of the same strenuous effort to define an architectural ensemble with light and shadow while preserving the precision of the linear description may be observed in Rodin's most detailed sketches for *The Gates of Hell*, when the basic scheme was still inspired by the panels of Ghiberti's *Gates of Paradise*. But Rodin was moving from the framework of garlands to the nudes at the corners of the panels. It is, however, particularly in the terracotta model for *The Gates*, preserved today in the Rodin Museum in Philadelphia, that Rodin's desire to unify sculpture and architecture in a vibrant pulsating whole is seen, built from tensions and rhythms of light and shadow that seem to be influenced by the graphic character of Michelangelo's late and anticlassical architectural designs.

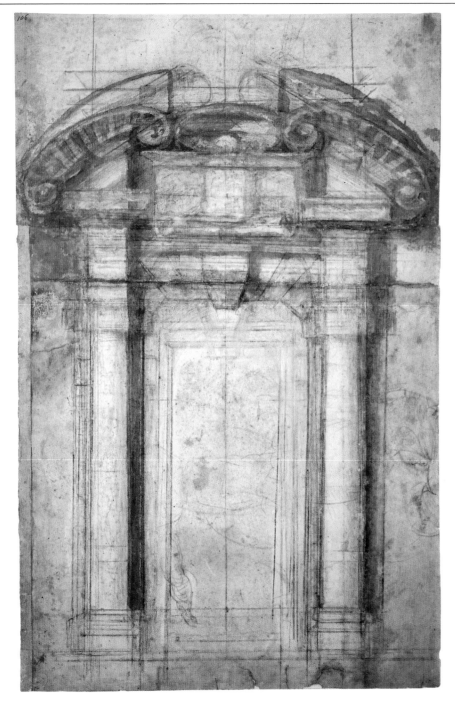

52. Attributed to Michelangelo
Christ on the Cross
c. 1562
Wood, height 8 ¹/₁₆" (20.5 cm)
Casa Buonarroti, Florence. Inv. 195

Exhibited in Philadelphia only

In a paper delivered at the twenty-first International Congress of the History of Art in Bonn in 1964, Charles De Tolnay attributed this small wooden crucifix, which is unfinished and lacking arms, to Michelangelo. The characteristics of the modeling of the body, "for example, the torso, where the chest bulges out and the abdomen is sucked in as if the figure is drawing its last breath" (De Tolnay 1967, p. 72), as well as other compositional solutions (the vertical position of the legs drawn together, the form of the knees) led De Tolnay to link this little model to a famous series of drawings that depict Christ between the Virgin and Saint John. This series was executed in the summer of 1562 for a wooden crucifix, to which two letters, written by Lorenzo Mariottini and Cesare Bittino in August of that year, refer (Florence 1964, p. 193). The effect of the extension of the body into the space around it that is found in this *bozzetto* from the Casa Buonarroti should be compared, according to De Tolnay, to that of the artist's drawings in which "the modeling is barely sketched in, and the repeated outlines form a sort of halo around the figures" (De Tolnay 1967, p. 73). This attribution has subsequently been followed only in the corpus of Michelangelo's sculpture by Umberto Baldini (Baldini 1981, p. 62, no. 51, figs. 208–9) and tentatively in a catalogue entry by Janice Shell, who thought the statuette seemed "consonant with the works of Michelangelo's late period" (Shell 1992, p. 270).

In 1875 this small model was exhibited in the fourth cabinet of the Library of the Casa Buonarroti (Fabbrichesi 1875, p. 22, no. 5) alongside the wax of *David* and the group of *Hercules and Cacus*; the only other published citation of this piece on the occasion of the 1875 quadricentennial was its listing among the "clay [terracotta and wax] and wooden models" in the popular *Ricordo al popolo italiano* (*Ricordo* 1875, p. 178). Later inventories describe the crucifix in the same arrangement, and thus Rodin would have been able to see it during his visits to Tuscany after that of 1876 (one in 1898 is proved by a letter in Rodin 1985, p. 186; another trip in 1901 is reconstructed in Butler 1993, p. 370; and a third in 1902, when even in Italy, Rodin was a celebrity and newspapers paid attention to him, is documented in "Notizie" 1902, p. 3). By this time his interest in Michelangelo, combined with the growing demand for his marble figures and a reputation more and more linked to the unfinished quality of his work, led Rodin to become concerned about the issue of direct carving and its implications for his sculpture.

Rodin's interest in Michelangelo's unfinished work was coupled with a thorough theoretical examination of it by the Romantics. This found its most significant expression in the famous pages of 1853 from Delacroix's *Journal* (where the incompleteness was seen as the outcome of an unequal struggle between the concept and the ability to realize it: "One sees clearly, from the parts left in a sketchy condition, from feet not yet cut from the block, and others where the material was lacking, that the vice of the work comes rather from the manner of conceiving and executing than from the extraordinary demands of a genius made for higher attainments and arrested before he could content himself. It is more probable that his conception was vague, and that he counted too much on the inspiration of the moment for the development of his thought"; Delacroix 1937, p. 308). This was

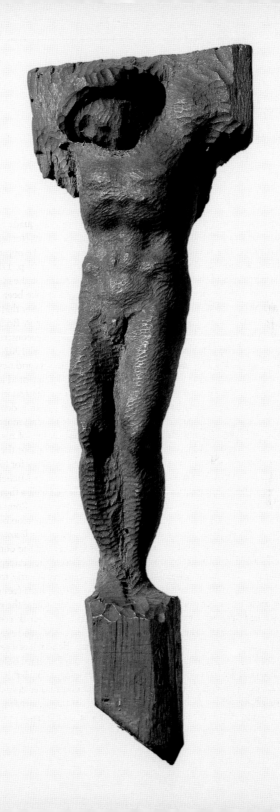

followed by a radical change of perspective (the unfinished as "supreme effort to strengthen the pictorial aspect of sculpture"; Barocchi in Vasari 1962, vol. 4, p. 1657) at the time of the quadricentennial, with the essay of Eugène Guillaume, director and instructor of sculpture at the École des Beaux-Arts in Paris ("When the works of Michelangelo are unfinished, his inspiration shines through with a brilliant vitality: the viewer follows the concept through his disappointments and his rages. One always catches sight of the sublime ideal, and the artist's talent appears even greater than his works.... The notion of human forces at work, the sense of the thought that rears up under the reins of art, the image of a terrible struggle against his material—all are unleashed in these works, in which strength is even more powerfully expressed than order"; Guillaume 1876, p. 117). For Rodin, even though he rarely took a critical stance regarding Michelangelo's unfinished work (one should mention, however, a passage in an interview granted in 1910 to Muriel Ciolkowska: "Michelangelo's finest work are precisely those which are called 'unfinished.' Works which are called 'finished' are works which are clear, that is all"; Ciolkowska 1910, pp. 266–67), the question was to be continually raised in his own work, at least beginning with his decision to exhibit at his 1886 show at the Galerie Georges Petit, four "sketches executed in marble" (Geffroy 1886, p. 1, identified in Beausire 1989, p. 94), in which parts that were completely finished live comfortably with sections that are only in rough form. And, particularly in the years of transition between the nineteenth and the twentieth centuries, the solid presence of incomplete parts in Rodin's marbles dominated critical discussion. The reference to Michelangelo could be employed in terms of exaltation (Rodin, by reclaiming the technique of the unfinished, "restores tradition and shapes the future"; Mauclair 1901, p. 775) or to accuse the artist of technical sloppiness, as in an especially hostile review by Ettore Ximenes, an Italian sculptor with a particular antipathy to the new: "Michelangelo carved his figures out of the stone block. Rodin does not carve from the block, but rather, he skillfully allows to be chiseled only what is enough to produce the desired effect.... The untutored public applauds, evoking recollections of an age of greatness, and shouts: Behold, here is a new Michelangelo! But exactly why does Rodin leave his figures incomplete? Because his mind is dead" (Ximenes 1901, p. 284).

Rodin, as is known, did not carve his figures directly from marble but modeled them in plaster, entrusting their translation by mechanical means to his studio assistants. His method then was completely different from the way Michelangelo created the model of this crucifix, which bears the carving marks that search out, within the wood, the nude figure of Christ. Yet the anatomical quality of this figure, with its breathing and dramatic physicality, shares something of Rodin's concept of a sculpted body that appears to communicate power and vibrancy to the surrounding space, as the artist explained in 1911 to Paul Gsell: "Instead of imagining the various parts of the body as more or less flat surfaces, I represented them as projections of interior volumes.... And so the trueness of my figures, instead of being superficial, appeared to grow from the inside outward, as in life itself" (Rodin 1984, p. 25).

Bibliographical Abbreviations

"Académie" 1878
"L'Académie des Beaux-Arts."
L'Année Artistique, 1878, pp.
37–50.

Agosti and Farinella 1987
Giovanni Agosti and Vicenzo
Farinella. *Michelangelo e l'arte
classica*. Exh. cat. Florence:
Cantini Edizioni d'Arte, 1987.

Alexandre 1900
Arsène Alexandre. *Exposition
de 1900: L'Oeuvre de Rodin*.
Exh. cat. Paris: Place de
l'Alma, 1900.

Alhadeff 1963
Albert Alhadeff. "Michelangelo
and the Early Rodin." *Art
Bulletin*, vol. 45 (December
1963), pp. 363–67.

Alinari 1873
*Catalogo generale delle
riproduzioni fotografiche
pubblicate per cura dei Fratelli
Alinari*. Florence: Tipografia
G. Barbera, 1873.

Alinari 1881
*Seconda appendice al catalogo
generale delle riproduzioni
fotografiche pubblicate per cura
dei Fratelli Alinari*. Florence:
Tipografia G. Barbera, 1881.

Alinari 1893
"Prospetto dei disegni e degli
oggetti d'arte della Galleria
Buonarroti fotografiti dal Sig.
Vittorio Alinari." Unpublished
manuscript, March 8, 1893.
Archivio Buonarroti Moderno.
Casa Buonarroti, Florence.

Alvin 1875
Louis Alvin. *Souvenir du IVe
centenaire de Michel-Ange*.
Brussels: Extrait du Compte
Rendu de la Séance du 30
septembre 1875 de l'Académie
de Belgique, 1875.

Balas 1995
Edith Balas. *Michelangelo's
Medici Chapel: A New
Interpretation*. Philadelphia:
American Philosophical
Society, 1995.

Baldini 1981
Umberto Baldini. *The
Sculpture of Michelangelo*.
New York: Rizzoli, 1981.

Ballu 1875, "Centenaire"
Roger Ballu. "Le Quatrième
Centenaire de Michel-Ange
Buonarroti." *L'Art*, vol. 1, part
3 (1875), pp. 73–84.

Ballu 1875, "Concurrents"
Roger Ballu. "Les Concurrents
aux Prix de Rome: Peinture et
sculpture." *L'Art*, vol. 1, part 2
(1875), pp. 346–50.

Barbet de Jouy 1876
[Henri] Barbet de Jouy. "La
Porte de Crémone au Louvre."
Gazette des Beaux-Arts, 2nd
period, vol. 13 (1876), pp.
313–22.

Barocchi 1962
Paola Barocchi. *Michelangelo
e la sua scuola: I disegni di
Casa Buonarroti e degli Uffizi*.
Florence: Leo S. Olschki,
1962.

Barr 1951
Alfred H. Barr, Jr. *Matisse: His
Art and His Public*. New York:
Museum of Modern Art, 1951.

Bartlett 1965
Truman H. Bartlett. "Auguste
Rodin, Sculptor." *American
Architect and Building News*,
vol. 25 (January 19–June 15,
1889), pp. 27–285 passim.
Reprinted in Elsen 1965, pp.
13–109.

Beausire 1986
Alain Beausire. "Le
Marcottage." In Paris 1986,
pp. 95–106.

Beausire 1989
Alain Beausire. *Quand Rodin
exposait*. Exh. cat. Paris:
Musée Rodin, 1989.

Bédat 1968
Claude Bédat. "L'Achat des dessins de Carlo Maratta par la Real Academia de San Fernando." *Melanges de la Casa de Velásquez*, vol. 4 (1968), pp. 413–15.

Benelli 1901
Sem Benelli. *La IV Esposizione, con i ritratti dei maggiori espositori*. Florence: G. Calvetti, 1901.

Berenson 1903
Bernhard Berenson. *The Drawings of the Florentine Painters Classified, Criticised and Studied as Documents in the History and Appreciation of Tuscan Art*. 2 vols. New York: E. P. Dutton, 1903.

Berenson 1938
Bernhard Berenson. *The Drawings of the Florentine Painters*. 3 vols. Chicago: University of Chicago Press, 1938.

Berti, Cecchi, and Natali 1985
Luciano Berti, Alessandro Cecchi, and Antonio Natali. *Michelangelo: I disegni di Casa Buonarotti*. Florence: Cantini Edizioni d'Arte, 1985.

Birolli 1990
Renato Birolli. "Testimonianza per Alberto Viani." In *Alberto Viani*, ed. P. C. Santini. Milan: Electa, 1990.

Blanc 1876
Charles Blanc. "Le Génie de Michel-Ange dans le dessin." *Gazette des Beaux-Arts*, 2nd period, vol. 13 (1876), pp. 5–33.

Boccioni 1972
Umberto Boccioni. "Note per la conferenza tenuta a Roma." [1911]. In *Altri inediti e apparati critici*, ed. Z. Birolli. Milan: Feltrinelli, 1972.

Boccioni 1973
Umberto Boccioni. "Technical Manifesto of Futurist Sculpture." In *Futurist Manifestos*, ed. Umbro Apollonio. New York: Viking Press, 1973.

Both de Tauzia 1879
L. Both de Tauzia. *Notice supplémentaire des dessins, cartons, pastels et miniatures des diverses écoles exposés, depuis 1869, dans les salles du 1er étage au Musée National du Louvre*. Paris: Société des Imprimeries Réunies, 1879.

Braun 1876
Ad. Braun & Cie. *Catalogue des dessins de maîtres de toutes les écoles reproduits en facsimile: Musée du Louvre*. Mulhouse: Ad. Braun & Cie., 1876.

Braun 1877
Ad. Braun & Cie. *Catalogue des dessins reproduits en facsimile: Albertina, Collection de S.A.I. l'Archiduc Albert, à Vienne*. Mulhouse: Ad. Braun & Cie., 1877.

Braun 1887
Ad. Braun & Cie. *Catalogue géneral des photographies inaltérables au charbon et héliogravures faites d'après les originaux peintures, fresques, dessins et sculptures des principaux musées d'Europe, des galeries et collections particulières les plus remarquables*. Paris and Dornach: Ad. Braun & Cie., 1887.

Brinckmann 1925
Albert Erich Brinckmann, ed. *Michelangelo Zeichnungen*. Munich: R. Piper, 1925.

Brogi 1879
Catalogue général des photographies publiées par la maison Giacomo Brogi de Florence. Florence: Tipografia Civelli, 1879.

Brogi 1889
Catalogo delle fotografie artistiche pubblicate dallo

stabilimento Giacomo Brogi: Seguito al catalogo 1878. Florence: Tipografia Fratelli Bencini, 1889.

Brownell 1980
William C. Brownell. *French Art.* 1892. Excerpted in Butler 1980, pp. 78–81.

Brownlee 1989
David B. Brownlee. *Building the City Beautiful: The Benjamin Franklin Parkway and the Philadelphia Museum of Art.* Exh. cat. Philadelphia: Philadelphia Museum of Art, 1989.

Burckhardt 1860
Jacob Burckhardt. *Der Cicerone: Eine Anleitung zum Genuss der Kunstwerke Italiens.* Basel: Schweighauserische Verlagsbuchhandlung, 1860.

Burroughs 1925
Bryson Burroughs. "Drawings by Michelangelo for the Libyan Sibyl." *Bulletin of the Metropolitan Museum of Art*, vol. 20 (1925), pp. 6–14.

Butler 1980
Ruth Butler, ed. *Rodin in Perspective.* Englewood Cliffs, N.J.: Prentice-Hall, 1980.

Butler 1981
Ruth Butler. "Rodin and the

Paris Salon." in Elsen 1981, pp. 19–49.

Butler 1993
Ruth Butler. *Rodin: The Shape of Genius.* New Haven: Yale University Press, 1993.

Caso 1972
Jacques de Caso. "Rodin's Mastbaum Album." *Master Drawings*, vol. 10 (Summer 1972), pp. 155–61.

Cecchi 1994
Alessandro Cecchi. "Bust of Michelangelo." In *The Renaissance from Brunelleschi to Michelangelo: The Representation of Architecture.* Exh. cat. New York: Rizzoli, 1994.

Champsaur 1980
Félicien Champsaur. "Celui qui revient de l'enfer: Auguste Rodin." *Le Figaro*, supplement, January 16, 1886. Translated and excerpted in Butler 1980, pp. 48–52.

Chennevières 1880
Philippe de Chennevières. *Les Dessins de maîtres anciens exposés à l'École des Beaux-Arts en 1879.* Paris: Gazette des Beaux-Arts, 1880.

Ciolkowska 1910
Muriel Ciolkowska. "Auguste

Rodin on Prejudice in Art." *Englishwoman*, April 1910, pp. 263–69.

Cladel 1903
Judith Cladel. *Auguste Rodin: Pris sur la vie.* Paris: Éditions de la Plume, 1903.

Cladel 1908
Judith Cladel. *Auguste Rodin: L'Oeuvre et l'homme.* Brussels: G. Van Oest, 1908.

Cladel 1937
Judith Cladel. *Rodin.* 1936. Translated by James Whithall. New York: Harcourt, Brace and Co., 1937.

Cladel 1953
Judith Cladel. *Rodin.* 1952. Translated by Lucy Norton. London: William Heinemann, 1953.

Clark 1956
Kenneth Clark. *The Nude: A Study in Ideal Form.* New York: Pantheon, 1956.

Courajod 1890
Louis Courajod. "Eugène Piot et les objets d'art légués au Musée du Louvre." *Gazette des Beaux-Arts*, 3rd period, vol. 41 (1890), pp. 395–425.

Dargenty 1883
G. Dargenty [Arthur

d'Echerac]. "Le Salon national." *L'Art*, vol. 9, part 4 (1883), pp. 26–40.

De Musset 1875
Paul de Musset. "La Chapelle de San Lorenzo." *L'Art*, vol. 1, part 3 (1875), pp. 149–52.

De Sanna 1985
J. De Sanna. *Medardo Rosso o la creazione dello spazio moderno*. Milan: Mursia, 1985.

De Tolnay 1954
Charles De Tolnay. *Michelangelo: IV. The Tomb of Julius II*. Princeton: Princeton University Press, 1954.

De Tolnay 1964
Charles De Tolnay. "L'Hercule de Michel-Ange à Fontainebleau." *Gazette des Beaux-Arts*, vol. 64 (1964), pp. 125–40.

De Tolnay 1967
Charles De Tolnay. "Un bozzetto in legno di Michelangelo." In *Stil und Überlieferung in der Kunst des Abendlandes: Akten des 21 Internationalen Kongresses für Kunstgeschichte in Bonn 1964*. Vol. 2, *Michelangelo*, pp. 71–73. Berlin: Gebr. Mann, 1967.

De Tolnay 1969
Charles De Tolnay. *The Youth of Michelangelo*. 2nd ed. rev.

De Tolnay 1975–80
Charles De Tolnay. *Corpus dei disegni di Michelangelo*. 4 vols. Novara: Istituto Geografico De Agostini, 1975–80.

Delacroix 1837
Eugène Delacroix. "Sur le Jugement dernier de Michel-Ange." *Revue des Deux Mondes*, vol. 11 (1837), pp. 337–43.

Delacroix 1937
Eugène Delacroix. *The Journal of Eugene Delacroix*. Translated by Walter Pach. New York: Covici, Friede, 1937.

Dujardin-Beaumetz 1965
Henri-Charles-Étienne Dujardin-Beaumetz. *Entretiens avec Rodin*. 1913. Translated in Elsen 1965, pp. 145–85.

Dupré 1875
Giovanni Dupré. "Les Tombeaux des Médicis à San Lorenzo: Courtes considérations artistiques." *L'Art*, vol. 1, part 3 (1875), pp. 118–20.

Dussler 1959
Luitpold Dussler. *Die Zeichnungen des Michelangelo: Kritischer Katalog*. Berlin: Gebr. Mann, 1959.

Elsen 1963
Albert E. Elsen. *Rodin*. New York: Museum of Modern Art, 1963.

Elsen 1965
Albert E. Elsen, ed. *Auguste Rodin: Readings on His Life and Work*. Englewood Cliffs, N.J.: Prentice-Hall, 1965.

Elsen 1981
Albert E. Elsen, ed. *Rodin Rediscovered*. Exh. cat. Washington, D.C.: National Gallery of Art, 1981.

Elsen 1981, "Gates"
Albert E. Elsen. "The Gates of Hell: What They Are About and Something of Their History." In Elsen 1981, pp. 63–79.

Elsen 1981, "Sculptures"
Albert E. Elsen. "When the Sculptures Were White: Rodin's Work in Plaster." In Elsen 1981, pp. 127–50.

Elsen 1985
Albert E. Elsen. *The Gates of Hell by Auguste Rodin*. Stanford: Stanford University Press, 1985.

Elsen and Varnedoe 1971
Albert E. Elsen and J. Kirk T. Varnedoe. *The Drawings of Rodin*. New York: Praeger, 1971.

Emiliani Giudici 1859
Paolo Emiliani Giudici. "Nouvelles de Florence." *Gazette des Beaux-Arts*, 1st period, vol. 4 (1859), pp. 189–90.

Emiliani Giudici 1862
Paolo Emiliani Giudici. "La Galerie Buonarroti à Florence." *Gazette des Beaux-Arts*, 1st period, vol. 12 (1862), pp. 476–83.

Fabbrichesi 1875
Angiolo Fabbrichesi. *Guide de la Galerie Buonarroti*. Florence: Tip. Cenniniana delle Murate, 1875.

Fabbrichesi 1886
Angiolo Fabbrichesi. *Guida della Galleria Buonarroti*. Florence: C. Ademollo e C., 1886.

Fath and Schmoll 1991
Manfred Fath and J. A. Schmoll gen. Eisenwerth, eds. *Auguste Rodin: Das Höllentor—Zeichnungen und Plastik*. Exh. cat. Munich: Prestel, 1991.

Fisher 1852
Joseph Fisher. *Seventy Etched Fac-similes on a Reduced Scale after the Original Studies by Michael Angelo and Raffaele in the University Galleries, Oxford*. Oxford: I. Shrimpton, 1852.

Florence 1880
Società Donatello, Florence. *Prima esposizione internazionale di quadri moderni inaugurata da S. Maestà il Re d'Italia Umberto I nel Palazzo del sig. Conte Serristori gentilmente concesso dal proprietario il 13 settembre 1880: Catalogo ufficiale*. Exh. cat. Florence: Stabilimento tipografico Mariani, 1880.

Florence 1964
Casa Buonarroti, Florence. *Michelangelo: Mostra di disegni, manoscritti e documenti*. Exh. cat. Florence: Leo S. Olschki, 1964.

Florence 1994
Casa Buonarroti, Florence. *Michelangelo nell'Ottocento: Il centenario del 1875*. Exh. cat. Milan: Charta, 1994.

Frey 1909–11
Karl Frey, ed. *Die Handzeichnungen Michelagniolos Buonarroti*. 3 vols. Berlin: J. Bard, 1909–11.

Frisch and Shipley 1939
Victor Frisch and Joseph T. Shipley. *Auguste Rodin: A Biography*. New York: Frederick A. Stokes, 1939.

Gaborit 1990
Jean-René Gaborit. "Michel-Ange entre fragment et inachevé." In Paris 1990, pp. 85–93.

Gambillo and Fiori 1958
Maria Drudi Gambillo and Teresa Fiori. *Archivi del Futurismo*. Vol. 1. Rome: De Luca Editore, 1958.

Gantner 1953
Joseph Gantner. *Rodin und Michelangelo*. Vienna: Anton Schroll, 1953.

Garnier 1876
Charles Garnier. "Michel-Ange architecte." *Gazette des Beaux-Arts*, 2nd period, vol. 13 (1876), pp. 187–203.

Geffroy 1886
Gustave Geffroy. "Chronique—Rodin." *La Justice*, July 11, 1886.

Geffroy 1889
Gustave Geffroy. "Auguste Rodin." In *Claude Monet, A. Rodin*. Exh. cat. Paris: Galerie Georges Petit, 1889.

Geissbuhler 1966
Elisabeth Chase Geissbuhler. "Rodin's Abstractions: The Architectural Drawings." *Art Journal*, vol. 26 (Fall 1966), pp. 22–29.

Geissbuhler 1971
Elisabeth Chase Geissbuhler. "Preliminary Notes on Rodin's Architectural Drawings." In Elsen and Varnedoe 1971, pp. 141–56.

Goldscheider 1962
Ludwig Goldscheider. *A Survey of Michelangelo's Models in Wax and Clay.* London: Phaidon Press, 1962.

Goldscheider 1989
Cécile Goldscheider. *Auguste Rodin: Catalogue raisonné de l'oeuvre sculpté, I. 1840–1886.* Lausanne and Paris: Wildenstein Institute, 1989.

Gonse 1875
Louis Gonse. "Les Fêtes du centenaire de Michel-Ange." *Gazette des Beaux-Arts*, 2nd period, vol. 12 (1875), pp. 375–84.

Gonse 1877
Louis Gonse. "La Salle de Michel-Ange au Louvre et sa nouvelle installation." *Gazette des Beaux-Arts*, 2nd period, vol. 14 (1877), pp. 347–52.

Gotti 1875
Aurelio Gotti. *Vita di Michelangelo Buonarroti.* 2 vols. Florence: Tipografia della Gazzetta d'Italia, 1875.

Gsell 1911
Paul Gsell. *L'Art: Entretiens réunis par Paul Gsell.* Paris: Bernard Grasset, 1911.

"Guide to South Kensington" n.d.
A Guide to the South Kensington Museum Illustrated with Ground Plans and Wood Engravings. N.p., n.d.

Guillaume 1876
Eugène Guillaume. "Michel-Ange sculpteur." *Gazette des Beaux-Arts*, 2nd period, vol. 13 (1876), pp. 34–118.

Guitton 1876
Gaston Guitton. "La Porte de Crémone: II. Le Monument." *Gazette des Beaux-Arts*, 2nd period, vol. 13 (1876), pp. 323–35.

Hartt 1969
Frederick Hartt. *Michelangelo: The Complete Sculpture.* London: Thames and Hudson, 1969.

Hartt 1970
Frederick Hartt. *Michelangelo Drawings.* New York: Harry N. Abrams, 1970.

Hartt 1987
Frederick Hartt. *David by the Hand of Michelangelo: The Original Model Discovered.* New York: Abbeville, 1987.

Hawley 1996
Henry Hawley. "Rodin's Titans." *The Cleveland Museum of Art Members Magazine*, vol. 36 (September 1996), pp. 6–7.

Hindenburg 1931
Helene von Nostitz Hindenburg. *Dialogues with Rodin.* Translated by H. L. Ripperger. New York: Duffield and Green, 1931.

Hirst 1988
Michael Hirst. *Michelangelo Draftsman.* Exh. cat. Milan: Olivetti, 1988.

Horn 1966
Axel Horn. "Jackson Pollock: The Hollow and the Bump." *Carleton Miscellany*, vol. 7 (Summer 1966), pp. 80–87.

Hulten, Dumitresco, and Istrati 1987
Pontus Hulten, Natalia Dumitresco, and Alexandre Istrati. *Brancusi.* New York: Harry N. Abrams, 1987.

Janson 1968
H. W. Janson. "Rodin and Carrier-Belleuse: The Vase des Titans." *Art Bulletin*, vol. 50 (September 1968), pp. 278–80.

Judrin 1981
Claudie Judrin. "Rodin's Drawings of Ugolino." In Elsen 1981, pp. 191–200.

Judrin 1984–92
Claudie Judrin. *Inventaire des dessins*. 6 vols. Paris: Éditions du Musée Rodin, 1984.

Justi 1908
Carl Justi. *Miscellaneen aus drei Jahrhunderten spanischen Kunstlebens*. Berlin: G. Grote'sche Verlagsbuchhandlung, 1908.

Kassner 1980
Rudolf Kassner. "Notizen zu Rodins Skulpturen." [1900]. In *Motive Essays*. 1906. Translated in Butler 1980, pp. 101–5.

Klaczko 1880
Julian Klaczko. "Causeries Florentines: I. Dante et Michel-Ange." *Revue des Deux Mondes*, 3rd period, vol. 37 (1880), pp. 241–80.

Kubler 1962
George Kubler. *The Shape of Time: Remarks on the History of Things*. New Haven: Yale University Press, 1962.

Lafayette 1852
Charles Calemard de Lafayette. *Dante, Michel-Ange, Machiavel*. Paris: E. Didier, 1852.

Lamartine 1868
Alphonse de Lamartine. "Vie de Michel-Ange." *Cours familier de littérature: Un entretien par mois*. Vol. 26, pp. 289–355. Paris, 1868.

Lanneau Rolland 1860
A. Lanneau Rolland. *Michel-Ange poète. Première traduction complète de ses poésies, précédée d'une étude sur Michel-Ange et Vittoria Colonna*. Paris: Didier, 1860.

Lawton 1906
Frederick Lawton. *The Life and Work of Auguste Rodin*. London: T. Fisher Unwin, 1906.

Le Normand-Romain 1990
Antoinette LeNormand-Romain. "Torses féminins." In Paris 1990, pp. 133–55.

Leroi 1875, "Publications"
Paul Leroi. "Les Publications du centenaire, VII." *L'Art*, vol. 1, part 3 (1875), pp. 137–41.

Leroi 1875, "12 septembre"
Paul Leroi. "12 septembre 1875." *L'Art*, vol. 1, part 3 (1875), pp. 313–33.

Leroi 1876
Paul Leroi. "Concours Michel-Ange, Grand Prix de Florence: Aux artistes de toutes les nations." *L'Art*, vol. 2, part 3 (1876), pp. 3–5.

Levkoff 1994
Mary L. Levkoff. *Rodin in His Time: The Cantor Gifts to the Los Angeles County Museum of Art*. Los Angeles: Los Angeles County Museum of Art, 1994.

Longhi 1961
Roberto Longhi. "La scultura futurista di Boccioni." [1914]. Reprinted in *Scritti giovanili, 1912–22*, pp. 133–62. Florence: Sansoni, 1961.

"Maîtres anciens" 1879
Catalogue descriptif des dessins de maîtres anciens exposés à l'École des Beaux-Arts. Paris: G. Chamerot, 1879.

Mantz 1865
Paul Mantz. "Musée rétrospectif: La Renaissance et les temps modernes." *Gazette des Beaux-Arts*, 1st period, vol. 19 (1865), pp. 326–49.

Mantz 1872
Paul Mantz. "La Galerie de M. Maurice Cottier." *Gazette des Beaux-Arts*, 2nd period, vol. 5 (1872), pp. 375–97.

Mantz 1876
Paul Mantz. "Michel-Ange peintre." *Gazette des Beaux-Arts*, 2nd period, vol. 13 (1876), pp. 119–86.

Mastrorocco 1989
Mila Mastrorocco. "Il centenario michelangiolesco del 1875." In *La scultura italiana dal XV al XX secolo nei calchi della Gipsoteca*. Exh. cat. Florence: Cassa di Risparmio, 1989.

Mauclair 1901
Camille Mauclair. "Auguste Rodin: Son oeuvre, son milieu, son influence." *Revue Universelle*, August 17, 1901, pp. 767–75.

Ménard 1878
Louis Ménard. "La Sculpture au Salon de 1878." *L'Art*, vol. 4, part 3 (1878), pp. 273–82.

Mirbeau 1980
Octave Mirbeau. "Auguste Rodin." *La France*, February 18, 1885. Translated in Butler 1980, pp. 45–48.

Mirbeau 1993
Octave Mirbeau. "L'Indiscrétion." In *Combats esthétiques 1877–1892*. Vol. 1. Paris: Nouvelles Éditions Séguier, 1993.

Moore 1966
Henry Moore. *Henry Moore on Sculpture*. Ed. Philip James. London: Macdonald, 1966.

Moreau 1984
Gustave Moreau. *L'Assembleur de rêves: Écrits complets de Gustave Moreau*. Ed. Pierre-Louis Mathieu. Fontfroide: Bibliothèque Artistique & Littéraire, 1984.

"Moulages" 1900
Catalogue des moulages en vente au Palais du Louvre: Antiquité. Paris: Imprimerie Nationale, 1900.

Moureyre-Gavoty 1975
Françoise de La Moureyre-Gavoty. *Sculpture italienne: Paris, Musée Jacquemart-André*. Paris: Éditions des Musées Nationaux, 1975.

Müntz [1889]
Eugene Müntz. *Guide de l'École Nationale des Beaux-Arts*. Paris: Maison Quantin, [1889].

"Notizie" 1902
"Notizie." *Il Marzocco*, September 9, 1902.

Ollivier 1872
Émile Ollivier. *Une visite à la chapelle des Médicis: Dialogue sur Michel-Ange et Raphael*. Paris: Sandoz et Fischbacher, 1872.

Paris 1982
Musée Rodin, Paris. *Ugolin*. Exh. cat. Paris: n.p., 1982.

Paris 1986
Galeries Nationale du Grand Palais, Paris. *La Sculpture française au XIXe siècle*. Exh. cat. Paris: Éditions de la Réunion des Musées Nationaux, 1986.

Paris 1989
Musée Rodin, Paris. *Claude Monet—Auguste Rodin: Centenaire de l'exposition de 1889*. Exh. cat. Paris: Éditions du Musée Rodin, 1989.

Paris 1990
Musée d'Orsay, Paris. *Le Corps en morceaux*. Exh. cat. Paris: Éditions de la Réunion des Musées Nationaux, 1990.

Paris 1993, "Copier"
Musée du Louvre, Paris. *Copier Créer. De Turner à Picasso: 300 oeuvres inspirées*

par les maîtres du Louvre. Exh. cat. Paris: Éditions du Réunion des Musées Nationaux, 1993.

Paris 1993, "Matisse"
Centre Georges Pompidou, Paris. *Henri Matisse 1904–1917.* Exh. cat. Paris: Éditions du Centre Georges Pompidou, 1993.

Passerini 1875
Luigi Passerini. *La bibliografia di Michel Angelo Buonarroti e gli incisori delle sue opere.* Florence: M. Cellini, 1875.

Pérez Sánchez 1978
Alfonso E. Pérez Sánchez. *I grandi disegni italiani delle collezioni di Madrid.* Milan: Silvana Editoriale d'Arte, 1978.

Piot 1863
Eugène Piot. "La Maison de Michel-Ange Buonarroti à Florence." In *Le Cabinet de l'Amateur par M. Eugène Piot: Années 1861 et 1862*, pp. 133–41. Paris: Librairie Firmin Didot Frères, Fils, et Cie., 1863.

Piot 1878
Eugène Piot. "Exposition Universelle: La Sculpture à l'exposition rétrospective du Trocadéro." *Gazette des Beaux-Arts*, 2nd period, vol. 18 (1878), pp. 576–600.

"Porte de Crémone" 1877
"Musée du Louvre: La Porte de Crémone." *Magasin Pittoresque*, vol. 45 (1877), pp. 249–50.

Praz 1960
Mario Praz. "Auguste Rodin." In *Bellezza e bizzarria.* Milan: Il Saggiatore, 1960.

Praz 1995
Mario Praz. "Auguste Rodin o la retorica del gesto." [1958]. In *Il patto col serpente: Paralipomeni di la carne, la morte e il diavolo nella letteratura romantica*, pp. 437–44. Milan: A. Mondadori, 1995.

Procacci 1965
Ugo Procacci. *La Casa Buonarroti a Firenze.* Milan: Electa, 1965.

Quatremère 1835
Antoine-Chrysostome Quatremère de Quincy. *Histoire de la vie et des ouvrages de Michel-Ange Bonarroti.* Paris: F. Didot Frères, 1835.

Rambosson 1900
Yvanhoé Rambosson. "Le Modèle et le mouvement dans les oeuvres de Rodin." *Rodin et son oeuvre.* Special issue of *La Plume*, nos. 266–71 (May 15–August 1, 1900), pp. 70–73.

Reiset 1875
[Marie] F[rédéric de] Reiset. "Michel-Ange: Étude pour le groupe de la Vierge et de l'Enfant Jésus que l'on voit dans la Chapelle Saint-Laurent à Florence d'après le dessin original faisant partie du Musée du Louvre." *L'Art*, vol. 1, part 3 (1875), pp. 142–45.

Reiset 1878
Marie Frédéric de Reiset. *Notice des dessins, cartons, pastels, miniatures et émaux exposés dans les salles du 1er et du 2e étage au Musée National du Louvre. Vol. 1, Écoles d'Italie, écoles allemande, flamande et hollandaise.* Paris: Charles de Mourgues Frères, 1878.

"Relazione" 1876
Relazione del centenario di Michelangiolo Buonarroti nel settembre del 1875 in Firenze. Florence: Giuseppe Civelli, 1876.

"Ricordo" 1875
Michelangiolo Buonarroti: Ricordo al popolo italiano. Florence: G. C. Sansoni, 1875.

Rilke 1965
Rainer Maria Rilke. *Rodin*.
1903. Translated in Elsen 1965,
pp. 110–44.

Rilke 1986
Rainer Maria Rilke. *Rodin and
Other Prose Pieces*. Translated
by C. Craig Houston. London:
Quartet Books, 1986.

Rodin 1906
Auguste Rodin. "La Leçon de
l'antique." *Le Musée*, vol. 1
(1904), pp. 15–18. Translated
in Lawton 1906, pp. 191–95.

Rodin 1984
Auguste Rodin. *Art:
Conversations with Paul Gsell*.
1911. Translated by Jacques de
Caso and Patricia B. Sanders.
Berkeley: University of
California Press, 1984.

Rodin 1985
Auguste Rodin.
*Correspondance de Rodin: I.
1860–1899*. Ed. Alain Beausire
and Hélène Pinet. Paris:
Éditions du Musée Rodin, 1985.

Rousseau 1869
Jean Rousseau. "Une
épigramme de Michel-Ange:
La Chapelle des Médicis."
Gazette des Beaux-Arts, 2nd
period, vol. 12 (1869),
pp. 451–54.

Rumohr 1827–31
Carl Friedrich von Rumohr.
Italienische Forschungen.
3 vols. Berlin and Stettin:
Nicholai'sche Buchhandlung,
1827–31.

Shell 1992
Janice Shell. "Christ on the
Cross." In *The Genius of the
Sculptor in Michelangelo's
Work*. Exh. cat. Montreal:
Montreal Museum of Fine
Arts, 1992.

Smorti 1875
*Album michelangiolesco dei
disegni originali riprodotti in
fotolitografia*. Florence:
P. Smorti, 1875.

Steinmann 1905
Ernst Steinmann. *Die
Sixtinische Kapelle*. Vol. 2,
Michelangelo. Munich:
F. Bruckmann, 1905.

Stendhal 1854
Stendhal [Marie-Henri Beyle].
*Oeuvres complètes de Stendhal:
Histoire de la peinture en Italie
par Stendhal*. 1817. Paris:
Michel Lévy Frères, 1854.

Stendhal 1973
Stendhal [Marie-Henri Beyle].
Stendhal and the Arts. Ed.
David Wakefield. London:
Phaidon Press, 1973.

Sylvester 1988
David Sylvester. *The Brutality
of Fact: Interviews with Francis
Bacon*. 3rd ed., enlarged. New
York: Thames and Hudson,
1988.

Taine 1867
Hippolyte-Adolphe Taine.
Italy: Naples and Rome.
London: Williams and
Norgate, 1867.

Tamassia Mazzarotto 1949
S. Tamassia Mazzarotto. *Le arti
figurative nell'arte di Gabriele
D'Annunzio*. Milan: Fratelli
Bocca, 1949.

Tancock 1976
John L. Tancock. *The Sculpture
of Auguste Rodin: The
Collection of the Rodin
Museum, Philadelphia*.
Philadelphia: Philadelphia
Museum of Art, 1976.

Thode 1913
Henry Thode. *Michelangelo:
Kritische Untersuchungen
über seine Werke*. Vol. 3.
Berlin: G. Grote'sche
Verlagsbuchhandlung, 1913.

Tosi 1968
Guy Tosi. "D'Annunzio, Taine
et Paul de Saint-Victor." *Studi
Francesi*, no. 34 (January–April
1968), pp. 18–38.

Varnedoe 1971
J. Kirk T. Varnedoe. "Rodin as a Draftsman—A Chronological Perspective." In Elsen and Varnedoe 1971, pp. 25–120.

Varnedoe 1981
J. Kirk T. Varnedoe. "Rodin's Drawings." In Elsen 1981, pp. 153–89.

Varnedoe 1985
J. Kirk T. Varnedoe. "Rodin's Drawings, 1854–1880." In Ernst Gerhard Güse, *Auguste Rodin: Drawings and Watercolors*, pp. 13–29. New York: Rizzoli, 1985.

Vasari 1912–15
Giorgio Vasari. *Lives of the Most Eminent Painters, Sculptors, and Architects.* Translated by Gaston Du C. De Vere. 10 vols. London: Philip Lee Warner, 1912–15.

Vasari 1962
Giorgio Vasari. *La vita di Michelangelo nelle redazioni del 1550 e del 1568.* Ed. Paola Barocchi. 5 vols. Milan: Riccardo Ricciardi Editore, 1962.

"Vente Piot" 1864
"Vente Eugène Piot." *La Chronique des Arts et de la Curiosité*, May 1, 1864, pp. 139–40.

Véron 1879
Eugène Véron. *Le Salon de 1878.* Paris, 1879.

Wilde 1928
Johannes Wilde. "Due modelli di Michelangelo ricomposti." *Dedalo*, vol. 8 (1927–28), pp. 653–71.

Wilde 1932
Johannes Wilde. "Eine Studie Michelangelos nach der Antike." *Mitteilungen des Kunsthistorischen Institute in Florenz*, vol. 4 (July 1932), pp. 41–64.

Wilde 1936
Johannes Wilde. "Der ursprüngliche Plan Michelangelos zum Jüngsten Gericht." *Die Graphischen Künste*, new series, vol. 1 (1936), pp. 7–11.

Wilde 1953
Johannes Wilde. *Italian Drawings in the Department of Prints and Drawings in the British Museum: Michelangelo and His Studio.* London: Trustees of the British Museum, 1953.

Wilde 1959
Johannes Wilde. "'Cartonetti' by Michelangelo." *Burlington Magazine*, vol. 101 (1959), pp. 370–81.

Wilde 1978
Johannes Wilde. *Michelangelo: Six Lectures.* Oxford: Clarendon, 1978.

Ximenes 1901
Ettore Ximenes. "Rodin." *La Rassegna Internazionale della Letteratura e dell'Arte Contemporanea*, March 1, 1901.

Photography Credits

Alinari Photographic Services, New York (p. 120)

Casa Buonarroti, Florence (pp. 14, 15, 17, 18, 21, 22, 118, 155, 161, 165, 169, 171, 173, 181, 185, 187, 190, 191, 195, 199, 200, 203, 205, 209, 213, 217, 219, 221); Antonio Quattrone (p. 24)

The Cleveland Museum of Art (pp. 99, 175)

Graphische Sammlung Albertina, Vienna (p. 166 [fig. 2])

The Hermitage Museum, Saint Petersburg (p. 134)

Los Angeles County Museum of Art (p. 68)

The Metropolitan Museum of Art, New York (pp. 162 [fig. 3], 177, 178)

Musée du Louvre, Paris (pp. 57, 65, 88, 154); A. Giraudon (p. 210)

Musée Rodin, Paris (pp. 34, 63, 168, 170, 174, 192); Charles Bodmer (p. 198); B. Hatala (p. 97, right); © Bruno Jarret / ADAGP (pp. 79, 91, 93, 95, 145, 158, 193 [fig. 3]); © Adam Rzepka / ADAGP (p. 97, left)

The Nelson-Atkins Museum of Art, Kansas City, Missouri © The Nelson Gallery Foundation (p. 208)

Philadelphia Museum of Art (pp. 26, 60, 66 [fig. 15], 138, 162 [fig. 2], 166, 182, 196, 206, 207, 211); Lynn Rosenthal (pp. 50, 54, 55, 59, 61, 156, 158 [fig. 3], 172, 180, 189); Murray Weiss (pp. 142, 216); Graydon Wood (pp. 46, 64, 85, 87, 89, 101, 103, 105, 107, 109, 111, 113, 115, 117, 119, 121, 125, 127, 128, 129, 131, 133, 135, 137, 139, 141, 143, 147, 149, 151, 153, 214)

Santa Barbara Museum of Art (p. 37)

Library of Congress Cataloging-in-Publication Data

Rodin e Michelangelo. English.
 Rodin and Michelangelo : a study in artistic inspiration / Flavio
Fergonzi . . . [et al.].
 p. cm.
 Catalog of an exhibition with the same title held at Casa
Buonarroti, Florence, June 11–Sept. 30, 1996, and the Philadelphia
Museum of Art, Mar. 27–June 22, 1997.
 Includes bibliographical references.
 ISBN 0-87633-110-X (cloth : alk. paper). — ISBN 0-87633-109-6
(paper : alk. paper)
 1. Rodin, Auguste, 1840–1917—Exhibitions. 2. Rodin, Auguste,
1840–1917—Criticism and interpretation. 3. Michelangelo Buonarroti,
1475–1564—Influence—Exhibitions. I. Fergonzi, Flavio. II. Casa
Buonarroti (Florence, Italy). III. Philadelphia Museum of Art. IV. Title.
NB553.R7A4 1997
730'.92—dc21 97-6631
 CIP